HOW TO DRAW
ANIME & GAME CHARACTERS

Vol. 3
Bringing Daily Actions to Life

Introduction

When you are drawing your own original characters, don't you want to breathe life into them and see them move with vivacity?

When drawing characters, "daily actions" are very important. How does one make a character move naturally, with ease, and with charm? This is also very important in the world of 3D computer graphics.

"Motion" is a continued collection of momentary poses. With each of the individual poses, where to cut, what to show on the page, and enacting the character become conclusive factors. Finally, in directing the character, you become like the director of a movie.

This volume explains in great detail that poses to use, when to use them, the positions, and the effects of how the characters are shown. "Daily Actions" itself becomes the basics for Manga, animation, and video games.

The following is a list of special terms and abbreviations used in this book.

Bishoujo:	Young, pretty girl
Bishounen:	Young, attractive boy
CG:	Computer Graphics
Gakuen Genre:	School Life Genre
OVA:	Original Video Anime
RPG:	Role-playing Game
SD:	Simple Deformed (Exaggerated)
Shoujo:	Young girl
Shoujo manga:	Girl's comics
Takarazuka:	An all-women theatrical company in Japan

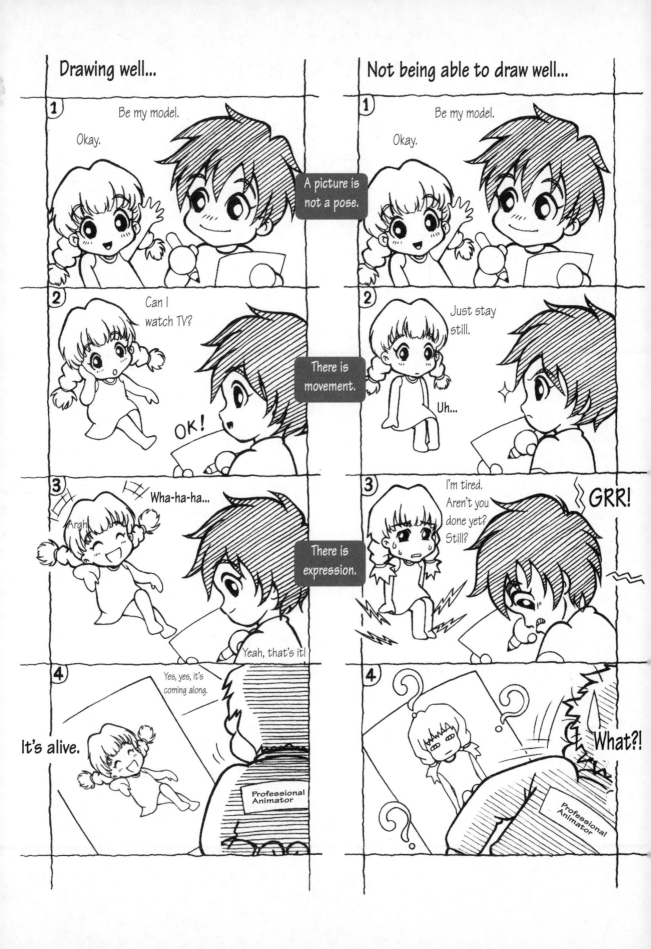

Table of Contents

HOW TO DRAW ANIME & GAME CHARACTERS Vol.3
Bringing Daily Actions to Life
by Tadashi Ozawa

Copyright © 1999 Tadashi Ozawa
Copyright © 1999 Graphic-sha Publishing Co., Ltd.

First designed and published in 1999 by Graphic-sha Publishing Co., Ltd.
This English edition was published in 2001 by
Graphic-sha Publishing Co., Ltd.
1-14-17 Kudan-kita, Chiyoda-ku, Tokyo 102-0073, Japan

Original layout and design: Motoi Zige
Cover drawing: Koh Kawarajima
English edition layout: Shinichi Ishioka
English translation: Língua fránca, Inc. (an3y-skmt@asahi-net.or.jp)
Japanese edition editor: Sahoko Hyakutake (Graphic-sha Publishing Co., Ltd.)
Foreign language edition project coordinator: Kumiko Sakamoto (Graphic-sha Publishing Co., Ltd.)

First printing: August 2001
Second printing: November 2001
Third printing: March 2002
Fourth printing: November 2002
Fifth printing: February 2003
Sixth printing: January 2004
Seventh printing: July 2004
Eighth printing: July 2006

ISBN: 4-7661-1175-3
Printed and bound in China by Everbest Printing Co., Ltd.

Chapter 1
Let's Master the Basics!
Understanding Perspectives

Chapter **1**

The First Step: The Character at Eye Level

Drawing a picture is the same as shooting a movie with a camera. The position of the camera (the height of your eyes) is the same as that of the character unless there is a special perspective. When characters approach the camera, they look larger in the image and become smaller as they become distant, right? So, how small or big should they be? Here, the use of perspective, or guidelines, becomes necessary.

The height of the camera = the character's eye level (the height of the eyes) → horizon line

This doesn't change even when something like a horizon isn't drawn in the background. However, it's different when you want a special perspective.

Don't forget this line.

It's very important.

Basics within the Basics

Under normal circumstances, wherever the character may go the eyes are above the horizon line.

The standard size of the character

The sizes of the characters, other than the protagonist are based on the size of the protagonist. Rival characters are drawn at a size of 1.2 times and friendly characters are double the size. Preparing a reference in this manner is helpful. Here, A is the protagonist.

Character C

Character A

Character B
(The same height as Character A)

Character D

Determining the Vanishing Point

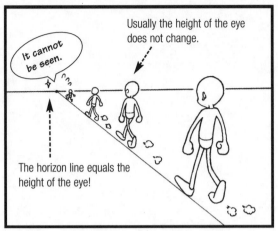

Usually the height of the eye does not change.

It cannot be seen.

The horizon line equals the height of the eye!

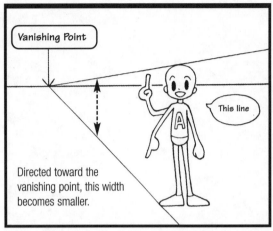

Vanishing Point

This line

Directed toward the vanishing point, this width becomes smaller.

A character progressively walking into the distance will eventually come to a point on the horizon line where he/she is no longer visible. This point on the ground is

The two lines drawn from the crown of the head and the place where the feet touch the ground are the perspective lines. They are the standard for everything.

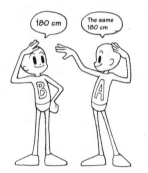

180 cm

The same 180 cm

If both have the same height with the same eye level, the horizon line and the percentage of perspective are the same.

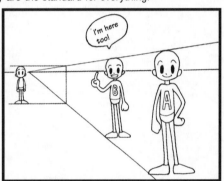

I'm here too!

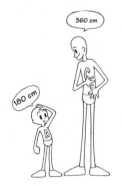

360 cm

180 cm

Character C, who is twice the height of Character A, becomes smaller remaining twice the height of Character A as he recedes towards the back.

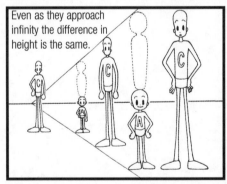

Even as they approach infinity the difference in height is the same.

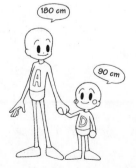

180 cm

90 cm

With Character D, who is half the height of Character A, no matter how far he recedes into the distance (and becomes small) he remains half the size of Chracter A.

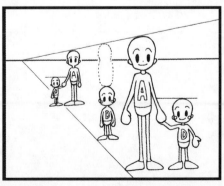

Movement of a Well-Balanced Drawing

Trying to Move the Characters Simply

Wherever the character is, it can be moved if there are perspective lines and a vanishing point.

Simply moving horizontally

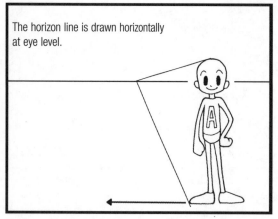

Draw a horizontal line from the tip of the foot to the point where you want to move the character.

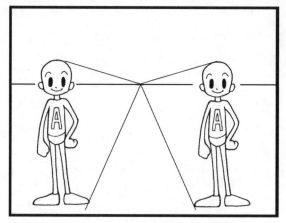

When the eye is at the horizon line and the foot is at the line extended from the original foot, the drawing is complete.

Moving back and to the side

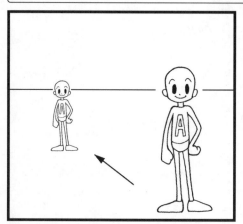

Moving back and to the side

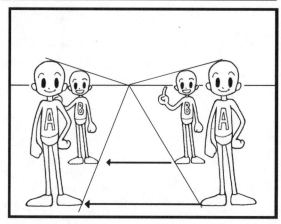

Moving to the back (becoming smaller) Character A moves to the side unchanged.

Randomly Moving

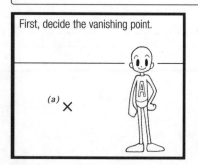

Write (a) at the destination point.

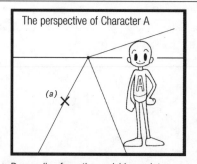

Draw a line from the vanishing point through (a).

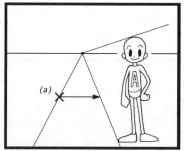

Draw a horizontal line from (a) to the perspective line of Character A.

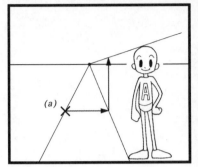

Draw a vertical line up from the point where the lines meet.

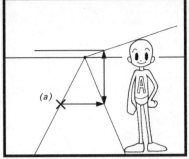

This is the same as the height of Character A when it is at (a).

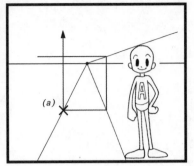

From (a) a line is drawn up toward the horizontal line.

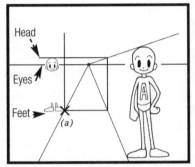

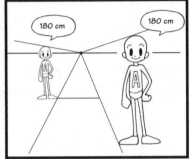

If the line you draw crosses the same points where the top of the head, eyes, and feet would be, the drawing can be made.

Even with Character C, who is twice the height of Character A, and with Character D, who is half the height of Character A, this is the same. The vertical length of the perspective lines is the character's height. Also, remember to place the eyes at the horizon line.

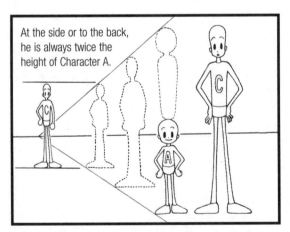

At the side or to the back, he is always twice the height of Character A.

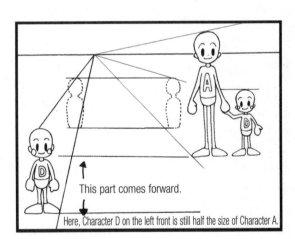

This part comes forward.

Here, Character D on the left front is still half the size of Character A.

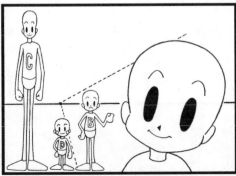

Keep in Mind!

Even with a close-up on the face, these strict rules do not change. This is particularly to an extreme staging of the expression of the principal character.

Enacting Pattern I

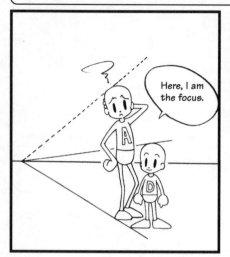

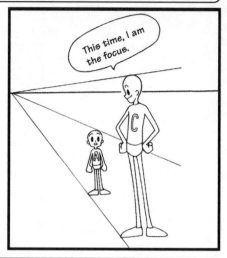

In these two scenes, instead of Character A, Characters C and D are the focus. To make this clear to the viewer, the eye level of the focus character is on the horizon line.

Here, I am the focus.

This time, I am the focus.

What to do in this situation?

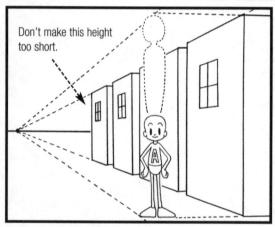

Don't make this height too short.

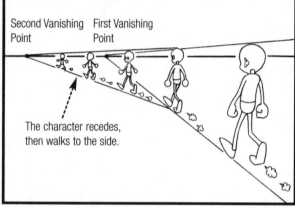

Second Vanishing Point First Vanishing Point

The character recedes, then walks to the side.

When drawing buildings: Compare it to drawing many figures like Character A, above. The perspective lines are drawn in the same manner as with Character C on the previous page.

Walking in a zig-zag: Without deciding the new vanishing point based on the degree of turn, the size becomes confused.

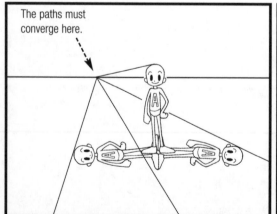

The paths must converge here.

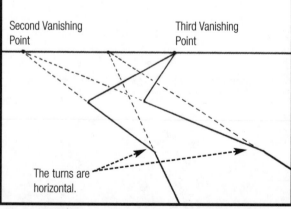

Second Vanishing Point

Third Vanishing Point

The turns are horizontal.

Creating the Path Width: If you want to make the path width twice the height of Character A, draw lines to the left and right of Character A. (Extending from the vanishing point and tangent to the heads of both characters that lay on their sides.) Be extra careful to make sure the vanishing point rests on the horizon line.

A Path of a Turn: The same as with a character turning and walking, a new vanishing point is made from the angle of the turn.

Enacting Pattern II

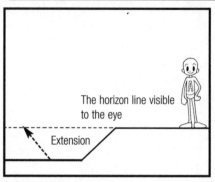

The horizon line visible to the eye

Extension

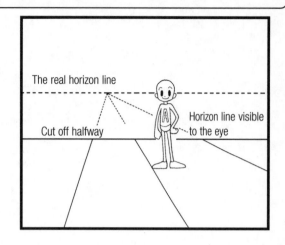

The real horizon line

Cut off halfway

Horizon line visible to the eye

When there is a slope: The horizon line visible to the eyes is different from the actual horizon line. To find the vanishing point, extend the perspective lines to the actual horizontal line.

Jumping and Crouching

A rectangle from the front. Diagonal lines are used to cut it in half.

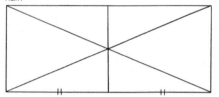

Looking at something diagonally, it is easy to confuse the effect of distance.

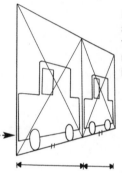

In other words, when slanted, something with the same width looks narrower as it recedes into the distance.

The halved rectangle is halved once again into quarters.

Although it is the same when slanted, the way it looks is different.

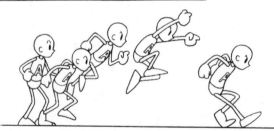

It becomes about 15 m (16.5 yd.)

2-3 m (2.2-3.3 yd.)

The same is true for the landing point of the jump. It is intentionally drawn narrowly.

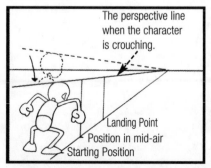

The perspective line when the character is crouching.

Landing Point
Position in mid-air
Starting Position

Before drawing a jump, the starting point, the position in mid-air, and the landing position must be decided based on the starting position. With these decided, establish the crouched character. Draw a perspective line from the crown of the head to the vanishing point. This way the height when the character lands will not get confused.

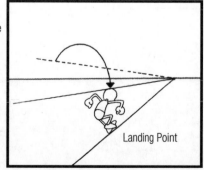

Landing Point

The Body's Perspective

When the body bends or changes direction, the drawing changes as well, right? This is because the perspective of the body changes shape. All parts of the body have volume; the lines of perspective exist. First, let's think of it in terms of boxes.

When seen from the front, the height of the eyes (the camera) is equal to the center of the box and is equal to the height of the horizon line. In this case, the vanishing point is hidden behind the box and is not visible.

Looking at it slightly slanted, the vanishing point is off and becomes visible.

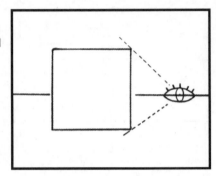

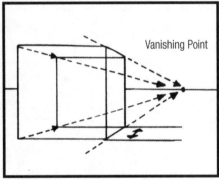

Vanishing Point

The lines drawn from the vanishing point to the corners of the box are the perspective lines of this box = the depth

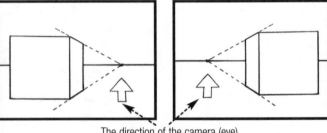

The direction of the camera (eye)

Depending on where the box is relative to the direction of the camera (eyes), the foreshortening (the perspective line) also varies.

Randomly Moving

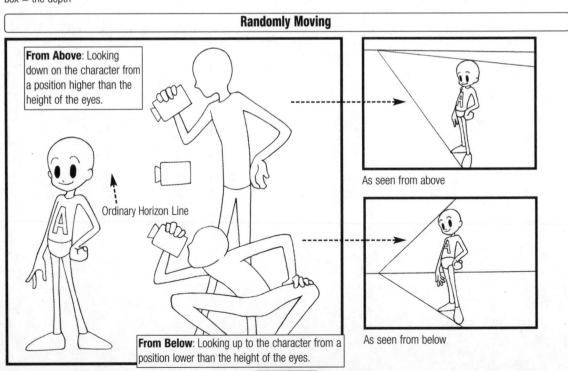

From Above: Looking down on the character from a position higher than the height of the eyes.

Ordinary Horizon Line

From Below: Looking up to the character from a position lower than the height of the eyes.

As seen from above

As seen from below

Let's take into consideration a Japanese wooden sandal, for example. If we look down upon it from above, the part worn is visible. Likewise, looking up at it from below would make the underside visible, right? Not only shifting the lateral (left-right) position changes the perspective but also shifting the vertical (up-down) position changes the perspective.

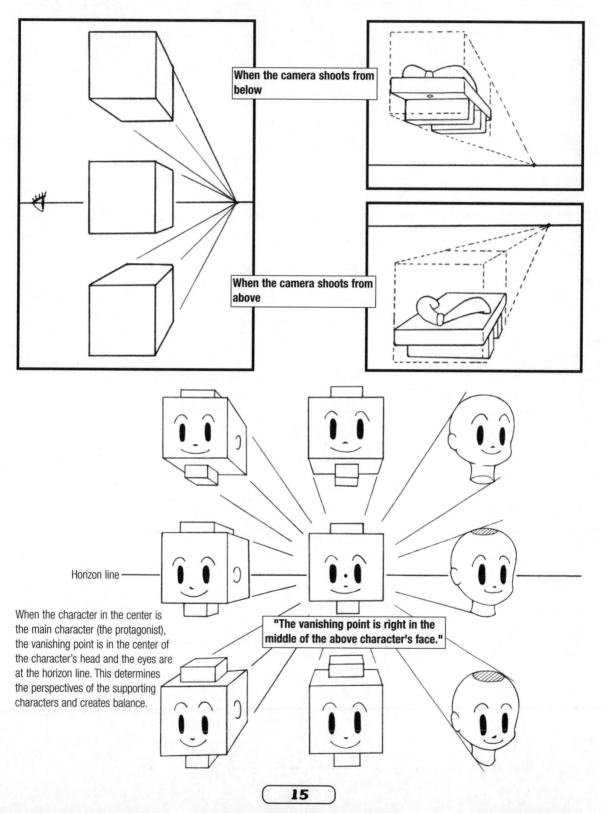

When the camera shoots from below

When the camera shoots from above

Horizon line

When the character in the center is the main character (the protagonist), the vanishing point is in the center of the character's head and the eyes are at the horizon line. This determines the perspectives of the supporting characters and creates balance.

"The vanishing point is right in the middle of the above character's face."

What's Strange? Why is it Strange?

These pictures look properly rendered at first, but isn't there something strange in some way? Let's take another look at the perspective.

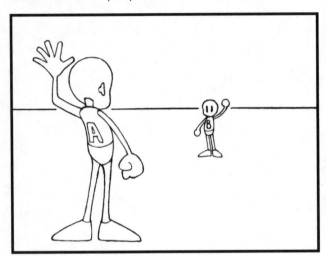

Even though the heights of Characters A and B are the same,

1. the height of the eyes of the characters is different. They do not rest on the same horizon line.
2. drawing a perspective line reveals that the height of Character B is not sufficient.

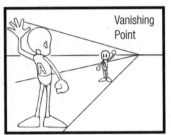

Is the phone booth too big?

The phone booth is the clue. First, extend the top and bottom of the booth and look for the vanishing point where they converge. From this point draw perspective lines to Character B.

Character A should be much larger, right?

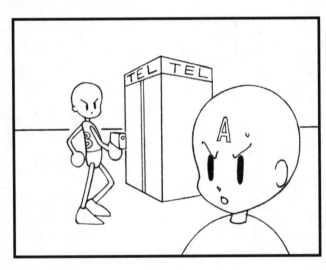

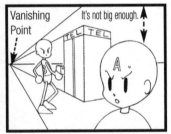

The vanishing points are different.

Even if attention is paid to drawing the seated characters, there's still a mistake.

Character A is seen from above, while Characters B and E are seen from below. Also, the vanishing points are different, right??

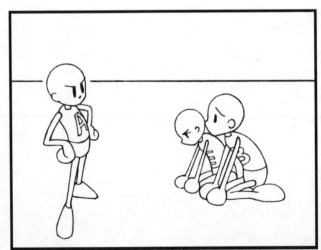

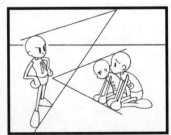

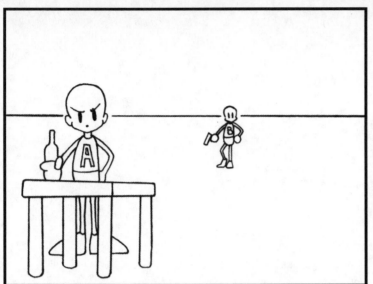

Is the direction of the table strange?

Though the perspective of Characters A and B is okay, the perspective of the table doesn't match the perspective of the characters.

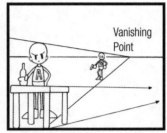

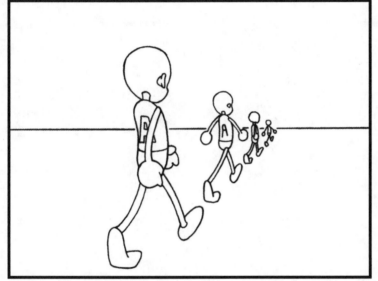

Are the horizon line and the perspective strange?

Even though it isn't seen from above, the horizon line is lower than the eyes of the character. Also, drawing perspective lines shows the height of the walking character is completely insufficient.

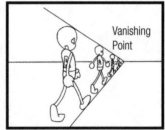

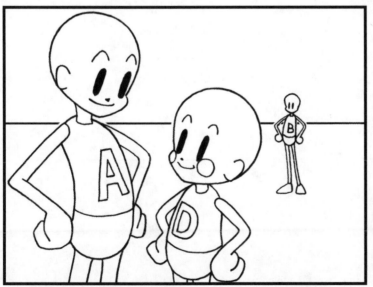

The body parts are not correct.

First draw perspective lines from Character A's shoulders and hips to the vanishing point. Character B, who is supposed to be the same height, does not have its hips or shoulders resting on these lines.

Also, though Character D is half the height of Character A, he is floating in this drawing.

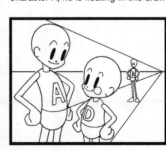

Advice from Young Illustrators

Hiroyuki Miyazaki

D.O.B. July 3rd, 1973
Tokyo
 After graduating from a technical college, Hiroyuki became the assistant of a Manga artist while getting involved as a freelance graphic artist with a number of video game productions. Also, he has participated in an animation illustration collection, card games, and computer graphics coloring. Currently he is enhancing his skills at a game software company in Tokyo.

To effectively improve your drawing what should be done? I, myself, want to become a true professional so I face this problem head on. After some trial and error, I still made a lot of mistakes. This time when I was asked to give advice, I thought I want advice myself! Truly, drawing is really difficult, isn't it? This won't be a complete answer, but I will let you know what has been effective for me. I'll be happy if it is of use to you.

1. Make a thorough comparison of parts (make a scrapbook). If you draw, there must be one or two people who you think are truly skillful. Copy their drawings. Then fully analyze your drawings by thoroughly comparing the individual parts. When doing so, don't pay so much attention to the overall finished product.
When I look at my drawing, I ask what lines are good? What is different from my drawing that is charming? Look at the parts separately and extensively analyze them. It'll be pretty easy to do.
Also, with the overall posing of the character, return to a wooden figure and make comparisons. Seeing the differences is interesting, I think.

2. Make sure to clean up your drawings.
Even if the base sketch is bad, make a clean copy. So the original is bad, but you will be able to see the weak points with a fresh eye.
To effectively improve your drawing it is important to find and tackle each weak point separately.

Even if there are many problem areas don't give up. If you give up then you'll have nothing, right? Hang in there!!

Chapter 2
Basic Movements

Chapter 2

What is a "Daily Action?"

A "daily action" is a pose found in the typical scenes of everday life. This is an important phrase used often in the world of animation and games. Being able to draw these is a barometer for judging ability.

In animation, dramatic actions by a giant robot or a street fighter certainly occur. But it is difficult to see clearly the details of the rapid motion with the eye. So long as the image of the movement gets communicated, it's fine.

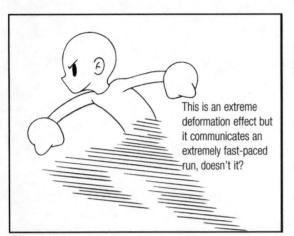

This is an extreme deformation effect but it communicates an extremely fast-paced run, doesn't it?

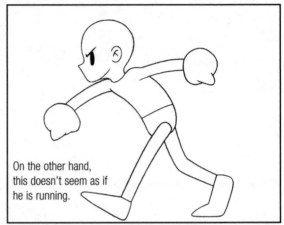

On the other hand, this doesn't seem as if he is running.

With poses that anyone can do, if the drawing is unclear or if it is difficult to communicate what is happening, then the work itself will be ruined completely. Actions that are not dramatic are more difficult to draw than bold actions.

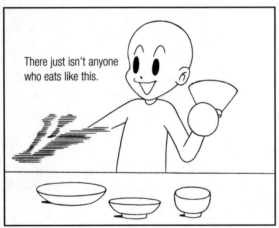

There just isn't anyone who eats like this.

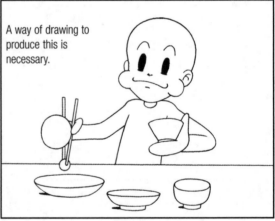

A way of drawing to produce this is necessary.

Errors in detail such as holding the rice bowl or chopsticks in an incorrect manner or drawing a tired person with his back straight result in a failure to convey the intent of the drawing.

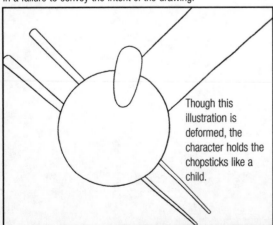

Though this illustration is deformed, the character holds the chopsticks like a child.

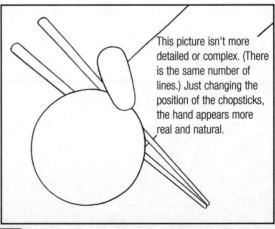

This picture isn't more detailed or complex. (There is the same number of lines.) Just changing the position of the chopsticks, the hand appears more real and natural.

There isn't anyone who makes the same exact pose in everyday life, right? The same is true of drawings. The poses must change with each character. Also, if it is the same character, the pose changes depending on the situation.

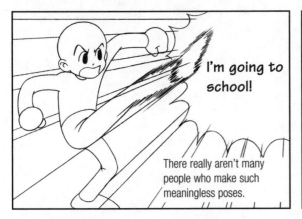

I'm going to school!

There really aren't many people who make such meaningless poses.

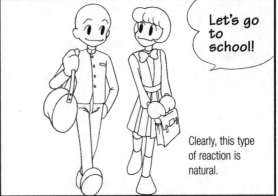

Let's go to school!

Clearly, this type of reaction is natural.

The action is the same, walking, but the conditions are explained just by looking at it, right? They even lead the reader to wonder what has happened.

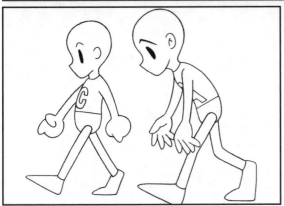

Only drawing angles and poses that are easy for you limits your drawings. Being able to draw a large variety of positions is a plus.

It is difficult to make an action pose like this, but luckily it doesn't change much with gender or age.

The first step is to closely examine the everyday gestures of ordinary people. Bring out the individuality of a character by drawing distinctions between people who shovel food into their mouths from those who take small bites and those who walk briskly from those who walk slowly. In this chapter, we will practice how to draw the basic movements for a countless number of "Daily Actions."

Standing I: Relaxed Stand

This is a standard standing pose. Let's first draw a relaxed situation.

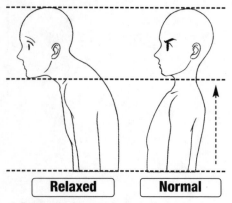

Relaxed **Normal**

- ◆ Exaggerate the curve on the back.
- ◆ The neck and back both bend forward while the chin and shoulders come roughly to the same height.
- ◆ The height of the shoulders doesn't change. (Dropping the shoulders would make this an expression of "Disappointment.")

First use a wire frame figure to get the curves and then use square boxes to fix the direction of the body.

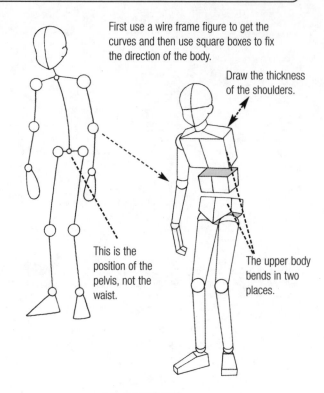

Draw the thickness of the shoulders.

This is the position of the pelvis, not the waist.

The upper body bends in two places.

Horizontal

The socket for the shoulder is drawn from the jaw.

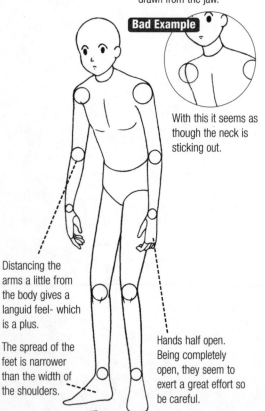

Bad Example

With this it seems as though the neck is sticking out.

Distancing the arms a little from the body gives a languid feel- which is a plus.

The spread of the feet is narrower than the width of the shoulders.

Hands half open. Being completely open, they seem to exert a great effort so be careful.

From Above

The face stands out the most. When relaxed, adjust the droop of the head and make it expressionless.

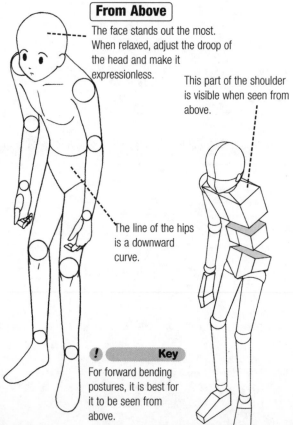

This part of the shoulder is visible when seen from above.

The line of the hips is a downward curve.

! Key

For forward bending postures, it is best for it to be seen from above.

Horizontal Back View

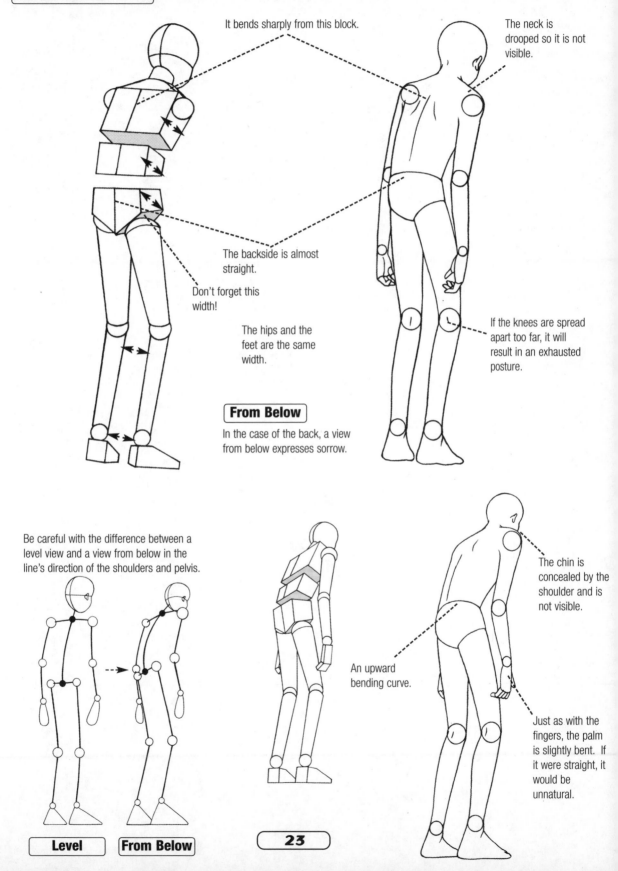

It bends sharply from this block.

The neck is drooped so it is not visible.

The backside is almost straight.

Don't forget this width!

The hips and the feet are the same width.

If the knees are spread apart too far, it will result in an exhausted posture.

From Below

In the case of the back, a view from below expresses sorrow.

Be careful with the difference between a level view and a view from below in the line's direction of the shoulders and pelvis.

The chin is concealed by the shoulder and is not visible.

An upward bending curve.

Just as with the fingers, the palm is slightly bent. If it were straight, it would be unnatural.

Level **From Below**

Standing II: Tense Stand

An exertion of will in a tense stand. This is different from being frightened or reprimanded.

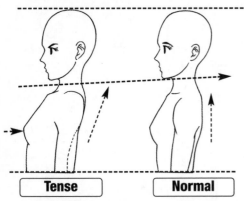

Tense **Normal**

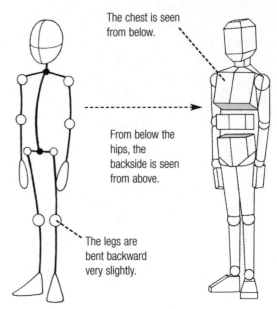

The chest is seen from below.

From below the hips, the backside is seen from above.

The legs are bent backward very slightly.

◆ The shoulder is raised slightly higher than "Normal."
◆ The chin is slightly pulled down.
◆ Apart from in exceptions, such as a woman with a large bust or a muscle man, the abdomen comes forward the most.

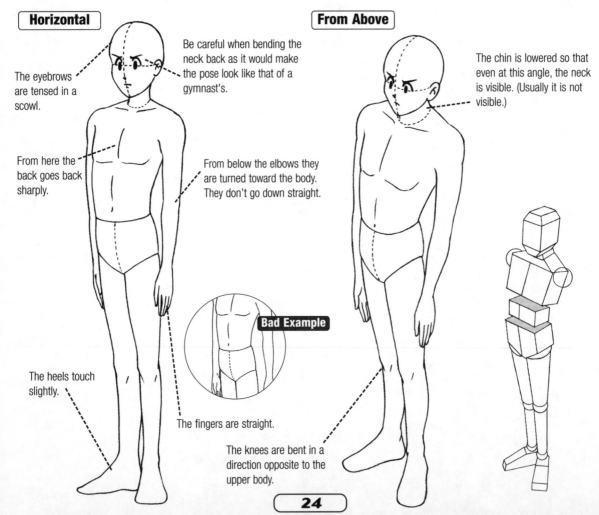

Horizontal

The eyebrows are tensed in a scowl.

Be careful when bending the neck back as it would make the pose look like that of a gymnast's.

From here the back goes back sharply.

From below the elbows they are turned toward the body. They don't go down straight.

Bad Example

The heels touch slightly.

The fingers are straight.

From Above

The chin is lowered so that even at this angle, the neck is visible. (Usually it is not visible.)

The knees are bent in a direction opposite to the upper body.

Horizontal Back View

The neck is quite visible, more so than when the body faces forward.

The chin is just barely visible.

The back is fairly curved.

The shoulders and the heels are aligned.

This part is fairly horizontal. Be careful not to bend the back from here. It is unnatural.

From Below

The chin is not visible.

Compared to when the neck is horizontal, the view is obscured.

The curve line of the socket becomes large.

To create this perspective, foreshorten the upper parts of the body and draw the feet so that they are large.

Looking up at the body the legs seem longer than usual.

Horizontal **From Below**

When seen from below the ankles are visible. (They are not visible when the body is seen from above.)

Sitting I: Chair ◆ Relaxing

The body is limp when relaxing.

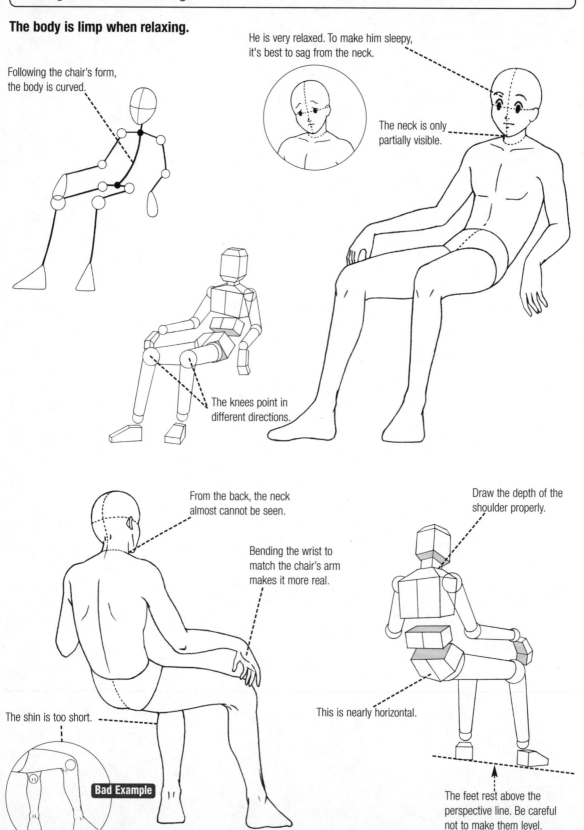

Following the chair's form, the body is curved.

He is very relaxed. To make him sleepy, it's best to sag from the neck.

The neck is only partially visible.

The knees point in different directions.

From the back, the neck almost cannot be seen.

Bending the wrist to match the chair's arm makes it more real.

Draw the depth of the shoulder properly.

This is nearly horizontal.

The shin is too short.

Bad Example

The feet rest above the perspective line. Be careful not to make them level.

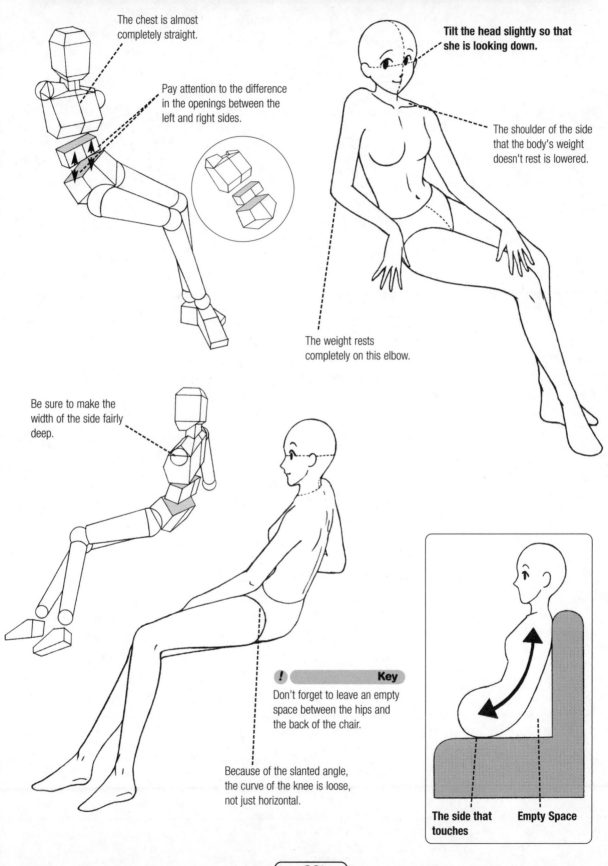

The chest is almost completely straight.

Pay attention to the difference in the openings between the left and right sides.

Tilt the head slightly so that she is looking down.

The shoulder of the side that the body's weight doesn't rest is lowered.

The weight rests completely on this elbow.

Be sure to make the width of the side fairly deep.

! Key

Don't forget to leave an empty space between the hips and the back of the chair.

Because of the slanted angle, the curve of the knee is loose, not just horizontal.

The side that touches

Empty Space

27

Sitting II: Chair ◆ Tense

Draw an upright, rigid, and tense body like this.

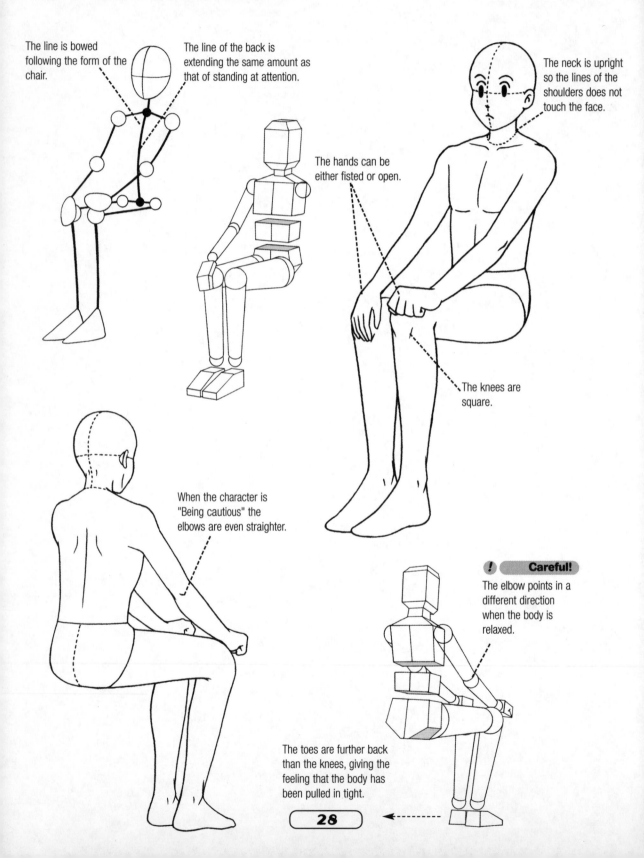

The line is bowed following the form of the chair.

The line of the back is extending the same amount as that of standing at attention.

The neck is upright so the lines of the shoulders does not touch the face.

The hands can be either fisted or open.

The knees are square.

When the character is "Being cautious" the elbows are even straighter.

⚠ Careful!

The elbow points in a different direction when the body is relaxed.

The toes are further back than the knees, giving the feeling that the body has been pulled in tight.

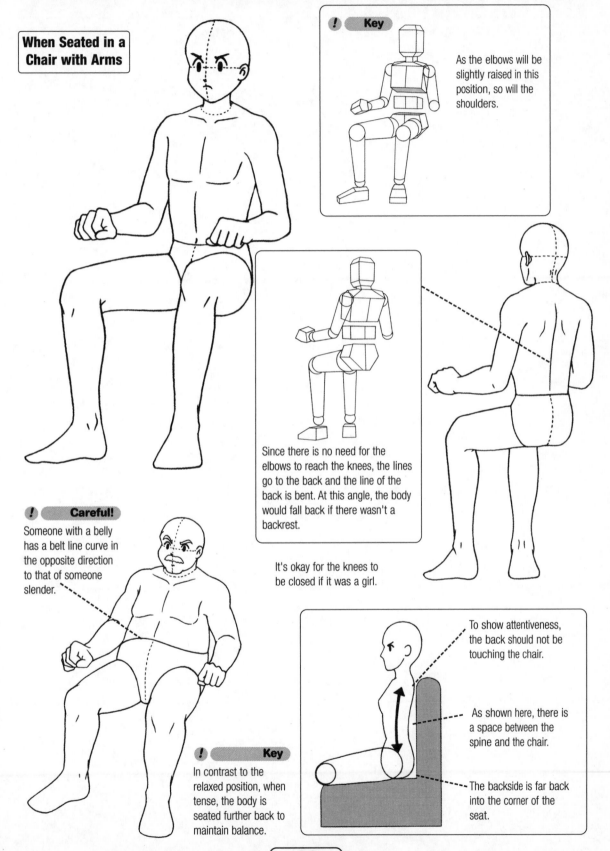

When Seated in a Chair with Arms

! Key

As the elbows will be slightly raised in this position, so will the shoulders.

Since there is no need for the elbows to reach the knees, the lines go to the back and the line of the back is bent. At this angle, the body would fall back if there wasn't a backrest.

It's okay for the knees to be closed if it was a girl.

! Careful!

Someone with a belly has a belt line curve in the opposite direction to that of someone slender.

! Key

In contrast to the relaxed position, when tense, the body is seated further back to maintain balance.

To show attentiveness, the back should not be touching the chair.

As shown here, there is a space between the spine and the chair.

The backside is far back into the corner of the seat.

Sitting III: Chair ◆ Without a Backrest

Make note that without a backrest, the body becomes qu
to be relaxed.

The curve here is opposite
of when there is a
backrest.

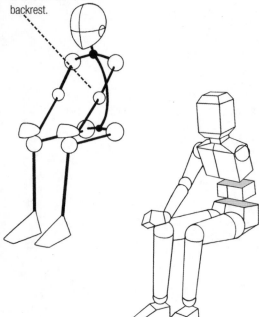

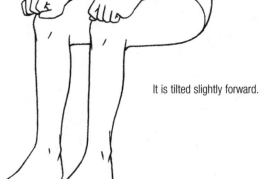

Since the weight of the
upper half of the body is on
the arms, the elbows are
straight.

It is tilted slightly forward.

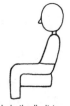
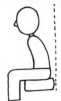
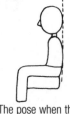
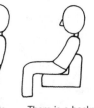

! Keep in Mind!

The natural pose
when there is no
backrest

The pose when the
hands do not rest
on the knees (an
uncommon pose).

This is the limit to
how far one can go
without a backrest.
Beyond this point, one
would topple over.

There is a backrest.

Locking the knees makes him
look lonely.

By first imagining different situations, it will allow you to draw a rich variety of expressions.

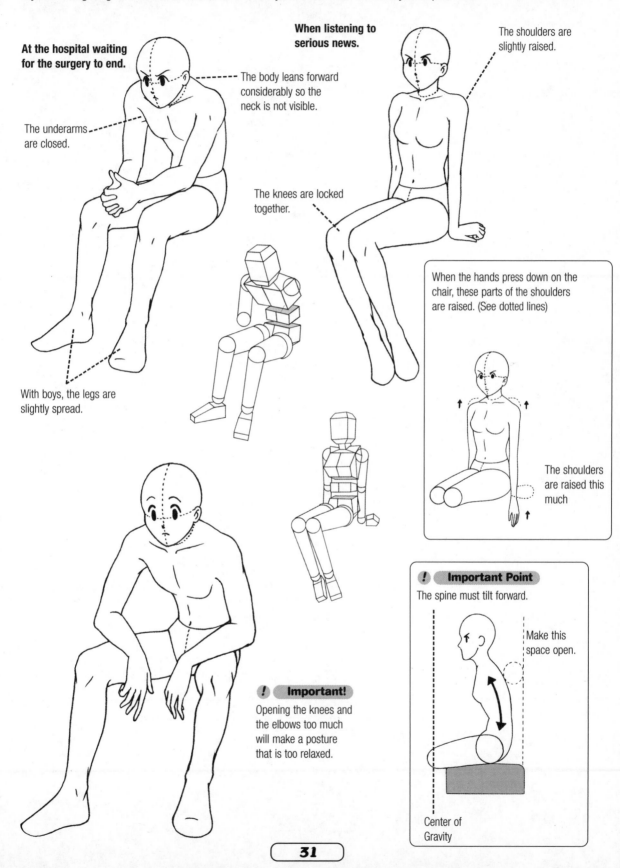

At the hospital waiting for the surgery to end.

The underarms are closed.

When listening to serious news.

The body leans forward considerably so the neck is not visible.

The knees are locked together.

With boys, the legs are slightly spread.

The shoulders are slightly raised.

When the hands press down on the chair, these parts of the shoulders are raised. (See dotted lines)

The shoulders are raised this much

! **Important!**

Opening the knees and the elbows too much will make a posture that is too relaxed.

! **Important Point**

The spine must tilt forward.

Make this space open.

Center of Gravity

Compared to sitting in a chair, sitting on the floor presents a greater variety of poses. Let's begin with the most basic sitting positions.

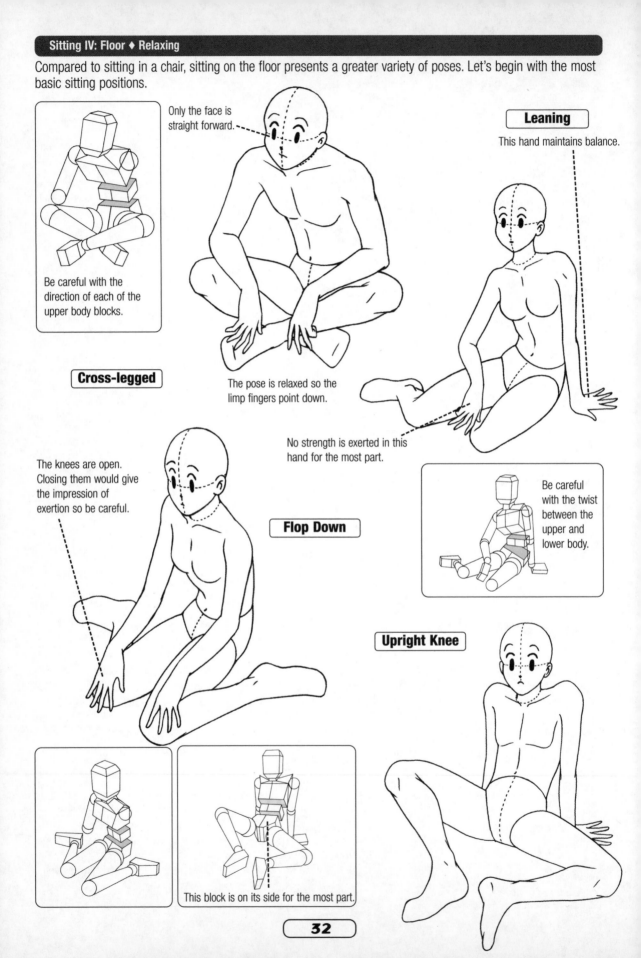

Be careful with the direction of each of the upper body blocks.

Only the face is straight forward.

Leaning

This hand maintains balance.

Cross-legged

The pose is relaxed so the limp fingers point down.

No strength is exerted in this hand for the most part.

The knees are open. Closing them would give the impression of exertion so be careful.

Flop Down

Be careful with the twist between the upper and lower body.

Upright Knee

This block is on its side for the most part.

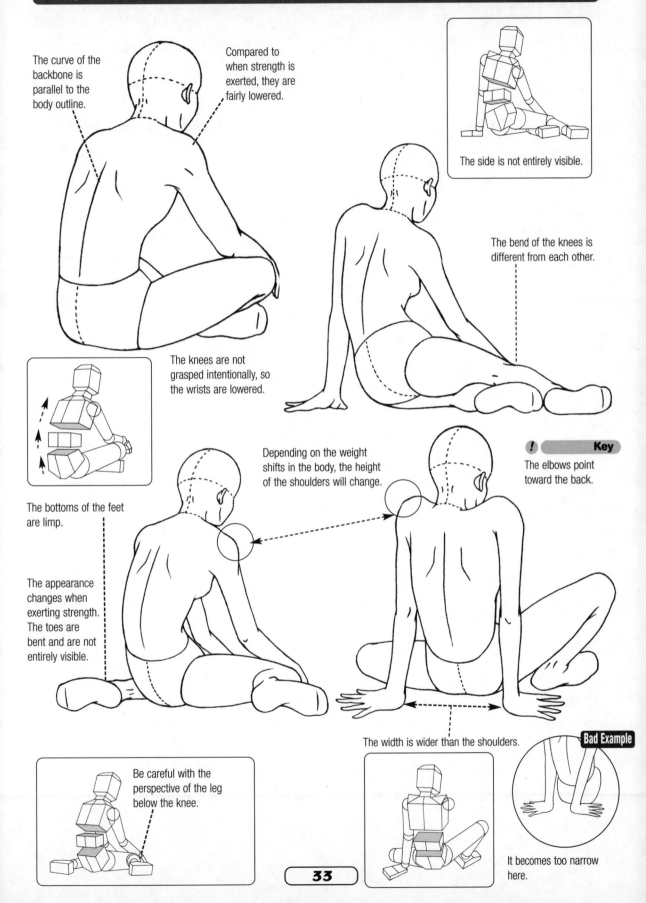

The curve of the backbone is parallel to the body outline.

Compared to when strength is exerted, they are fairly lowered.

The side is not entirely visible.

The bend of the knees is different from each other.

The knees are not grasped intentionally, so the wrists are lowered.

The bottoms of the feet are limp.

The appearance changes when exerting strength. The toes are bent and are not entirely visible.

Depending on the weight shifts in the body, the height of the shoulders will change.

! Key

The elbows point toward the back.

Be careful with the perspective of the leg below the knee.

The width is wider than the shoulders.

Bad Example

It becomes too narrow here.

Sitting V: Floor ◆ Tense

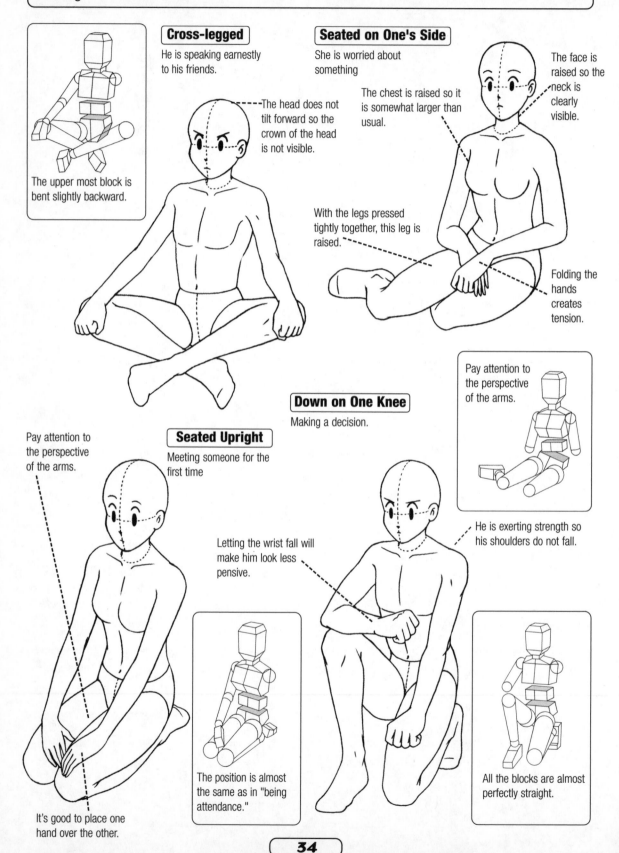

The upper most block is bent slightly backward.

Cross-legged

He is speaking earnestly to his friends.

The head does not tilt forward so the crown of the head is not visible.

Seated on One's Side

She is worried about something

The chest is raised so it is somewhat larger than usual.

The face is raised so the neck is clearly visible.

With the legs pressed tightly together, this leg is raised.

Folding the hands creates tension.

Pay attention to the perspective of the arms.

Down on One Knee

Making a decision.

Seated Upright

Meeting someone for the first time

Pay attention to the perspective of the arms.

Letting the wrist fall will make him look less pensive.

He is exerting strength so his shoulders do not fall.

It's good to place one hand over the other.

The position is almost the same as in "being attendance."

All the blocks are almost perfectly straight.

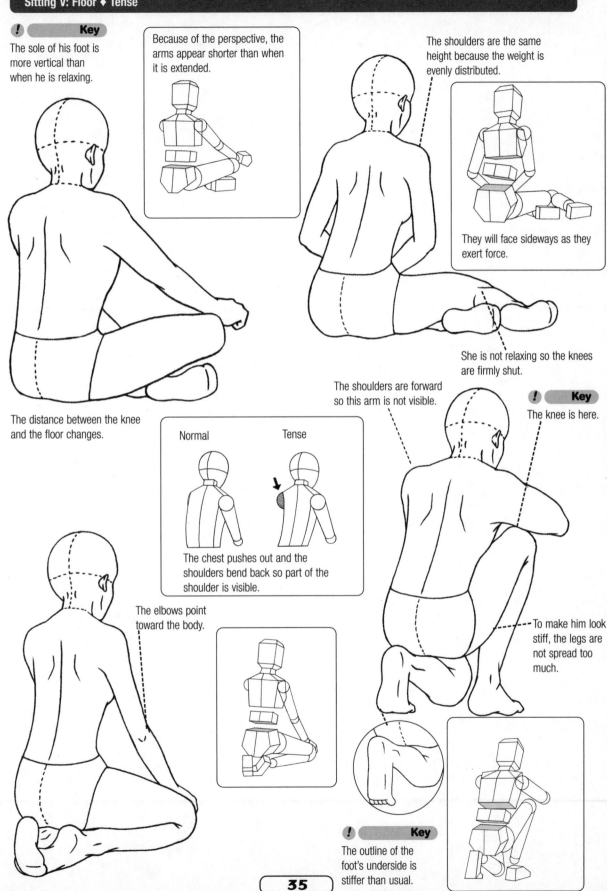

! **Key**

The sole of his foot is more vertical than when he is relaxing.

Because of the perspective, the arms appear shorter than when it is extended.

The shoulders are the same height because the weight is evenly distributed.

They will face sideways as they exert force.

The distance between the knee and the floor changes.

She is not relaxing so the knees are firmly shut.

The shoulders are forward so this arm is not visible.

! **Key**

The knee is here.

Normal Tense

The chest pushes out and the shoulders bend back so part of the shoulder is visible.

The elbows point toward the body.

To make him look stiff, the legs are not spread too much.

! **Key**

The outline of the foot's underside is stiffer than usual.

Sleeping I: Face Down

For a natural, relaxed feeling, the body is completely on the ground.

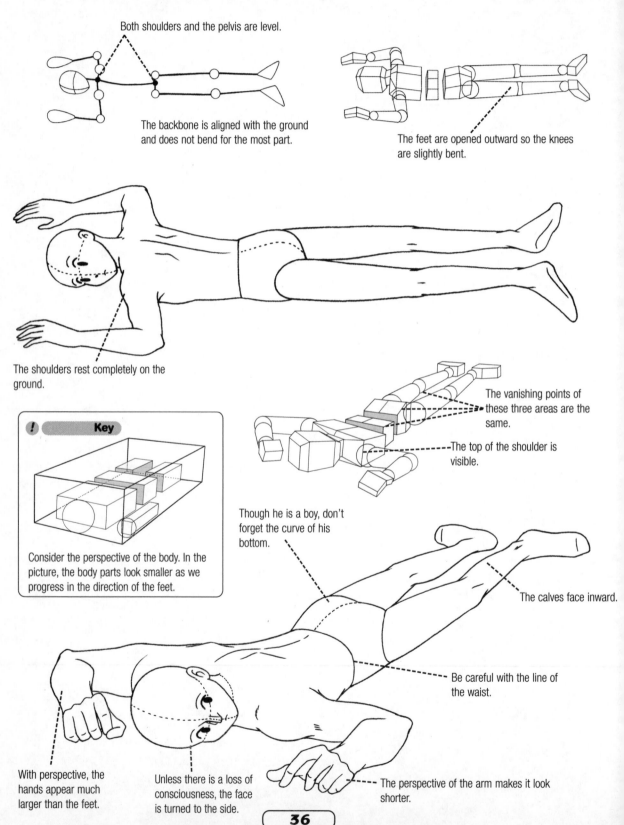

Both shoulders and the pelvis are level.

The backbone is aligned with the ground and does not bend for the most part.

The feet are opened outward so the knees are slightly bent.

The shoulders rest completely on the ground.

Key

Consider the perspective of the body. In the picture, the body parts look smaller as we progress in the direction of the feet.

The vanishing points of these three areas are the same.

The top of the shoulder is visible.

Though he is a boy, don't forget the curve of his bottom.

The calves face inward.

Be careful with the line of the waist.

With perspective, the hands appear much larger than the feet.

Unless there is a loss of consciousness, the face is turned to the side.

The perspective of the arm makes it look shorter.

 Key

Be careful with how the neck looks! When lying down, since the neck does not support the head, it does not exert strength.

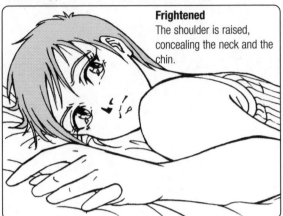

Frightened
The shoulder is raised, concealing the neck and the chin.

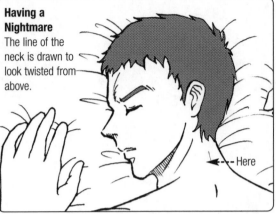

Having a Nightmare
The line of the neck is drawn to look twisted from above.

←— Here

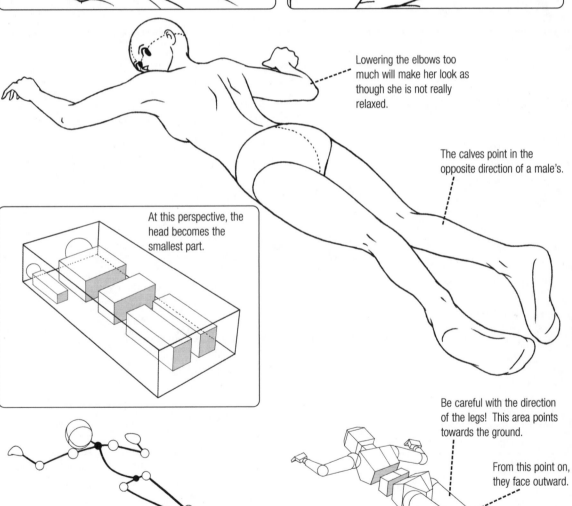

Lowering the elbows too much will make her look as though she is not really relaxed.

The calves point in the opposite direction of a male's.

At this perspective, the head becomes the smallest part.

Be careful with the direction of the legs! This area points towards the ground.

From this point on, they face outward.

Sleeping II: Face Up

Unlike when one is facing down, the toes can point in any direction, increasing the variety of positions of the knees.

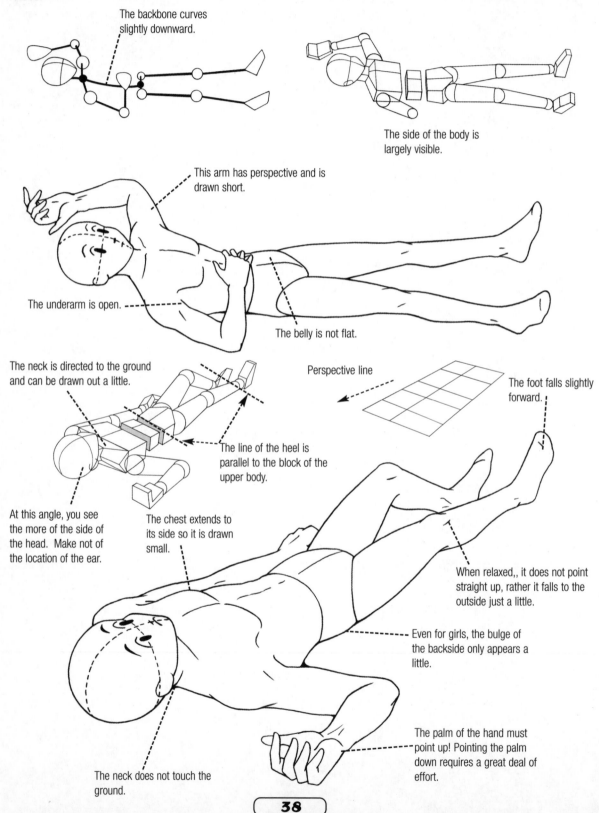

The backbone curves slightly downward.

The side of the body is largely visible.

This arm has perspective and is drawn short.

The underarm is open.

The belly is not flat.

The neck is directed to the ground and can be drawn out a little.

Perspective line

The foot falls slightly forward.

The line of the heel is parallel to the block of the upper body.

At this angle, you see the more of the side of the head. Make not of the location of the ear.

The chest extends to its side so it is drawn small.

When relaxed,, it does not point straight up, rather it falls to the outside just a little.

Even for girls, the bulge of the backside only appears a little.

The neck does not touch the ground.

The palm of the hand must point up! Pointing the palm down requires a great deal of effort.

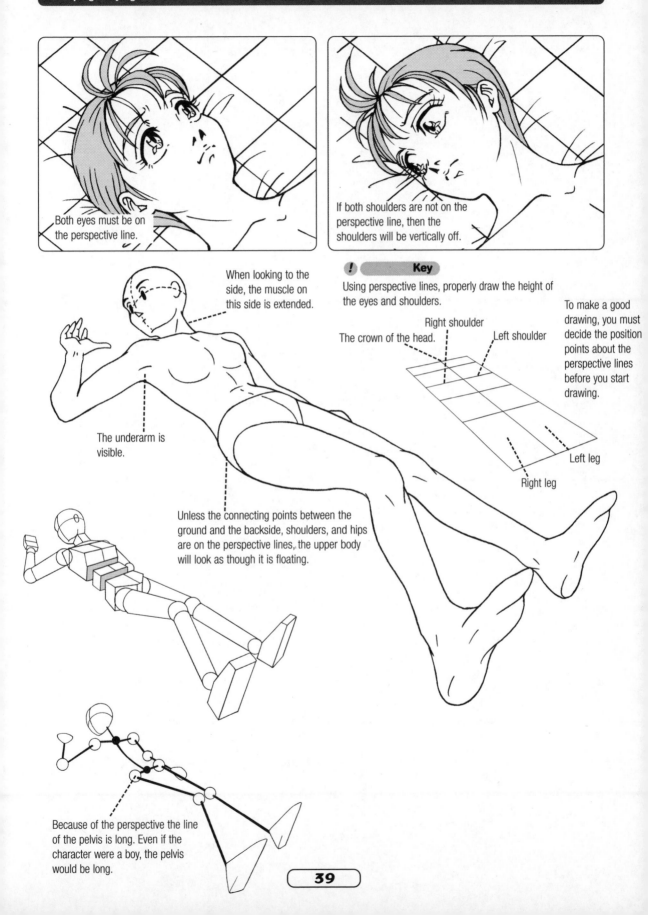

Both eyes must be on the perspective line.

If both shoulders are not on the perspective line, then the shoulders will be vertically off.

When looking to the side, the muscle on this side is extended.

The underarm is visible.

! **Key**

Using perspective lines, properly draw the height of the eyes and shoulders.

Right shoulder

The crown of the head.

Left shoulder

To make a good drawing, you must decide the position points about the perspective lines before you start drawing.

Left leg

Right leg

Unless the connecting points between the ground and the backside, shoulders, and hips are on the perspective lines, the upper body will look as though it is floating.

Because of the perspective the line of the pelvis is long. Even if the character were a boy, the pelvis would be long.

Sleeping III: Lying on the Side

Because the side rests on the ground, the curve of the waist is clearly expressed.

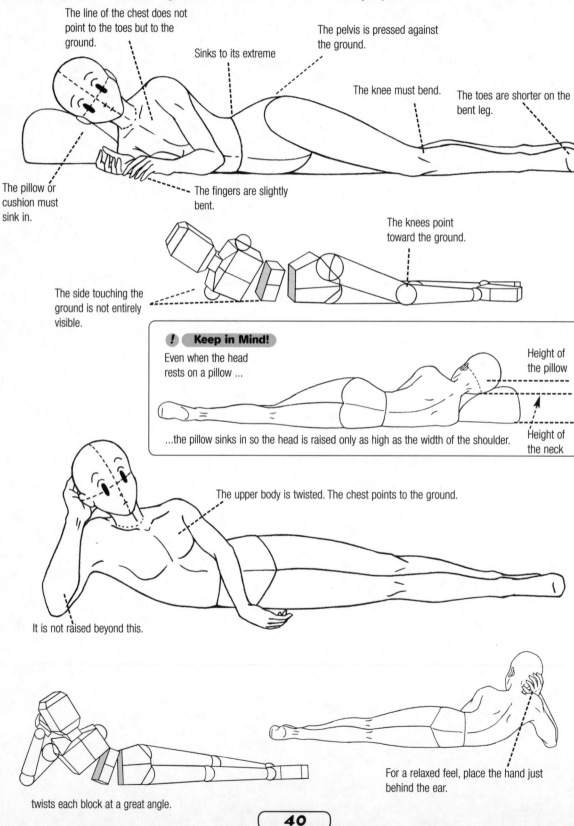

The line of the chest does not point to the toes but to the ground.

Sinks to its extreme

The pelvis is pressed against the ground.

The knee must bend.

The toes are shorter on the bent leg.

The pillow or cushion must sink in.

The fingers are slightly bent.

The knees point toward the ground.

The side touching the ground is not entirely visible.

! Keep in Mind!

Even when the head rests on a pillow ...

Height of the pillow

Height of the neck

...the pillow sinks in so the head is raised only as high as the width of the shoulder.

The upper body is twisted. The chest points to the ground.

It is not raised beyond this.

twists each block at a great angle.

For a relaxed feel, place the hand just behind the ear.

It's hard to draw someone sleeping vertically. So pay close attention to the details.

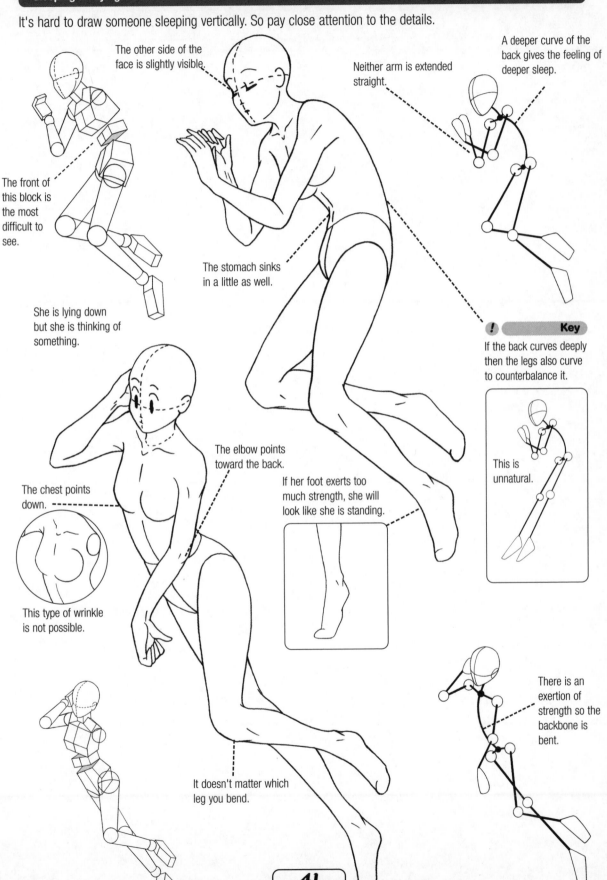

The other side of the face is slightly visible.

Neither arm is extended straight.

A deeper curve of the back gives the feeling of deeper sleep.

The front of this block is the most difficult to see.

The stomach sinks in a little as well.

She is lying down but she is thinking of something.

! **Key**

If the back curves deeply then the legs also curve to counterbalance it.

This is unnatural.

The chest points down.

The elbow points toward the back.

If her foot exerts too much strength, she will look like she is standing.

This type of wrinkle is not possible.

There is an exertion of strength so the backbone is bent.

It doesn't matter which leg you bend.

Walking I: Normal

Walking is the simplest of movements though it is also the hardest to draw. If you can draw a natural looking walk then you are full-fledged artist.

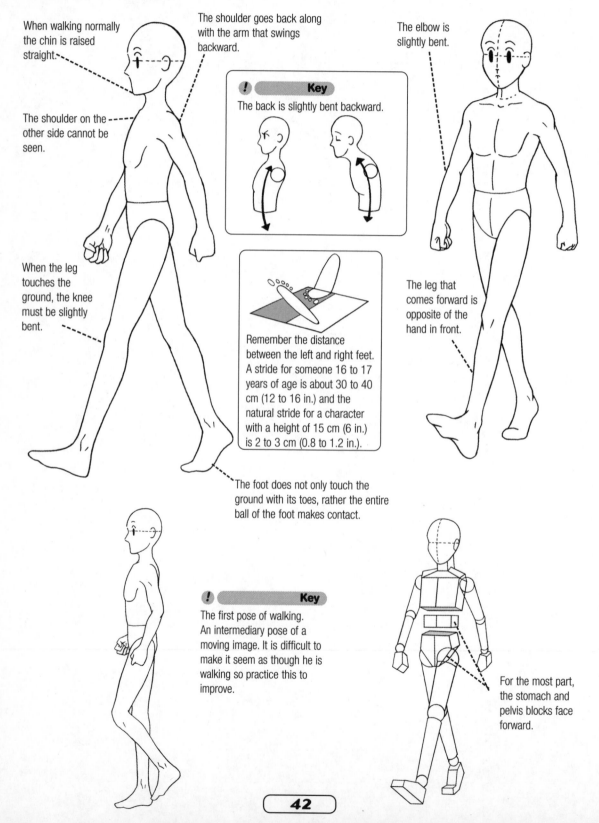

When walking normally the chin is raised straight.

The shoulder goes back along with the arm that swings backward.

The elbow is slightly bent.

The shoulder on the other side cannot be seen.

When the leg touches the ground, the knee must be slightly bent.

! Key

The back is slightly bent backward.

Remember the distance between the left and right feet. A stride for someone 16 to 17 years of age is about 30 to 40 cm (12 to 16 in.) and the natural stride for a character with a height of 15 cm (6 in.) is 2 to 3 cm (0.8 to 1.2 in.).

The leg that comes forward is opposite of the hand in front.

The foot does not only touch the ground with its toes, rather the entire ball of the foot makes contact.

! Key

The first pose of walking. An intermediary pose of a moving image. It is difficult to make it seem as though he is walking so practice this to improve.

For the most part, the stomach and pelvis blocks face forward.

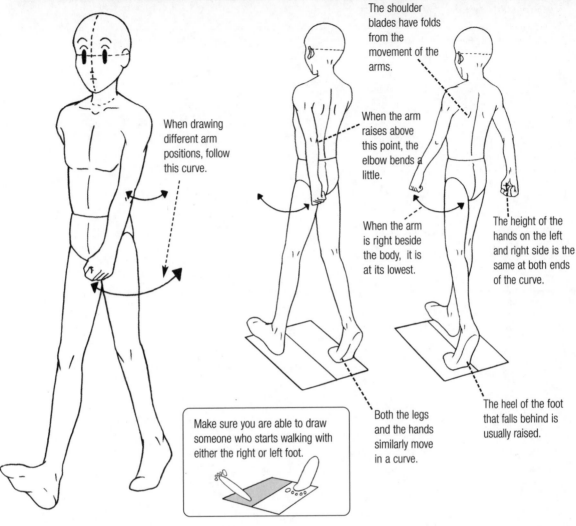

When drawing different arm positions, follow this curve.

The shoulder blades have folds from the movement of the arms.

When the arm raises above this point, the elbow bends a little.

When the arm is right beside the body, it is at its lowest.

The height of the hands on the left and right side is the same at both ends of the curve.

Make sure you are able to draw someone who starts walking with either the right or left foot.

Both the legs and the hands similarly move in a curve.

The heel of the foot that falls behind is usually raised.

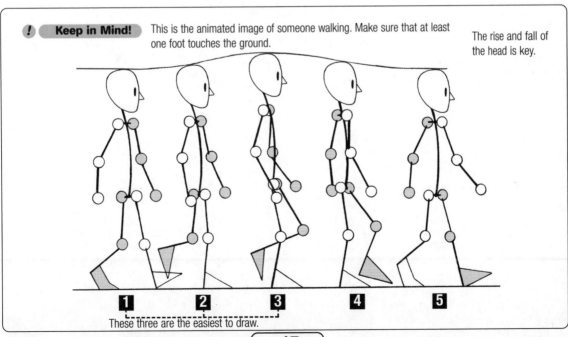

! Keep in Mind! This is the animated image of someone walking. Make sure that at least one foot touches the ground.

The rise and fall of the head is key.

1 **2** **3** **4** **5**

These three are the easiest to draw.

Walking II: Fast-paced

The key is to make the bends and the openings of each body part larger than normal.

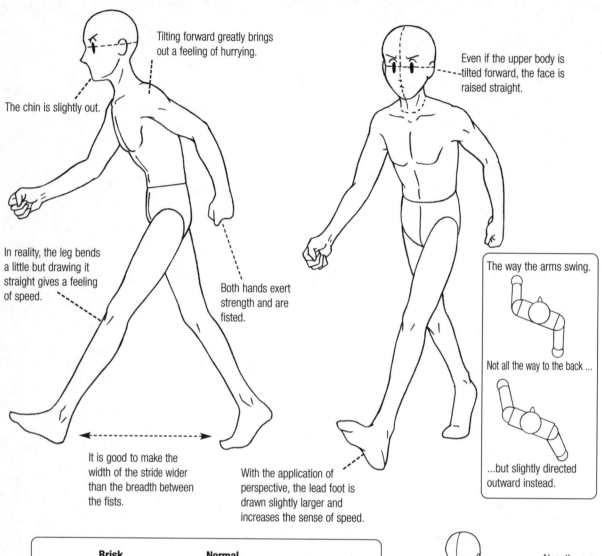

Tilting forward greatly brings out a feeling of hurrying.

The chin is slightly out.

Even if the upper body is tilted forward, the face is raised straight.

In reality, the leg bends a little but drawing it straight gives a feeling of speed.

Both hands exert strength and are fisted.

The way the arms swing.

Not all the way to the back ...

...but slightly directed outward instead.

It is good to make the width of the stride wider than the breadth between the fists.

With the application of perspective, the lead foot is drawn slightly larger and increases the sense of speed.

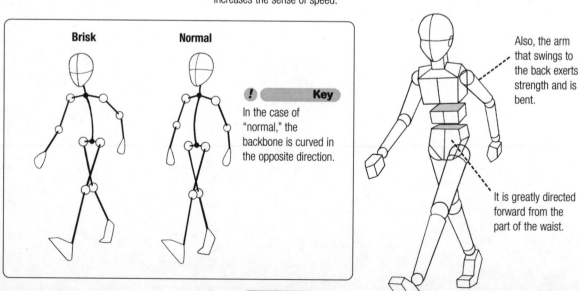

Brisk **Normal**

! Key

In the case of "normal," the backbone is curved in the opposite direction.

Also, the arm that swings to the back exerts strength and is bent.

It is greatly directed forward from the part of the waist.

Beginning to walk

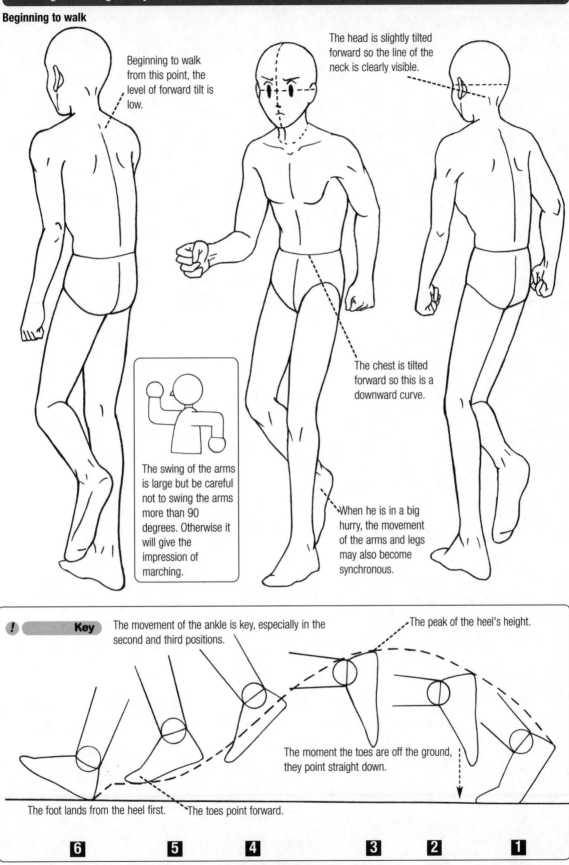

Beginning to walk from this point, the level of forward tilt is low.

The head is slightly tilted forward so the line of the neck is clearly visible.

The swing of the arms is large but be careful not to swing the arms more than 90 degrees. Otherwise it will give the impression of marching.

The chest is tilted forward so this is a downward curve.

When he is in a big hurry, the movement of the arms and legs may also become synchronous.

! Key

The movement of the ankle is key, especially in the second and third positions.

The peak of the heel's height.

The moment the toes are off the ground, they point straight down.

The foot lands from the heel first.

The toes point forward.

6 5 4 3 2 1

Walking III: Slow-paced

Tired or old characters walk differently. Let's begin with the basics and move on to variations little by little.

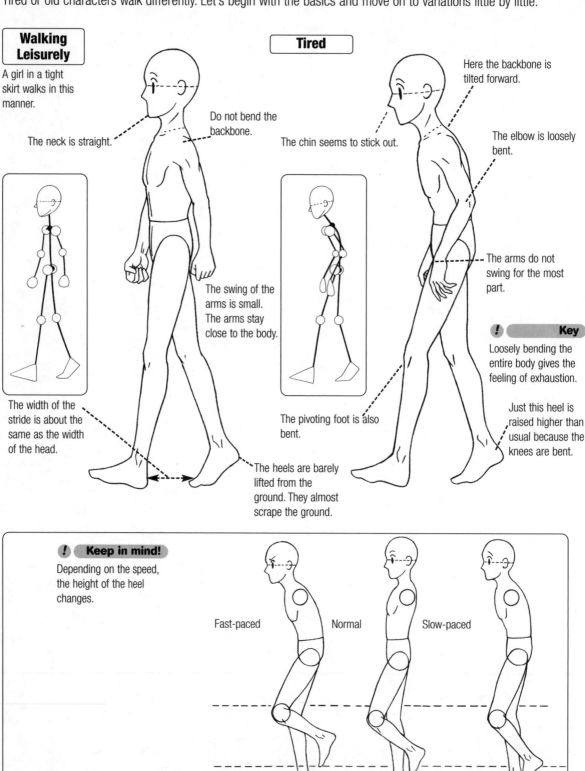

Walking Leisurely

A girl in a tight skirt walks in this manner.

The neck is straight.

Do not bend the backbone.

The width of the stride is about the same as the width of the head.

The swing of the arms is small. The arms stay close to the body.

The heels are barely lifted from the ground. They almost scrape the ground.

Tired

The chin seems to stick out.

Here the backbone is tilted forward.

The elbow is loosely bent.

The arms do not swing for the most part.

! Key

Loosely bending the entire body gives the feeling of exhaustion.

Just this heel is raised higher than usual because the knees are bent.

The pivoting foot is also bent.

! Keep in mind!

Depending on the speed, the height of the heel changes.

Fast-paced Normal Slow-paced

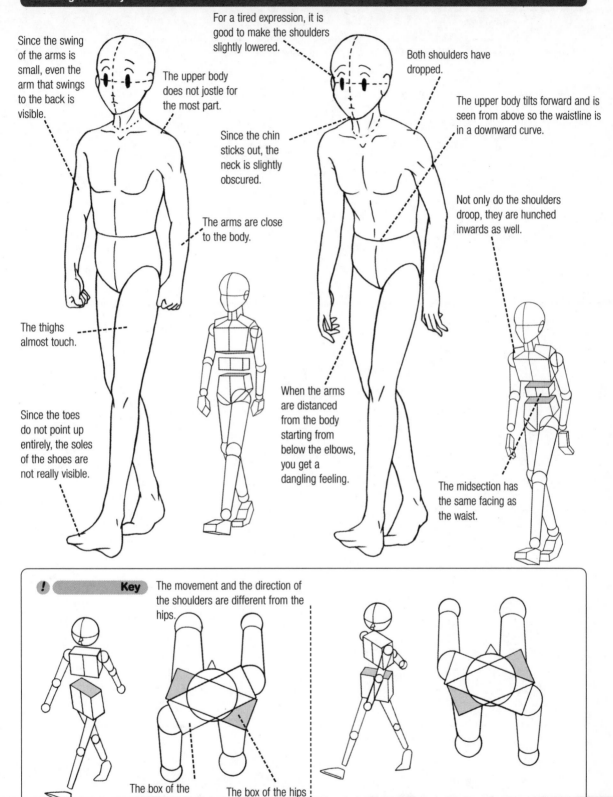

Since the swing of the arms is small, even the arm that swings to the back is visible.

The upper body does not jostle for the most part.

For a tired expression, it is good to make the shoulders slightly lowered.

Both shoulders have dropped.

Since the chin sticks out, the neck is slightly obscured.

The upper body tilts forward and is seen from above so the waistline is in a downward curve.

The arms are close to the body.

Not only do the shoulders droop, they are hunched inwards as well.

The thighs almost touch.

Since the toes do not point up entirely, the soles of the shoes are not really visible.

When the arms are distanced from the body starting from below the elbows, you get a dangling feeling.

The midsection has the same facing as the waist.

Key The movement and the direction of the shoulders are different from the hips.

The box of the shoulder

The box of the hips

The swing of the left and right arms and the extension of the legs are opposite to each other, right? The direction of the hips and the shoulders of the wooden figure are opposite. When the right arm is in front, the shoulder also comes forward. At the same time, the left leg comes forward and so does the left hip. The subtle twist is very important point.

Running I: Normal

It's based on walking. The forward tilt and the lift of the legs set the sense of speed.

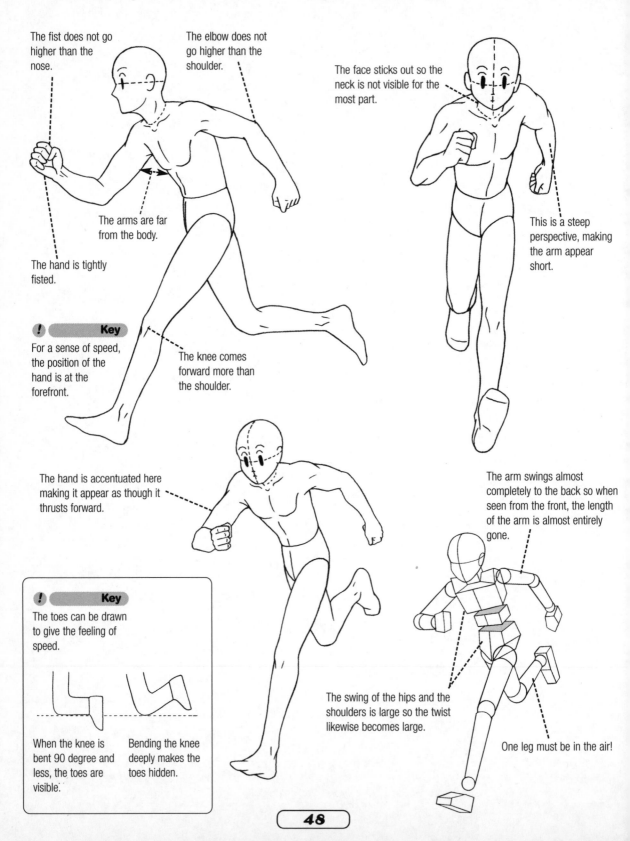

The fist does not go higher than the nose.

The elbow does not go higher than the shoulder.

The face sticks out so the neck is not visible for the most part.

The arms are far from the body.

The hand is tightly fisted.

This is a steep perspective, making the arm appear short.

! Key

For a sense of speed, the position of the hand is at the forefront.

The knee comes forward more than the shoulder.

The hand is accentuated here making it appear as though it thrusts forward.

The arm swings almost completely to the back so when seen from the front, the length of the arm is almost entirely gone.

! Key

The toes can be drawn to give the feeling of speed.

When the knee is bent 90 degree and less, the toes are visible.

Bending the knee deeply makes the toes hidden.

The swing of the hips and the shoulders is large so the twist likewise becomes large.

One leg must be in the air!

Moment of Landing

The more this arm appears larger, the greater the twist of the body resulting in conveying a sense of speed.

The shoulder is completely obscured by the body and is not visible.

The arm touches the body.

Just Before Stepping Forward

The shoulders are raised so the chin is entirely obscured.

The arm barely comes forward and is bent sharply.

The stomach points in the direction of movement.

From behind, be particularly careful with the perspective of the hips and the chest.

From the twist of the hips part of the backside is visible.

The hips are curved sharply. When seen from below the waist line is a large upward curve.

From below the knee, the leg faces the ground.

The knee bends the most before stepping forward (see chart 2).

This knee is extended almost entirely straight.

The foot is raised high.

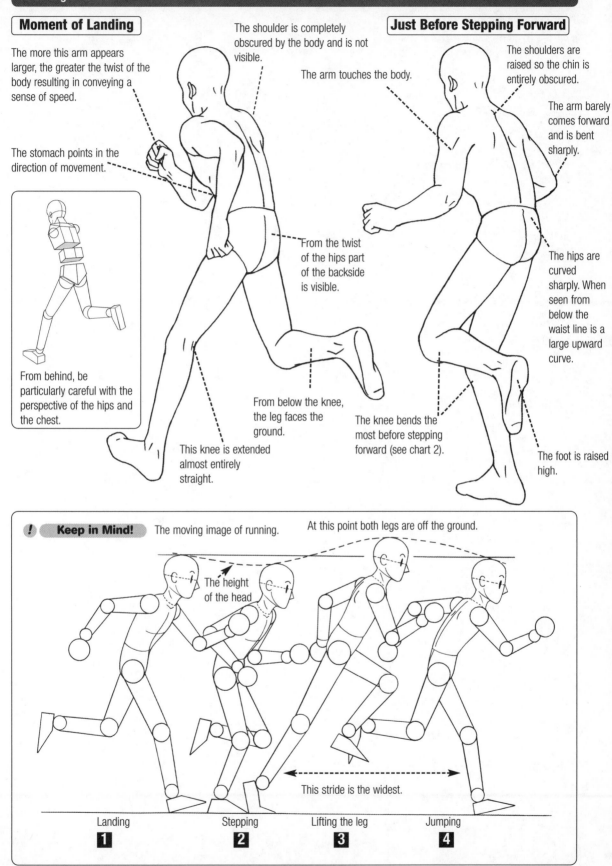

! Keep in Mind! The moving image of running. At this point both legs are off the ground.

The height of the head

This stride is the widest.

| Landing | Stepping | Lifting the leg | Jumping |
| **1** | **2** | **3** | **4** |

Running II: Dashing

Rather than drawing the knees and the elbows bent, draw them hyper-extended.

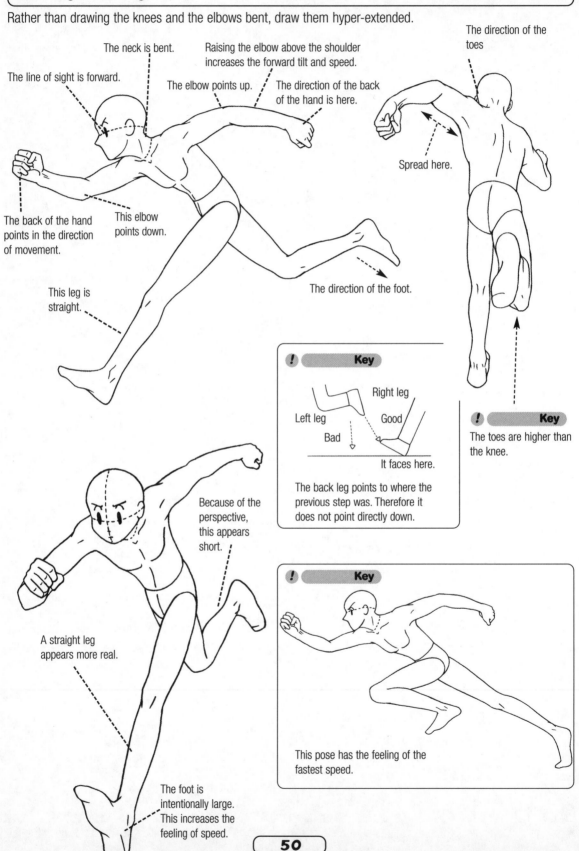

The neck is bent.

The line of sight is forward.

Raising the elbow above the shoulder increases the forward tilt and speed.

The elbow points up.

The direction of the back of the hand is here.

The direction of the toes

The back of the hand points in the direction of movement.

This elbow points down.

Spread here.

This leg is straight.

The direction of the foot.

! Key

Left leg Right leg

Good

Bad

It faces here.

The back leg points to where the previous step was. Therefore it does not point directly down.

! Key

The toes are higher than the knee.

Because of the perspective, this appears short.

A straight leg appears more real.

The foot is intentionally large. This increases the feeling of speed.

! Key

This pose has the feeling of the fastest speed.

Different characters run differently.

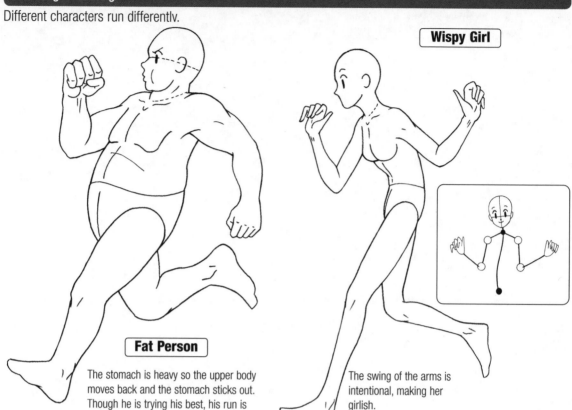

Wispy Girl

Fat Person

The stomach is heavy so the upper body moves back and the stomach sticks out. Though he is trying his best, his run is comical.

The swing of the arms is intentional, making her girlish.

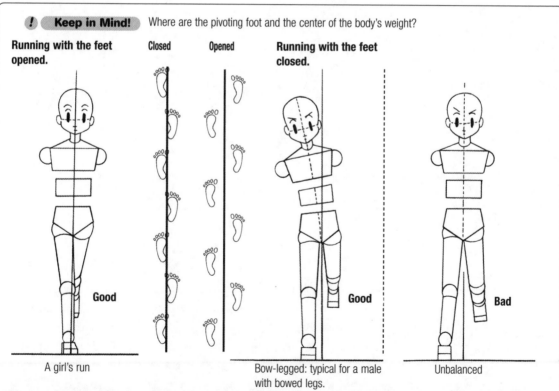

! Keep in Mind! Where are the pivoting foot and the center of the body's weight?

Running with the feet opened. Closed Opened **Running with the feet closed.**

Good

Good

Bad

A girl's run

Bow-legged: typical for a male with bowed legs.

Unbalanced

When running and walking, the footsteps do not fall on the center line. Depending on whether the center of gravity falls in the center or the left or right, the walk changes. But spreading the legs beyond the width of the shoulders or more will cause the person to topple over.

Advice from
Young Illustrators

Kazuto Mitsuishi

D.O.B. February 26th, 1979
Nagoya Prefecture
Graduated from a technical college, he is currently professionally
involved in 2D computer graphics. He keeps 3D graphics as his hobby.

"I can not stop emphasizing the importance of drawing."

Drawing the body is important.
It is essential for drawing illustrations.
It is also essential for drawing characters.
The balance of the body's areas, the overall proportion, muscles,
bones, and knowing all the different parts will give the characters
you draw a feeling of existence and persuasiveness.

After graduating from technical college, I made a movie using 3D
computer graphics. I was supposed to be able to use whatever
pose I wanted. But, in fact, the so called "free poses" are the
hardest to do. I can easily bend bones in 360-degree rotations
on the computer, but the movement of an actual human joint is
surprisingly limited. I made the 3D models based on what I
thought up. The images in my head was different and whatever
way I looked at it, the pose was unnatural. If I had turned this
into animation, it would have been all the more apparent. It
wasn't naturally human and looked like robots that weren't
sentient. Finally, I was able to make models of characters but I
wasn't able to complete the movie.

So, what was the root of the problem? I was too caught up in
drawing the shape of the body without closely examining the
condition of the body joints at a given posture. If only I had
realized this sooner. It's not something one can easily grasp just
by twisting his/her own joint and observing it.

That said, I talked about 3D here but even with illustration the
same can be said. The character with a pose seen from an angle
is in the end a 3D point of view.

Learn to draw the human body in many ways. It's very important.

Chapter 3
Variations of Movement

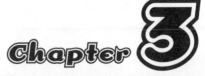

The S-shape is Key!

In chapter two, we introduced "relaxed" and "tense." The largest difference between the two is the curve of the backbone. A person's body is more pliable than you think and is made up entirely of curves. Muscle and clothing conceal the curve, but the line from the neck to the hips in particular is more complex than that of either the chest or the legs. It is more curved in its movements so pay careful attention to it.

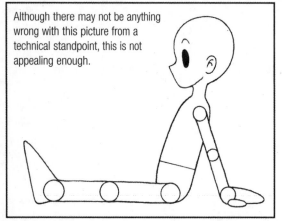

Although there may not be anything wrong with this picture from a technical standpoint, this is not appealing enough.

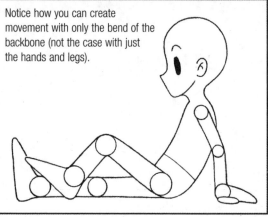

Notice how you can create movement with only the bend of the backbone (not the case with just the hands and legs).

With common (undramatic) poses, a badly planned drawing makes whatever that is going on difficult to understand, thereby ruining the work. This is honestly more difficult to draw than dramatic action.

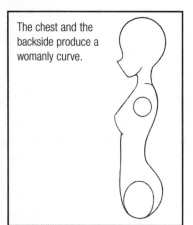

The chest and the backside produce a womanly curve.

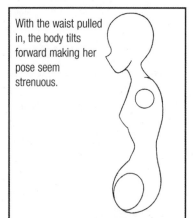

With the waist pulled in, the body tilts forward making her pose seem strenuous.

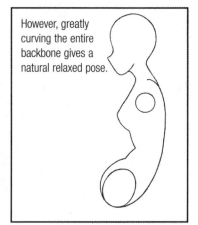

However, greatly curving the entire backbone gives a natural relaxed pose.

When perfectly erect, the line of the back isn't straight. Yet, because of aesthetics, pulling in the waist too much also makes the bend of the backbone look strange.

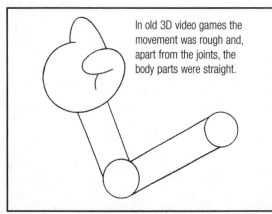

In old 3D video games the movement was rough and, apart from the joints, the body parts were straight.

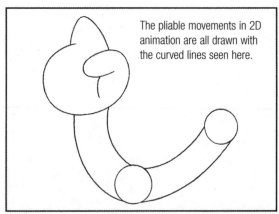

The pliable movements in 2D animation are all drawn with the curved lines seen here.

The backbone is not the only bone that bends. The arms and legs (not just their joints) bend as well. Even the parts with straight bones, the outline of the muscles or fat that covers the bone are drawn in a curve.

The center of gravity moves when running or walking. Not only do the feet move but don't forget that the upper body also moves. What is important here is the position of the pivoting foot on which the weight rests. Regardless of the extent to which the backbone is bent, removing the center of gravity from this position will ruin the balance.

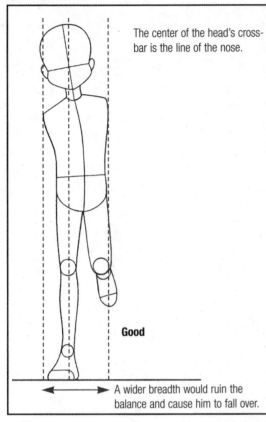

The center of the head's cross-bar is the line of the nose.

Good

A wider breadth would ruin the balance and cause him to fall over.

Bad

Bad

! Keep in Mind!

The lowered line of the nose is the center of gravity. The width of the face is equal to the breadth of the swing of the left and right legs.

The basic stick figure shape

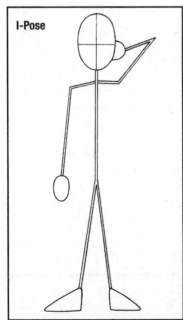

I-Pose

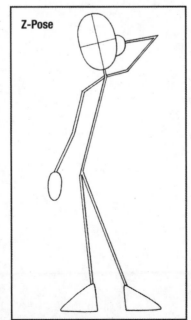

Z-Pose

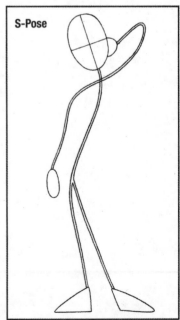

S-Pose

Before drawing, draw out the form with a stick figure. Prepare the basic form with the I-Pose. Then add the bend in the joints for the Z-Pose. Finally complete the stick-figure drawings for the S-Pose and decide on the curved lines of your figure.

Variations of Standing

Wearing Shoes: Boy Putting on shoes while he/she is standing, be careful with the way boys and girls balance themselves.

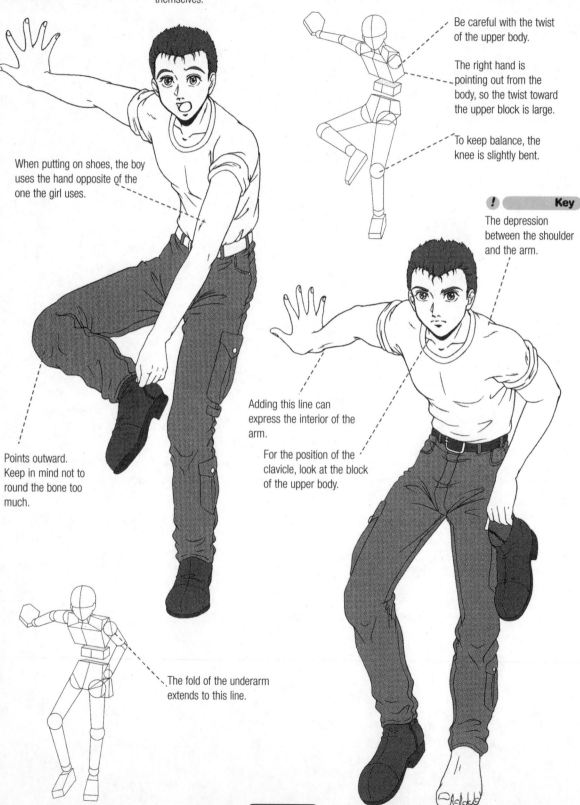

Be careful with the twist of the upper body.

The right hand is pointing out from the body, so the twist toward the upper block is large.

To keep balance, the knee is slightly bent.

When putting on shoes, the boy uses the hand opposite of the one the girl uses.

! **Key**

The depression between the shoulder and the arm.

Points outward. Keep in mind not to round the bone too much.

Adding this line can express the interior of the arm.

For the position of the clavicle, look at the block of the upper body.

The fold of the underarm extends to this line.

Wearing Shoes: Girl

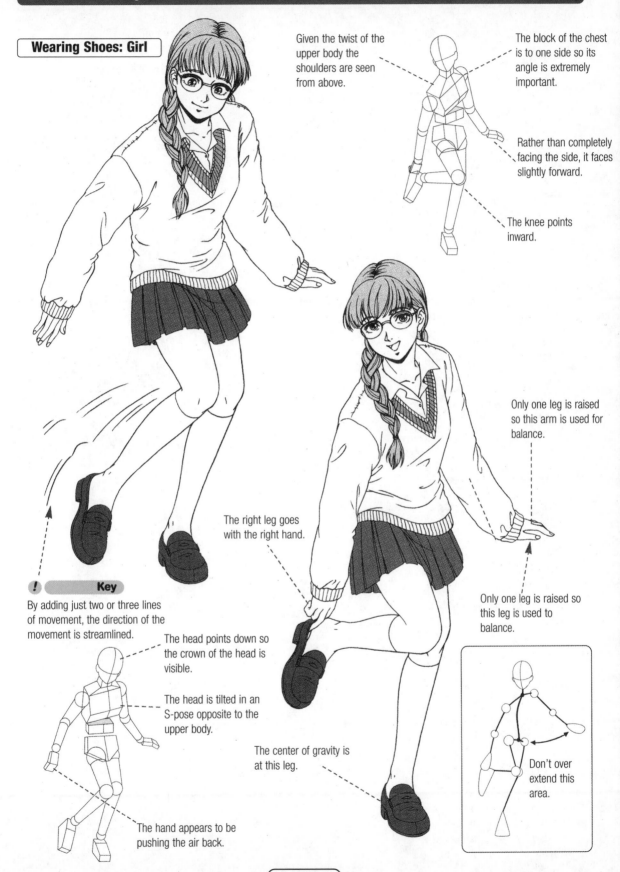

Given the twist of the upper body the shoulders are seen from above.

The block of the chest is to one side so its angle is extremely important.

Rather than completely facing the side, it faces slightly forward.

The knee points inward.

Only one leg is raised so this arm is used for balance.

The right leg goes with the right hand.

Only one leg is raised so this leg is used to balance.

! Key

By adding just two or three lines of movement, the direction of the movement is streamlined.

The head points down so the crown of the head is visible.

The head is tilted in an S-pose opposite to the upper body.

The center of gravity is at this leg.

Don't over extend this area.

The hand appears to be pushing the air back.

Variations of Standing

Waiting She is waiting and her mind is idle. "When will he show up?"
The situation is apparent from the drawing.

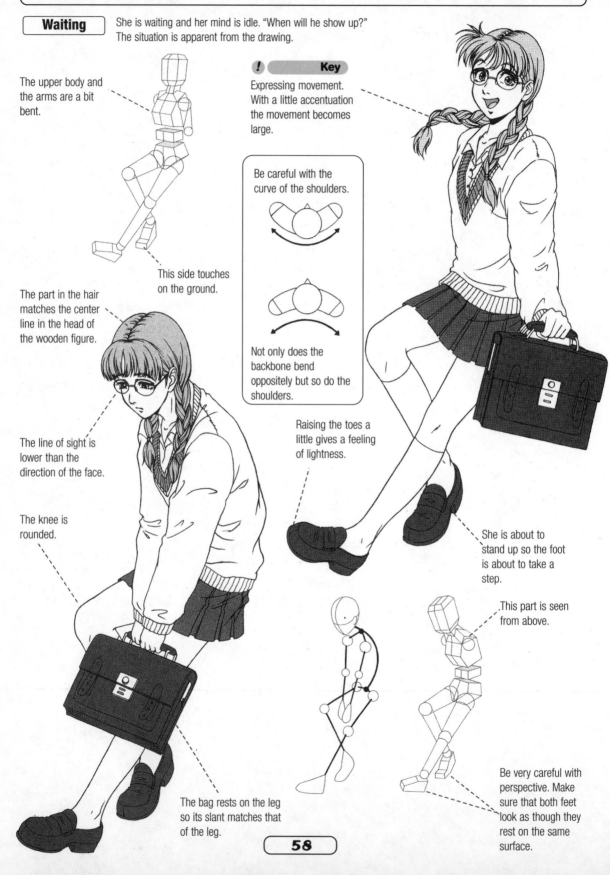

The upper body and the arms are a bit bent.

!　**Key**

Expressing movement. With a little accentuation the movement becomes large.

Be careful with the curve of the shoulders.

Not only does the backbone bend oppositely but so do the shoulders.

This side touches on the ground.

The part in the hair matches the center line in the head of the wooden figure.

The line of sight is lower than the direction of the face.

The knee is rounded.

Raising the toes a little gives a feeling of lightness.

She is about to stand up so the foot is about to take a step.

This part is seen from above.

The bag rests on the leg so its slant matches that of the leg.

Be very careful with perspective. Make sure that both feet look as though they rest on the same surface.

Expressing emotion with movement

It's good to imagine her speaking while you are drawing.

Wha . . .

A bored pose. She leans against something and looks into space.

The frame of the eyeglasses meets the ear and does not bend.

We said about now, didn't we?

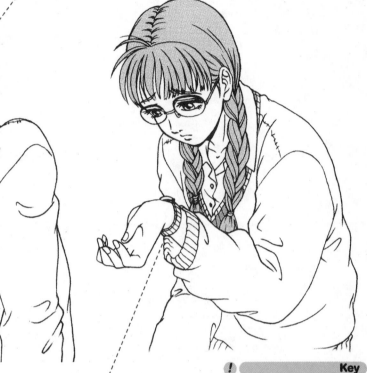

This fold is large. It makes the weight of the body fall to the back.

Having the face of the watch on the inside of the wrist is girlish.

! **Key**

The dip at the center line of the head shows the thickness of the hair.

The frame of the eyeglasses is visible.

Not yet...

Not showing the face at all is also one type of enactment.

This hand is also in front, as though she is holding the bag with both hands.

Do not connect this to the line of the back.

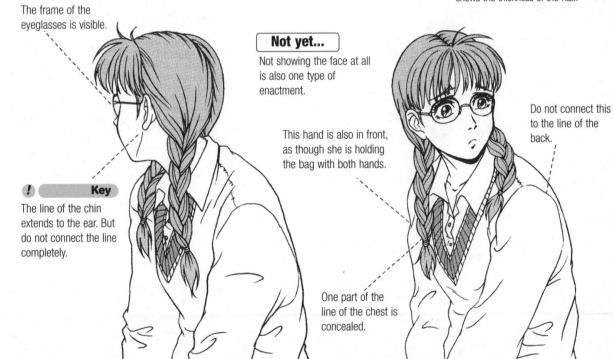

! **Key**

The line of the chin extends to the ear. But do not connect the line completely.

One part of the line of the chest is concealed.

Variations of Standing

Inside the Train I: Commuting Man

Exhausted, he cannot stand up straight.

! Key

Grasping with two fingers, not all five, makes him seem more tired.

The line of the chin is drawn without connecting it to the ear.

He also holds the bag is also with two fingers.

Face seems to rest on the arm and is tilted accordingly.

The upward curves show the bulge of his stomach.

Only one handle is being held. Be sure to include these kinds of details.

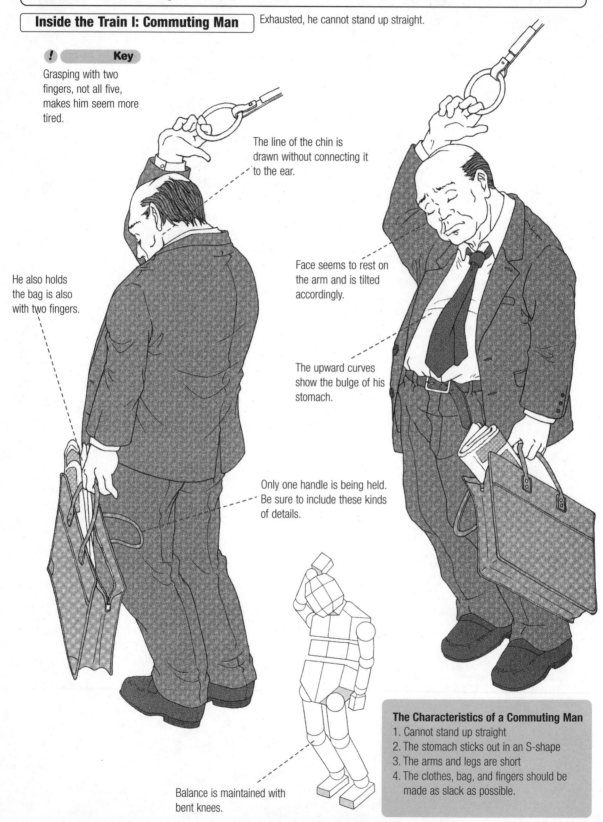

Balance is maintained with bent knees.

The Characteristics of a Commuting Man
1. Cannot stand up straight
2. The stomach sticks out in an S-shape
3. The arms and legs are short
4. The clothes, bag, and fingers should be made as slack as possible.

Inside the Train II: Youth

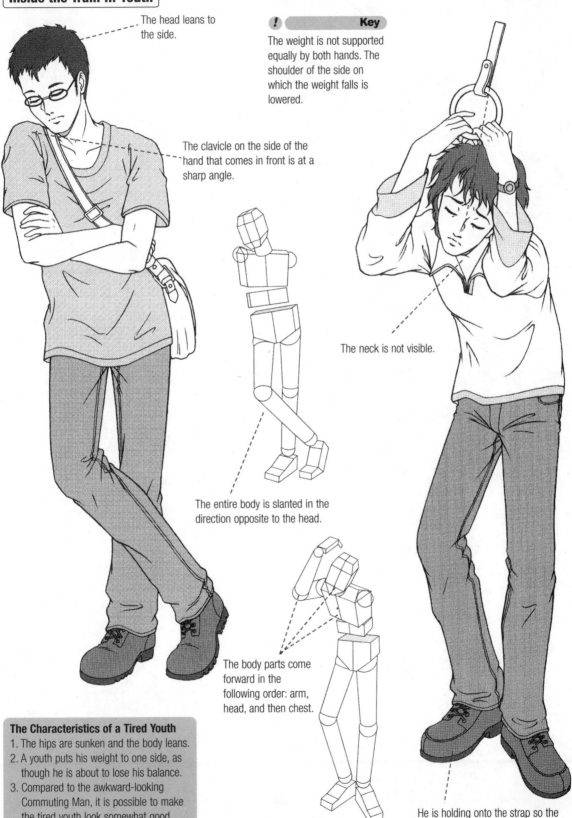

The head leans to the side.

Key

The weight is not supported equally by both hands. The shoulder of the side on which the weight falls is lowered.

The clavicle on the side of the hand that comes in front is at a sharp angle.

The neck is not visible.

The entire body is slanted in the direction opposite to the head.

The body parts come forward in the following order: arm, head, and then chest.

The Characteristics of a Tired Youth
1. The hips are sunken and the body leans.
2. A youth puts his weight to one side, as though he is about to lose his balance.
3. Compared to the awkward-looking Commuting Man, it is possible to make the tired youth look somewhat good.

He is holding onto the strap so the entire weight of the body is not completely supported by the feet.

Variations of Standing

Saluting Military scene. Different from the everyday scenes, these costumes and gestures are set. Ignoring this will make the drawing look bad.

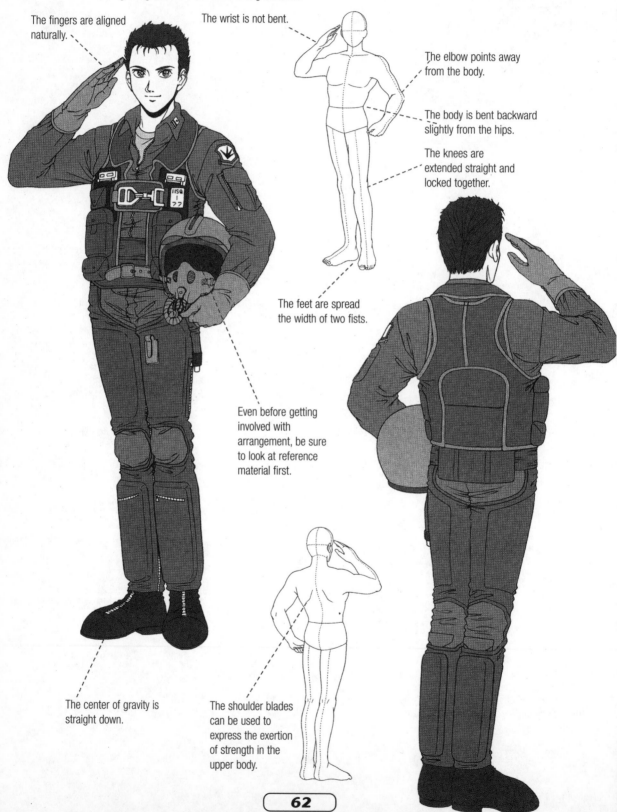

The fingers are aligned naturally.

The wrist is not bent.

The elbow points away from the body.

The body is bent backward slightly from the hips.

The knees are extended straight and locked together.

The feet are spread the width of two fists.

Even before getting involved with arrangement, be sure to look at reference material first.

The center of gravity is straight down.

The shoulder blades can be used to express the exertion of strength in the upper body.

Navy

The inside of the ship is small so the underarm is closed. The elbow cannot be to the side. It slants and comes forward.

The stiffness of the gloves can be expressed with the seam.

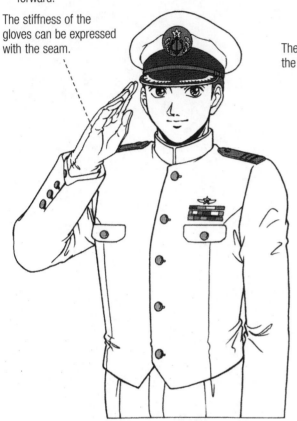

British Military

The elbow is open and the palm of the hand faces out.

The palm of the hand is shown.

The elbow is higher than the line of the underarm.

The shoulders are bent backward.

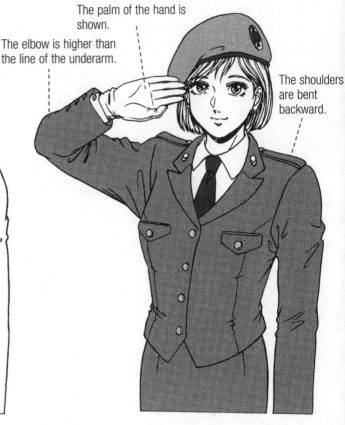

The brim of the hat almost conceals the brow.

Be careful with the perspective of the palm.

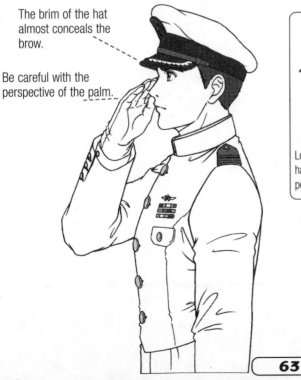

Looking from the side, the hat is not horizontal. Watch people who wear hats.

The salute is different for each armed force. At the very least, don't make mistakes with the most obvious ones, such as the Navy and the British Military.

Variations of Standing

Karaoke

Let's enhance the drawing by choreographing poses to get a feeling of rhythmical movement. This pose can also be used in dancing scenes.

Example of a rhythmical pose. The height of the wrist remains the same and only the elbow moves up and down.

The line of sight is down and to the side. Raised straight up and they become rigid.

It is moved out to the left considerably.

The head is slanted toward the direction of the center of gravity.

The center of gravity is on one foot producing an S-shaped line.

Bad Example

Be careful with the direction of the leg. The folds can be made in the direction shown here. Making them in the opposite direction creates the following look.

! Key

The upper body is curved in a direction opposite to that of the center of gravity.

! Key

Draw the grasp of the microphone properly.

Only the toes touch the ground.

The fist is open that portion of the microphone's column.

Depending on the song, the choreography is different.

Enchanting with Traditional Japanese Song

The face is raised straight and the chin is extended.

The hands reach out.

Slightly bent backwards.

The knees touch.

This leg and the upper body are twisted but the center of gravity is the line of the nose.

The face points up.

The back almost bends backward.

The knees are straight. They are bent slightly back.

Belting It Out

The center of gravity is on the right so the upper body bends to the right.

The feet are spread shoulder width apart.

Lost in his Own World

The line of sight is directly on the microphone.

The arm extends from the shoulder to the back. Because of the perspective the hand is drawn small.

The upper body twists laterally.

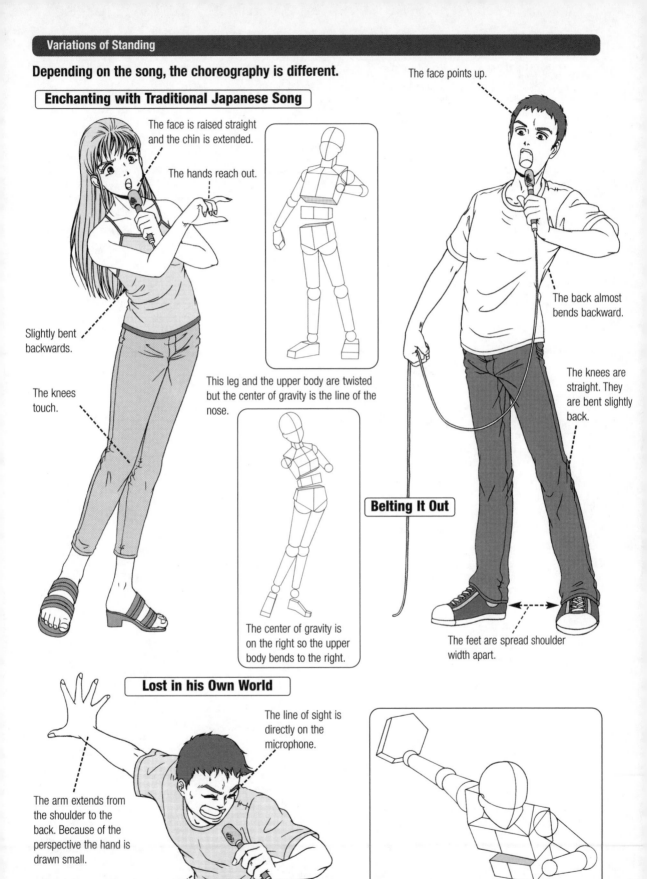

65

Variations of Standing

Putting on Jeans The knees stick out creating an S-shaped pose when seen from the side. This is the same for other pants as well.

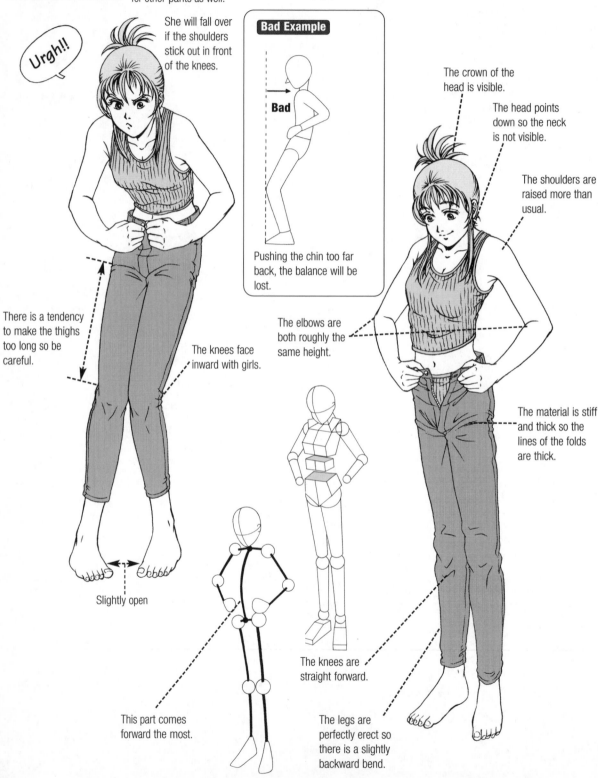

Urgh!!

She will fall over if the shoulders stick out in front of the knees.

There is a tendency to make the thighs too long so be careful.

The knees face inward with girls.

Slightly open

This part comes forward the most.

Bad Example

Bad

Pushing the chin too far back, the balance will be lost.

The elbows are both roughly the same height.

The knees are straight forward.

The legs are perfectly erect so there is a slightly backward bend.

The crown of the head is visible.

The head points down so the neck is not visible.

The shoulders are raised more than usual.

The material is stiff and thick so the lines of the folds are thick.

Putting on Pants while Sitting

Putting on the pants while sitting, then standing up to pull them up. Pay attention to which parts of the body exert effort.

The folds follow the form of the column's curve.

The line of sight is toward the feet.

The arm touches the body.

The knee falls inward.

Key

!

Mostly sideways

There is no exertion of strength.

The toes are flexed and point toward the ground.

The foot is outside the width of the body.

Strength is exerted here so the muscles are flexed a little.

The line begins from the underarm.

The neck is not visible.

Getting Up

She is tilted forward so the navel points down.

The way her knees are locked together is very girlish.

The shoulder is slightly raised.

The leg is used for balance.

The body is supported by this leg.

Variations of Standing

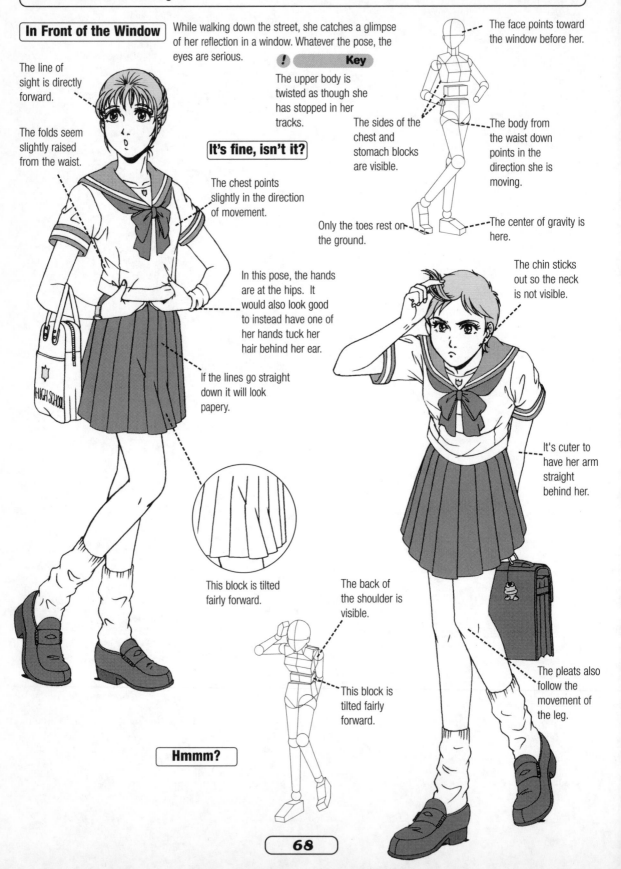

In Front of the Window

While walking down the street, she catches a glimpse of her reflection in a window. Whatever the pose, the eyes are serious.

! Key

The upper body is twisted as though she has stopped in her tracks.

It's fine, isn't it?

The face points toward the window before her.

The line of sight is directly forward.

The folds seem slightly raised from the waist.

The chest points slightly in the direction of movement.

The sides of the chest and stomach blocks are visible.

The body from the waist down points in the direction she is moving.

Only the toes rest on the ground.

The center of gravity is here.

In this pose, the hands are at the hips. It would also look good to instead have one of her hands tuck her hair behind her ear.

If the lines go straight down it will look papery.

The chin sticks out so the neck is not visible.

It's cuter to have her arm straight behind her.

This block is tilted fairly forward.

The back of the shoulder is visible.

This block is tilted fairly forward.

The pleats also follow the movement of the leg.

Hmmm?

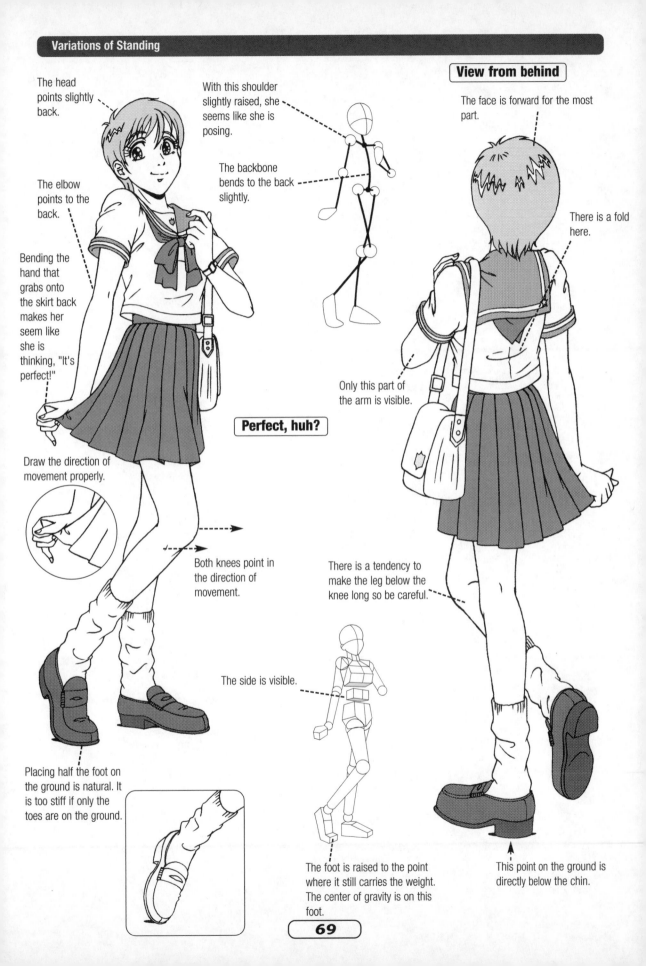

The head points slightly back.

With this shoulder slightly raised, she seems like she is posing.

The backbone bends to the back slightly.

View from behind

The face is forward for the most part.

The elbow points to the back.

Bending the hand that grabs onto the skirt back makes her seem like she is thinking, "It's perfect!"

There is a fold here.

Only this part of the arm is visible.

Perfect, huh?

Draw the direction of movement properly.

Both knees point in the direction of movement.

There is a tendency to make the leg below the knee long so be careful.

The side is visible.

Placing half the foot on the ground is natural. It is too stiff if only the toes are on the ground.

The foot is raised to the point where it still carries the weight. The center of gravity is on this foot.

This point on the ground is directly below the chin.

Variations of Standing

Posing with an Apron She is showing off her new outfit to her boyfriend. This pose is also used when a waitress is showing off new clothes. Adding a small amount of theatricality adds cuteness.

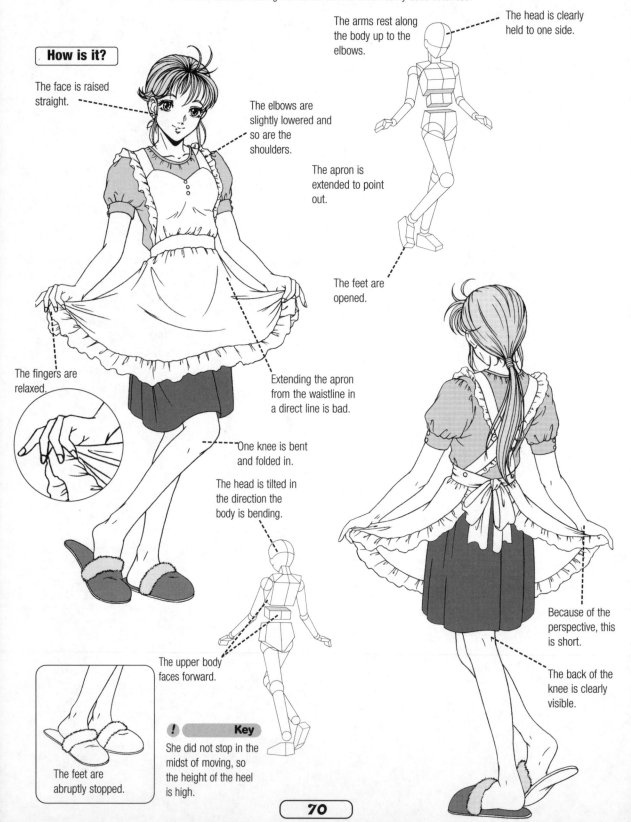

The arms rest along the body up to the elbows.

The head is clearly held to one side.

How is it?

The face is raised straight.

The elbows are slightly lowered and so are the shoulders.

The apron is extended to point out.

The fingers are relaxed.

The feet are opened.

Extending the apron from the waistline in a direct line is bad.

One knee is bent and folded in.

The head is tilted in the direction the body is bending.

The upper body faces forward.

Because of the perspective, this is short.

The back of the knee is clearly visible.

The feet are abruptly stopped.

! Key

She did not stop in the midst of moving, so the height of the heel is high.

The chest is slightly bowed. The apex of the chest points up.

The shoulders are bent back so the cloth at the chest is stretched, producing these folds.

She is seen from below so the curve of the waistline points up.

The knees are locked tightly together.

The legs are flexed so the back of the knees bends backward slightly.

Ahem.

Slightly emphasizing the raise in the shoulders is good.

The arms are tight against the body.

It's nice, huh?

The line of sight is directed at the other person.

The shoulders are raised.

The chin is slightly raised as though self-contended.

Only the neck twists.

Placing the back of the hand on the pelvis is more natural than placing it on the waistline.

Be careful with the direction of each block.

The body is not twisted so the side portion of each block may be viewed evenly.

It is good if the bend of the leg in front follows a pattern.

Variations of Seating

Cold Days/Hot Days

Boiling heat and freezing cold. Depending on the climate, a simple seated pose can change.

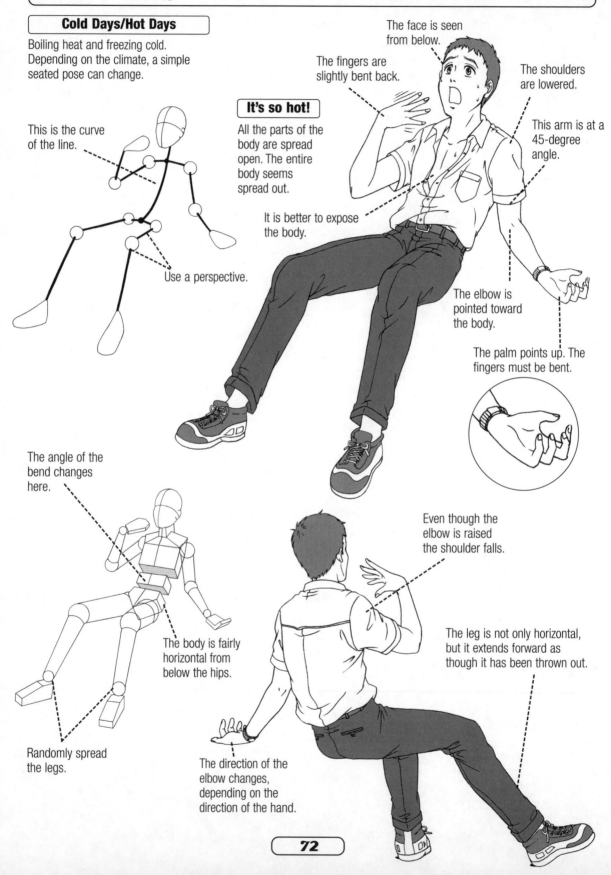

This is the curve of the line.

Use a perspective.

It's so hot!

All the parts of the body are spread open. The entire body seems spread out.

It is better to expose the body.

The face is seen from below.

The fingers are slightly bent back.

The shoulders are lowered.

This arm is at a 45-degree angle.

The elbow is pointed toward the body.

The palm points up. The fingers must be bent.

The angle of the bend changes here.

The body is fairly horizontal from below the hips.

Randomly spread the legs.

Even though the elbow is raised the shoulder falls.

The direction of the elbow changes, depending on the direction of the hand.

The leg is not only horizontal, but it extends forward as though it has been thrown out.

Shivering Opposite to the hot day, the entire body is drawn in. The center of the stomach is curled in.

The face points down.

! **Key**

The inward curve of the shoulders.

! **Warning!**

The hand warming the ear. This is different from resting the cheek on the hands.

This arm rests perfectly against the body.

From this point the sharp inward direction changes. Compare this to when it is hot.

It is almost completely straight from below the hips.

Clutching the satchel against the body adds life to the drawing.

She is curled up so the neck is not visible for the most part.

If the heels are separated then the toes should touch.

The knees touch.

Be careful with the curve of the backbone.

The coat seam is seen from above so it curves downward.

This curve follows the shape of the leg and points toward the knee.

The space is narrow.

The foot is slightly in front of the knee.

The line where the feet rest is parallel to the waistline.

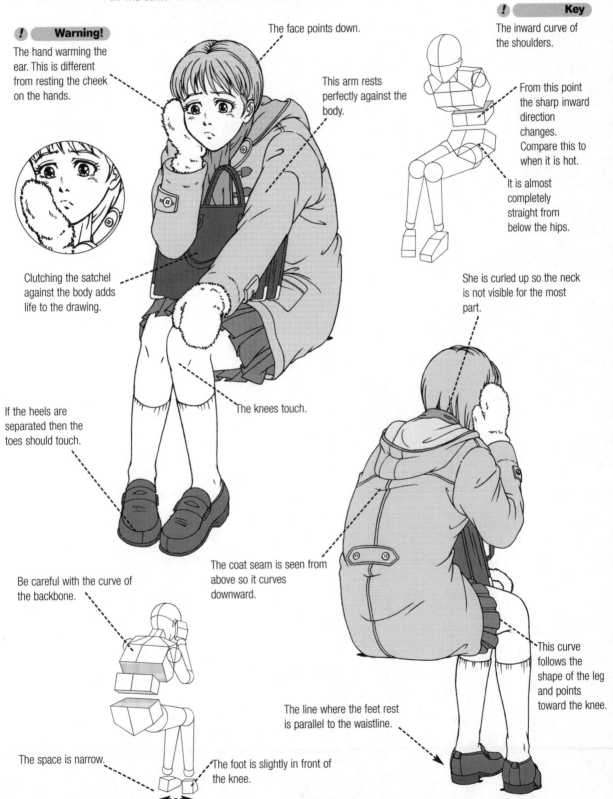

Variations of Sitting

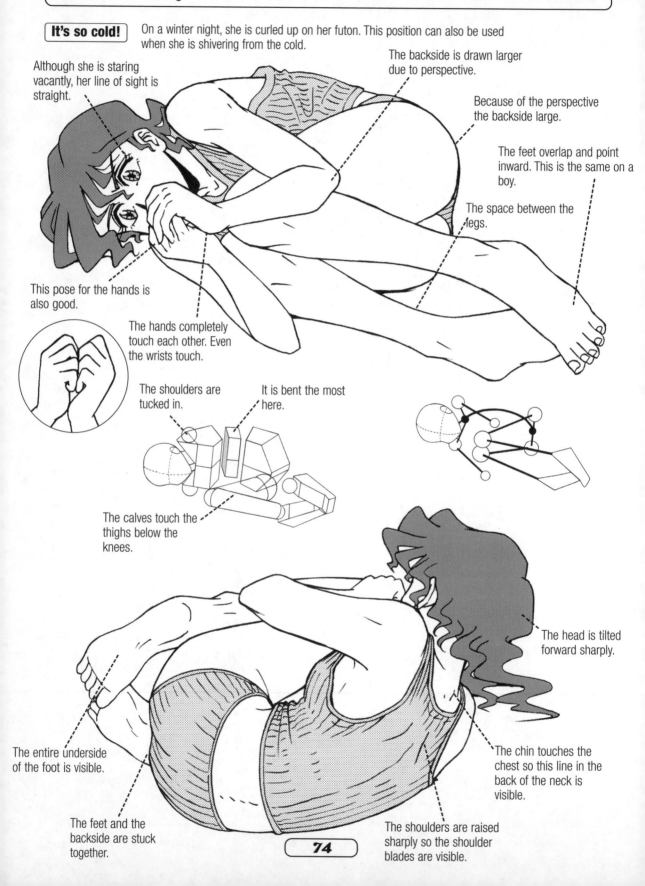

It's so cold! On a winter night, she is curled up on her futon. This position can also be used when she is shivering from the cold.

The backside is drawn larger due to perspective.

Although she is staring vacantly, her line of sight is straight.

Because of the perspective the backside large.

The feet overlap and point inward. This is the same on a boy.

The space between the legs.

This pose for the hands is also good.

The hands completely touch each other. Even the wrists touch.

The shoulders are tucked in.

It is bent the most here.

The calves touch the thighs below the knees.

The head is tilted forward sharply.

The entire underside of the foot is visible.

The chin touches the chest so this line in the back of the neck is visible.

The feet and the backside are stuck together.

The shoulders are raised sharply so the shoulder blades are visible.

Curled Up while Sitting

When sitting, the feet are bent loosely. Rather than pointing toward the stomach, the feet point toward the ground and are tucked in.

The head sticks forward.

The crown of the head is visible.

The shoulders are raised and point inward.

Add in the unevenness of the shoulder blades.

It is bent here the most.

The line of sight is downward.

The shoulder is visible from behind the face.

This slanted line is parallel to the block of the backside.

The elbows point outward.

Be careful with the position of the feet. If the feet are not aligned with the bottom, she will look as though she is floating.

Don't forget this curve either.

The act of trying to warm cold toes.

! Keep in Mind!

The action of cold hands

One hand is being grasped with the thumb of the other hand.

They don't touch here.

Variations of Sitting

Though these are all writing poses, each is different depending on the state of mind. Let's try to communicate the situation by just using the upper body.

Serious

Agony

This is okay too.

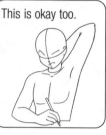

Serious

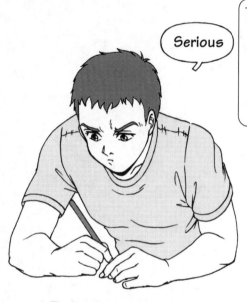

The body is not supported here because the elbow does not rest on table.

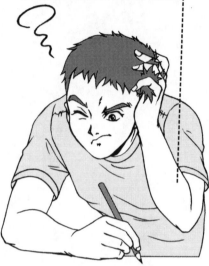

1. The line of sight is directed at the writing.
2. The hand that grasps the pencil is flexed.
3. The left hand holds down the paper.

1. The left hand is fumbling about.
2. The grasp of the right hand is loose.

Hmm

Uh . . .

Uh . . .

Hmm

It's also okay to make it something like this.

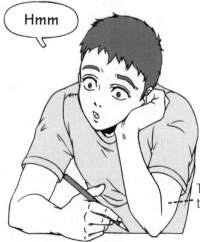

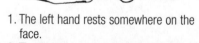
The weight rests on this arm.

1. The line of sight is beyond what is being written. (Staring into space is also okay.)
2. He rests his chin on his hand.
3. The grasp of the pencil is the loosest here.

1. The left hand rests somewhere on the face.
2. The upward angle of the line of sight looks very real. (Seen from below.)
3. The pencil is grasped tightly absent-mindedly.

While Deep in Thought

Writing on paper. From the shoulder up, she is focusing her effort mentally. But the rest of her body is the same as "Relaxed."

Check the curve of her back.

The hand supports the chin so the head is lowered.

The line of sight is directly on what is being written.

At this point the angle suddenly changes.

This fold follows the chest and hip blocks of the wooden figure.

The ankles are relaxed so the feet are moving about.

Tapping the foot unconsciously is also okay.

On the side where the cheek is resting on the hand, the shoulder is raised.

The shoulders are raised so only half of the back of the head is visible.

Because the shoulders are raised, the shoulder blades are close.

The elbows are off to the left and right. Her writing hand faces outward.

Draw the outline of the backside clearly.

! Key

Is it difficult to draw the head lowered?

1. The crown of the head is shown.
2. The distance from the eyes to the chin is about one-third of the entire head.
3. The line of the shoulders begins somewhere at the upper part of the ears.
4. The mouth curves downward.

Variations of Sitting

 Eating Rice The elbows open differently depending on whether she is holding a rice bowl or chopsticks. The way the neck and shoulders move is very important.

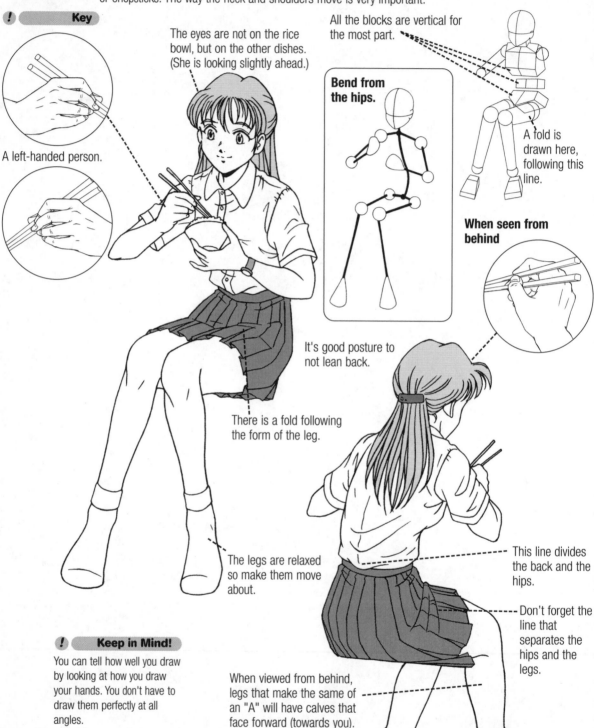

! **Key**

The eyes are not on the rice bowl, but on the other dishes. (She is looking slightly ahead.)

A left-handed person.

All the blocks are vertical for the most part.

Bend from the hips.

A fold is drawn here, following this line.

When seen from behind

It's good posture to not lean back.

There is a fold following the form of the leg.

The legs are relaxed so make them move about.

This line divides the back and the hips.

Don't forget the line that separates the hips and the legs.

! **Keep in Mind!**

You can tell how well you draw by looking at how you draw your hands. You don't have to draw them perfectly at all angles.

When viewed from behind, legs that make the same of an "A" will have calves that face forward (towards you).

Taking Food

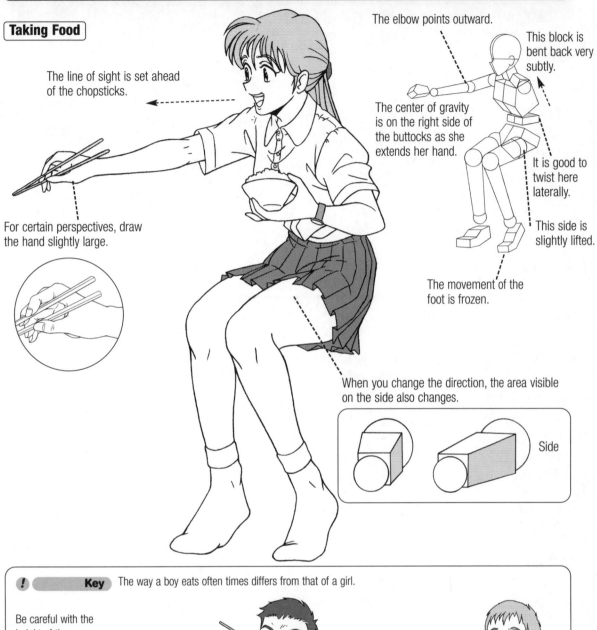

The line of sight is set ahead of the chopsticks.

For certain perspectives, draw the hand slightly large.

The elbow points outward.

This block is bent back very subtly.

The center of gravity is on the right side of the buttocks as she extends her hand.

It is good to twist here laterally.

This side is slightly lifted.

The movement of the foot is frozen.

When you change the direction, the area visible on the side also changes.

Side

! **Key** The way a boy eats often times differs from that of a girl.

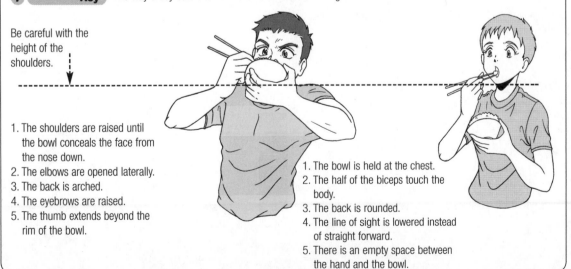

Be careful with the height of the shoulders.

1. The shoulders are raised until the bowl conceals the face from the nose down.
2. The elbows are opened laterally.
3. The back is arched.
4. The eyebrows are raised.
5. The thumb extends beyond the rim of the bowl.

1. The bowl is held at the chest.
2. The half of the biceps touch the body.
3. The back is rounded.
4. The line of sight is lowered instead of straight forward.
5. There is an empty space between the hand and the bowl.

Variations of Sitting

She can be either waiting in the hospital or for her exam results. She seems uneasy and a little nervous.

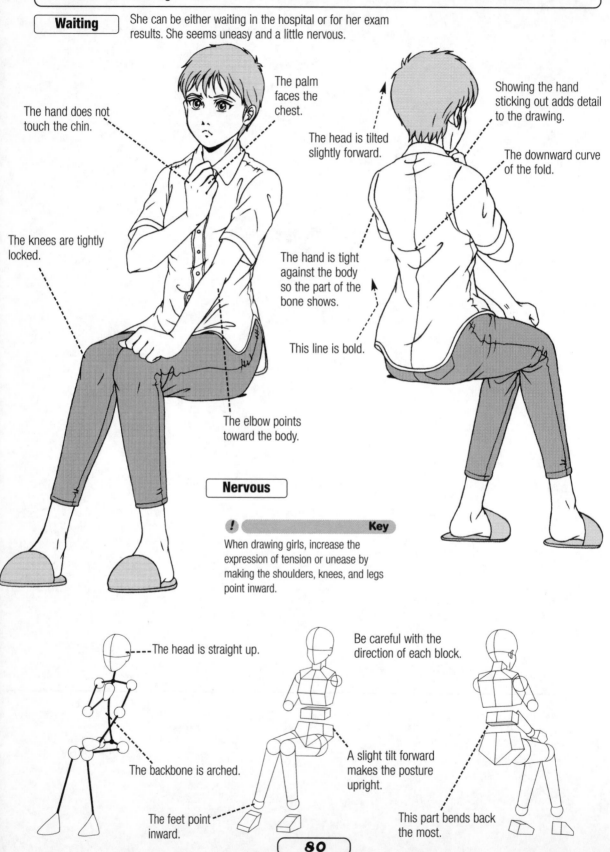

The hand does not touch the chin.

The palm faces the chest.

The head is tilted slightly forward.

Showing the hand sticking out adds detail to the drawing.

The downward curve of the fold.

The knees are tightly locked.

The hand is tight against the body so the part of the bone shows.

This line is bold.

The elbow points toward the body.

Nervous

! **Key**

When drawing girls, increase the expression of tension or unease by making the shoulders, knees, and legs point inward.

The head is straight up.

Be careful with the direction of each block.

The backbone is arched.

A slight tilt forward makes the posture upright.

The feet point inward.

This part bends back the most.

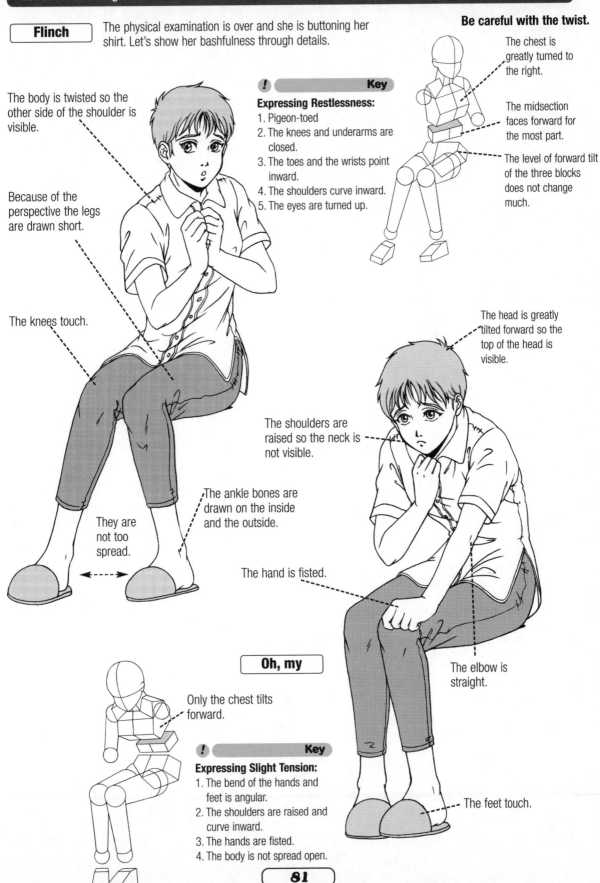

Flinch

The physical examination is over and she is buttoning her shirt. Let's show her bashfulness through details.

Be careful with the twist.

The chest is greatly turned to the right.

The midsection faces forward for the most part.

The level of forward tilt of the three blocks does not change much.

The body is twisted so the other side of the shoulder is visible.

! **Key**
Expressing Restlessness:
1. Pigeon-toed
2. The knees and underarms are closed.
3. The toes and the wrists point inward.
4. The shoulders curve inward.
5. The eyes are turned up.

Because of the perspective the legs are drawn short.

The knees touch.

The head is greatly tilted forward so the top of the head is visible.

The shoulders are raised so the neck is not visible.

They are not too spread.

The ankle bones are drawn on the inside and the outside.

The hand is fisted.

Oh, my

Only the chest tilts forward.

! **Key**
Expressing Slight Tension:
1. The bend of the hands and feet is angular.
2. The shoulders are raised and curve inward.
3. The hands are fisted.
4. The body is not spread open.

The elbow is straight.

The feet touch.

Variations of Sitting

When the body is on all fours, the back tilts forward greater than usual. Make the chest face the floor for the most part. When reading a newspaper, it's okay to have both hands on it.

The bulge of the shoulder blades is drawn clearly.

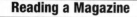

Hmm. . .

The shoulders conceal the neck.

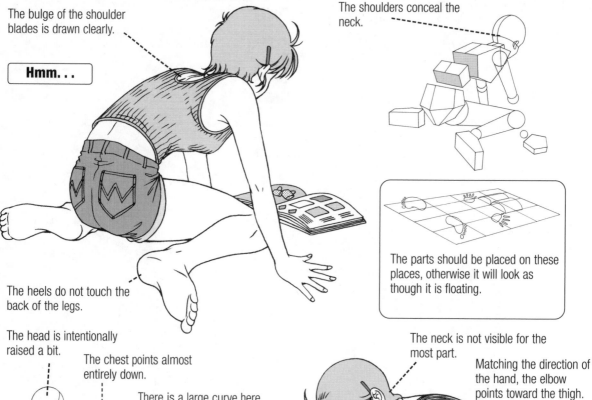

The heels do not touch the back of the legs.

The parts should be placed on these places, otherwise it will look as though it is floating.

The head is intentionally raised a bit.

The chest points almost entirely down.

There is a large curve here.

The backside is slightly horizontal.

The neck is not visible for the most part.

Matching the direction of the hand, the elbow points toward the thigh.

Turning the page

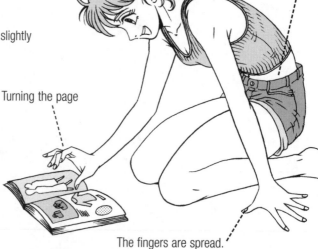

The fingers are spread.

Drawing the character like this will make her look broken-hearted.

Be careful where the hand is placed on the ground! Without bending the elbows, the degree of the tilt determines the distance of the hands from the body.

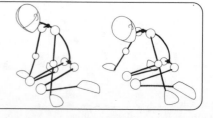

Wow!

Drawn in by an interesting article, her arm is frozen in the midst of its movement.

The top of the head is visible.

The position of the tip of the foot that is visible on the other side . . .

. . . meets the vanishing point of the hips.

As the upper body is in a lifted position, this brings the hand closer to the body.

The chest comes forward so the view of the stomach becomes small.

She sits on one leg.

Draw the magazine close to her.

No way!

Surprised, she unconsciously lifts up the magazine and doesn't take her eyes off of it.

When opened as wide as the shoulders, the angle of the page and the shoulder block is the same.

The line of sight is lower than the raise of the head.

Be careful with the height of this hand.

The clutched hand becomes vertical as it grasps the magazine firmly.

The neck is bent backward.

The line between the hands is parallel to the upper part of the shoulder block.

It bends backward from this point.

The elbows are bent slightly.

Variations of Sitting

Tired

The relief after being stressed. The pose is relaxed. Since she is not paying attention to her body, it's good to make all the parts seem like they are flying out.

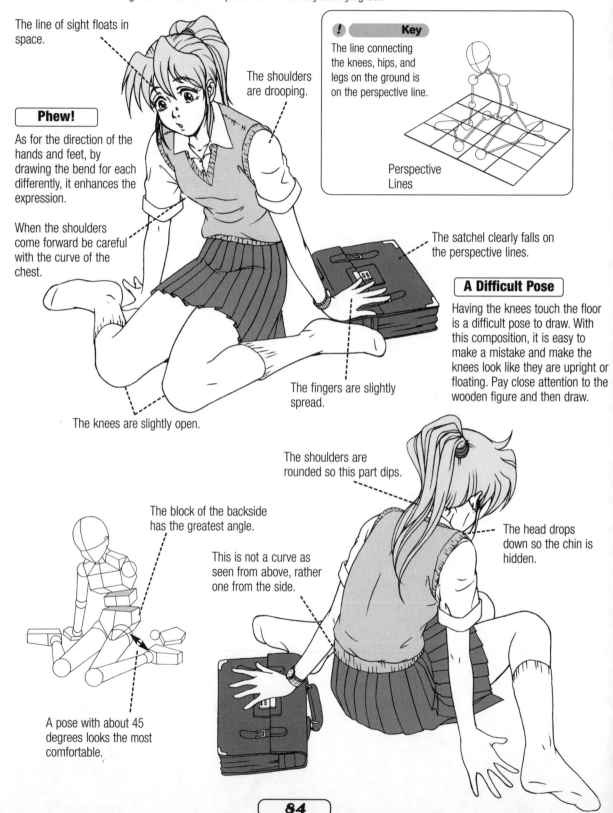

The line of sight floats in space.

Phew!

As for the direction of the hands and feet, by drawing the bend for each differently, it enhances the expression.

When the shoulders come forward be careful with the curve of the chest.

The shoulders are drooping.

Key

The line connecting the knees, hips, and legs on the ground is on the perspective line.

Perspective Lines

The satchel clearly falls on the perspective lines.

A Difficult Pose

Having the knees touch the floor is a difficult pose to draw. With this composition, it is easy to make a mistake and make the knees look like they are upright or floating. Pay close attention to the wooden figure and then draw.

The fingers are slightly spread.

The knees are slightly open.

The shoulders are rounded so this part dips.

The block of the backside has the greatest angle.

This is not a curve as seen from above, rather one from the side.

The head drops down so the chin is hidden.

A pose with about 45 degrees looks the most comfortable.

Deep Sadness So sad that she cannot speak, she seems powerless. She leans against the wall and broken-heartedly puts her hands on the ground. You can emphasize her loneliness by using small items.

Pinned between the wall and the body, the side is curved.

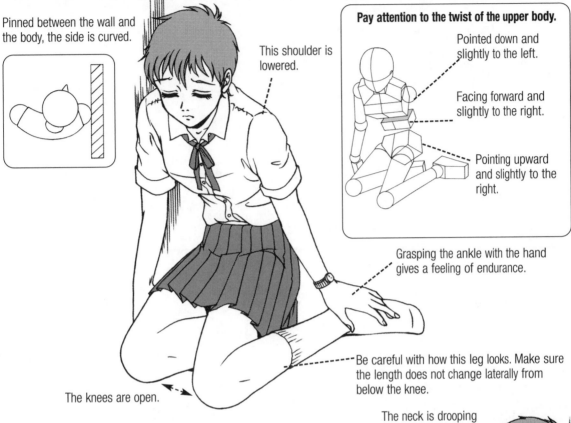

This shoulder is lowered.

Pay attention to the twist of the upper body.

Pointed down and slightly to the left.

Facing forward and slightly to the right.

Pointing upward and slightly to the right.

Grasping the ankle with the hand gives a feeling of endurance.

Be careful with how this leg looks. Make sure the length does not change laterally from below the knee.

The knees are open.

There are also these poses.

Pay attention to the S-line of the backbone.

Waistline

This arm seems to rest on the line of upper body.

The waistline is the upper part of the lowest block.

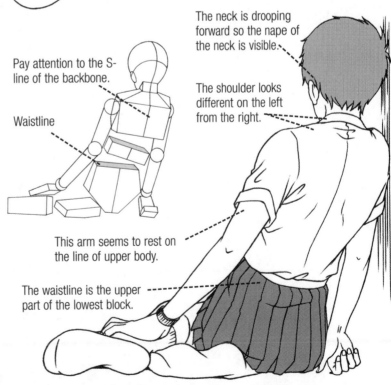

The neck is drooping forward so the nape of the neck is visible.

The shoulder looks different on the left from the right.

Variations of Sitting

Tying Shoelaces When tying the shoelaces tightly he is seated properly. This is a morning setting.

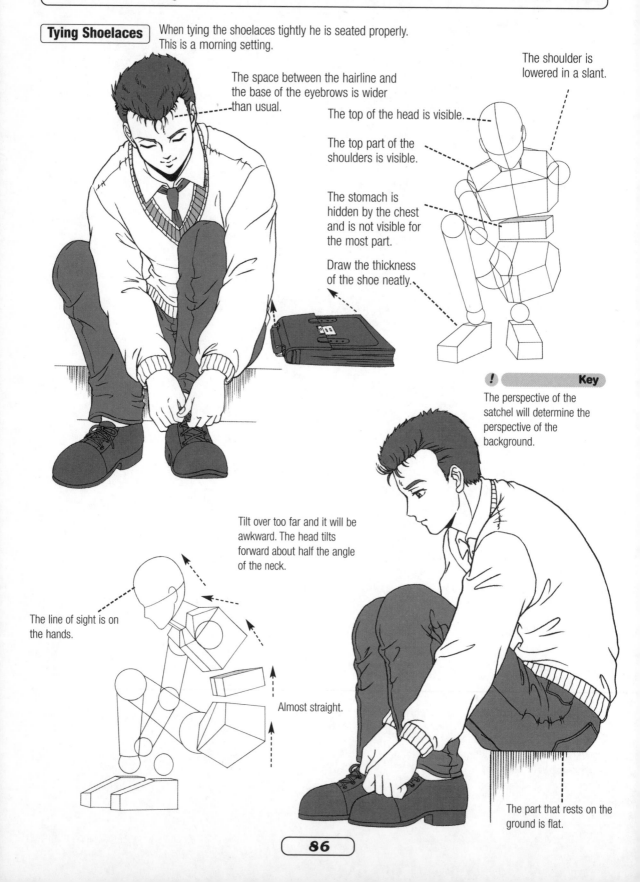

The space between the hairline and the base of the eyebrows is wider than usual.

The shoulder is lowered in a slant.

The top of the head is visible.

The top part of the shoulders is visible.

The stomach is hidden by the chest and is not visible for the most part.

Draw the thickness of the shoe neatly.

! Key

The perspective of the satchel will determine the perspective of the background.

Tilt over too far and it will be awkward. The head tilts forward about half the angle of the neck.

The line of sight is on the hands.

Almost straight.

The part that rests on the ground is flat.

Tightening the Laces

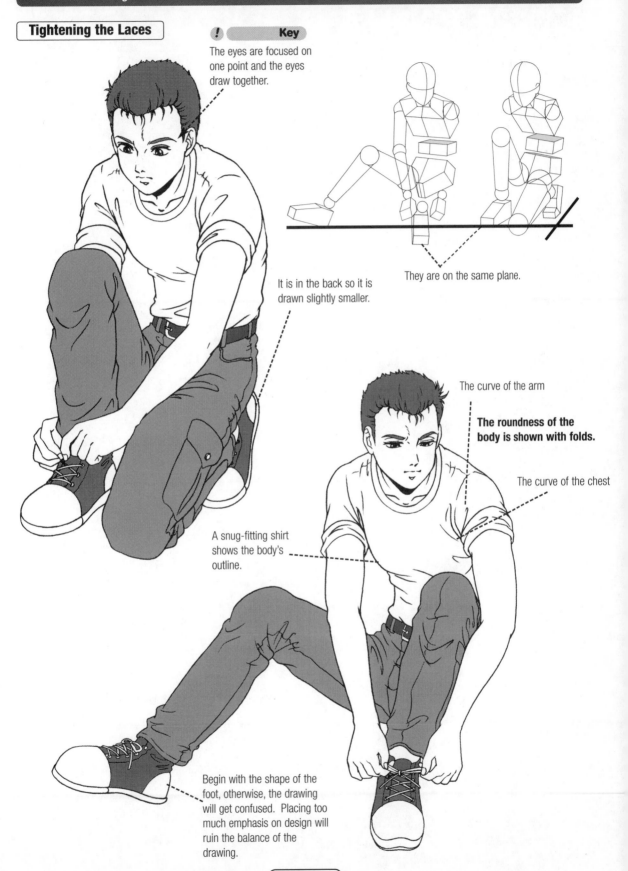

! Key

The eyes are focused on one point and the eyes draw together.

They are on the same plane.

It is in the back so it is drawn slightly smaller.

The curve of the arm

The roundness of the body is shown with folds.

The curve of the chest

A snug-fitting shirt shows the body's outline.

Begin with the shape of the foot, otherwise, the drawing will get confused. Placing too much emphasis on design will ruin the balance of the drawing.

Variations of Sitting

Sitting and Relaxing

Let's say she is at the riverside on a sunny day. Relaxing is the main activity.

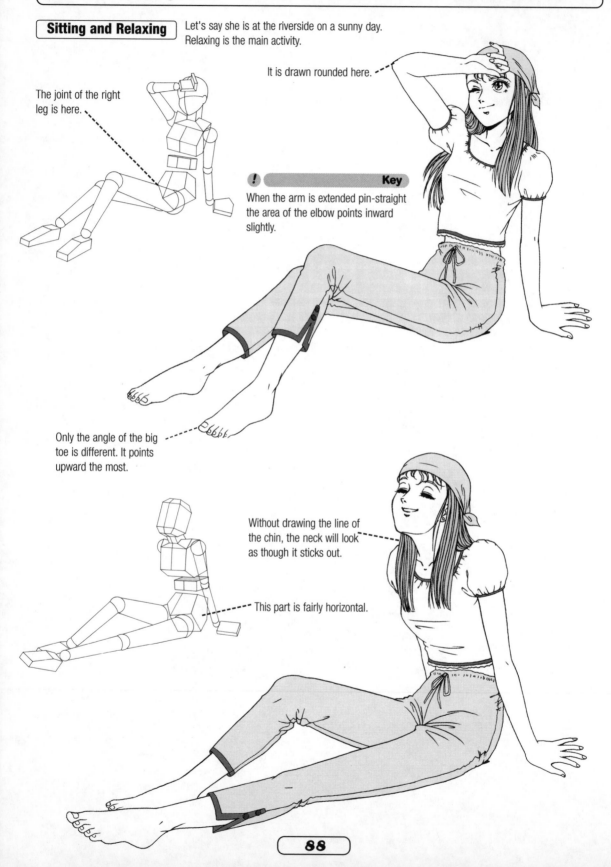

It is drawn rounded here.

The joint of the right leg is here.

! Key

When the arm is extended pin-straight the area of the elbow points inward slightly.

Only the angle of the big toe is different. It points upward the most.

Without drawing the line of the chin, the neck will look as though it sticks out.

This part is fairly horizontal.

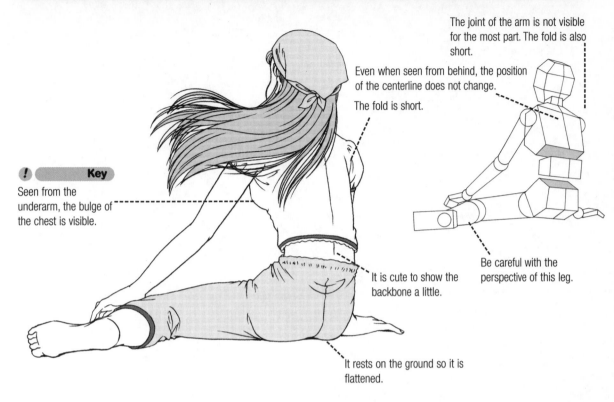

The joint of the arm is not visible for the most part. The fold is also short.

Even when seen from behind, the position of the centerline does not change.

The fold is short.

! Key

Seen from the underarm, the bulge of the chest is visible.

It is cute to show the backbone a little.

Be careful with the perspective of this leg.

It rests on the ground so it is flattened.

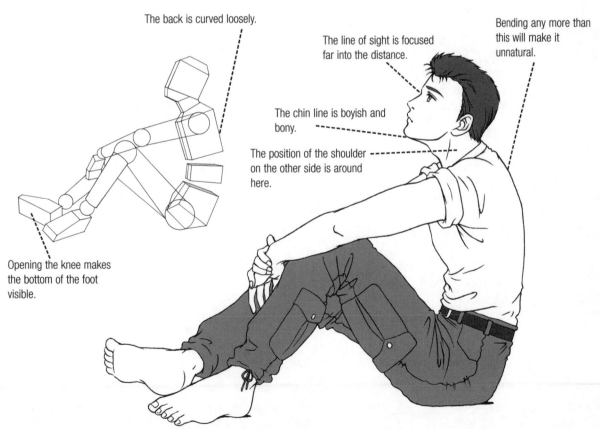

The back is curved loosely.

The line of sight is focused far into the distance.

Bending any more than this will make it unnatural.

The chin line is boyish and bony.

The position of the shoulder on the other side is around here.

Opening the knee makes the bottom of the foot visible.

Variations of Sitting

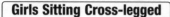 **Girls Sitting Cross-legged** For cuteness, don't make the legs crossed too tightly.

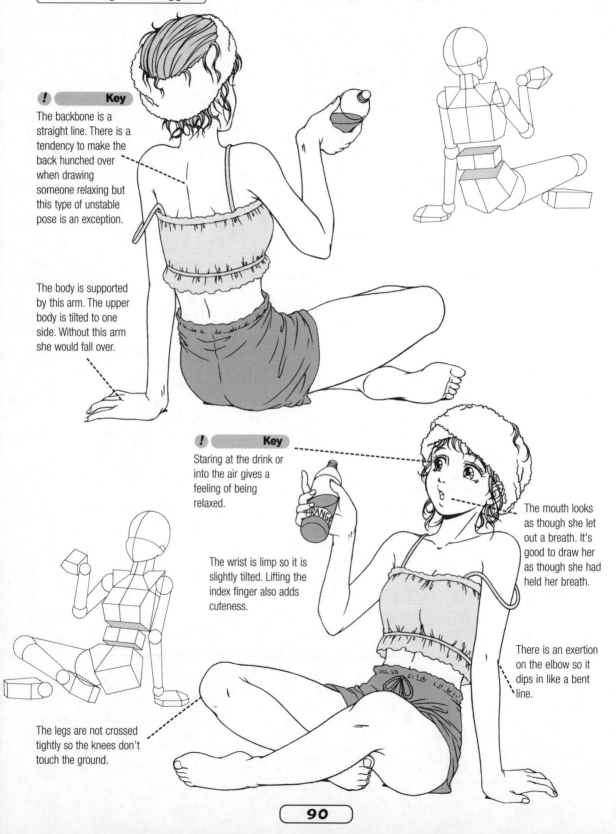

! Key

The backbone is a straight line. There is a tendency to make the back hunched over when drawing someone relaxing but this type of unstable pose is an exception.

The body is supported by this arm. The upper body is tilted to one side. Without this arm she would fall over.

! Key

Staring at the drink or into the air gives a feeling of being relaxed.

The wrist is limp so it is slightly tilted. Lifting the index finger also adds cuteness.

The legs are not crossed tightly so the knees don't touch the ground.

The mouth looks as though she let out a breath. It's good to draw her as though she had held her breath.

There is an exertion on the elbow so it dips in like a bent line.

Opposite to relaxing, there is an exertion of strength in this version. The elbows and the knees are pointed.

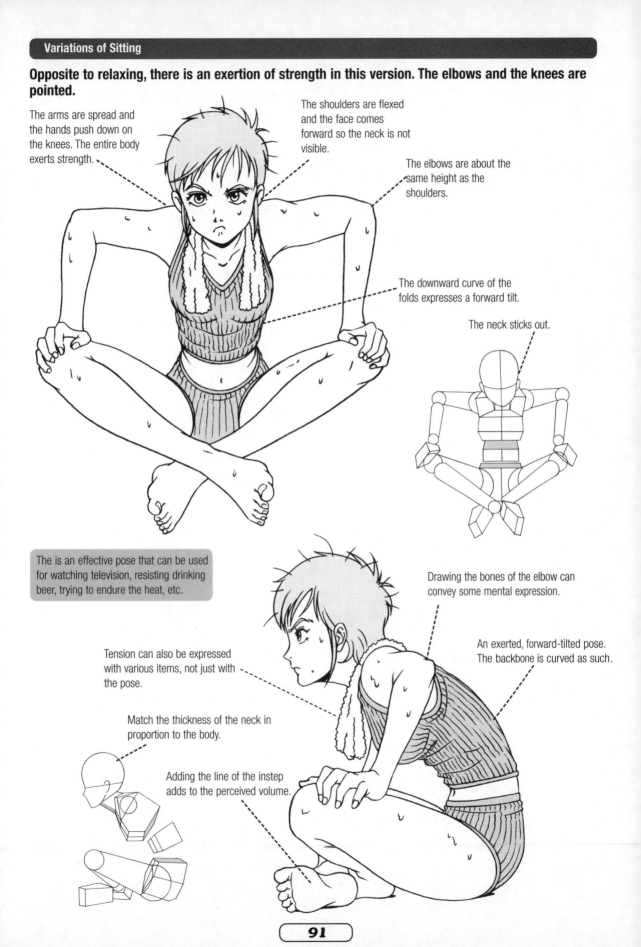

The arms are spread and the hands push down on the knees. The entire body exerts strength.

The shoulders are flexed and the face comes forward so the neck is not visible.

The elbows are about the same height as the shoulders.

The downward curve of the folds expresses a forward tilt.

The neck sticks out.

The is an effective pose that can be used for watching television, resisting drinking beer, trying to endure the heat, etc.

Drawing the bones of the elbow can convey some mental expression.

An exerted, forward-tilted pose. The backbone is curved as such.

Tension can also be expressed with various items, not just with the pose.

Match the thickness of the neck in proportion to the body.

Adding the line of the instep adds to the perceived volume.

Variations of Sitting

Arms Resting on the Knees

It is girlish to hold the knees and have them touch. In the case of a boy, it's better to cross the arms lower and spread the knees.

By focusing the eyes into the distance, this pose can also be used to express pensiveness.

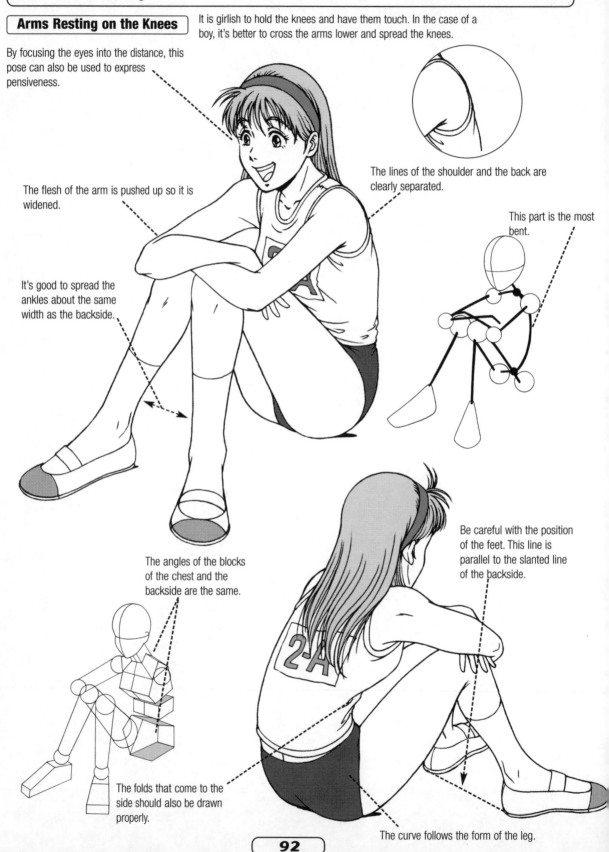

The lines of the shoulder and the back are clearly separated.

The flesh of the arm is pushed up so it is widened.

This part is the most bent.

It's good to spread the ankles about the same width as the backside.

Be careful with the position of the feet. This line is parallel to the slanted line of the backside.

The angles of the blocks of the chest and the backside are the same.

The folds that come to the side should also be drawn properly.

The curve follows the form of the leg.

Off I Go!

This moment when she stands up after being seated.

A twisted pose.

Right: Downward

Left: Backward and horizontal

Be careful with the direction of each of the blocks.

Key

The hips and shoulder tilt in opposite directions.

Don't make the toes point outward.

Drawing the heels pointing inward will confuse the balance, making it appear unsteady.

Bending both legs at the same angle is unnatural.

This knee points forward.

This knee points inward.

This leg is forward.

The face points up.

The neck is not visible.

The upper body is largely tilted forward. The shoulder of the hand that touches the ground is bent as it points down.

Be careful with the direction of the hand.

Key

The center of gravity proceeds from the backside to the supporting hand and legs and finally to the knees.

This block is twisted a lot.

The knee draws in.

The body is supported by the three points of the legs and hand.

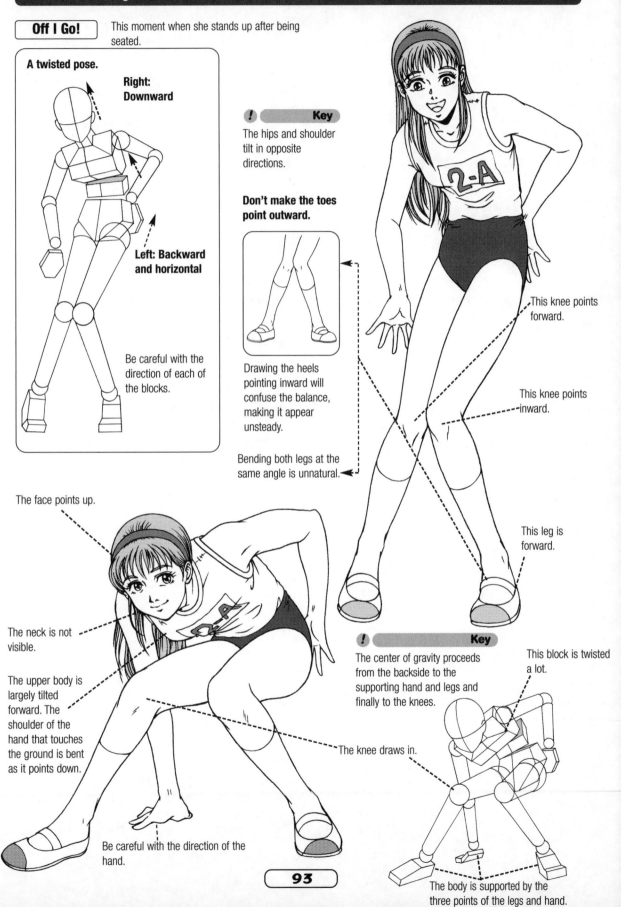

93

Variations of Sitting

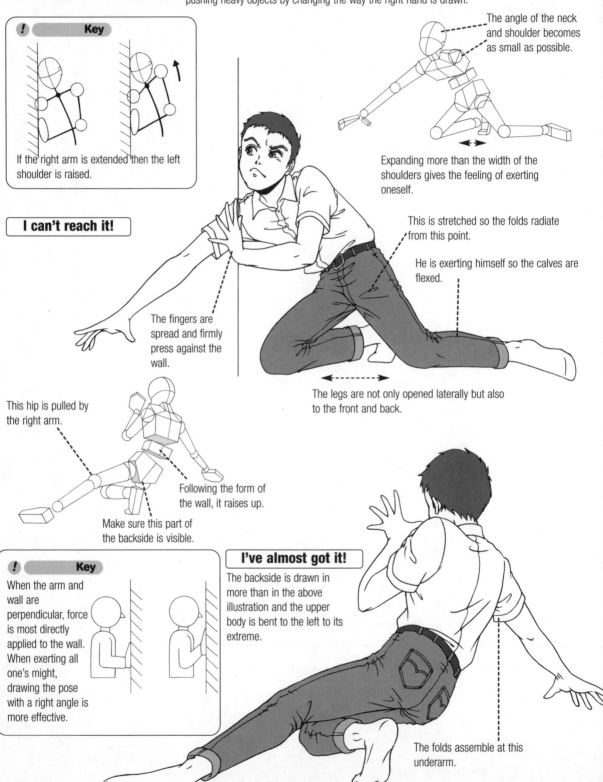

Reaching for Something

In this pose, all the strength is focused in one direction. This drawing can also be used for pushing heavy objects by changing the way the right hand is drawn.

! Key

If the right arm is extended then the left shoulder is raised.

The angle of the neck and shoulder becomes as small as possible.

Expanding more than the width of the shoulders gives the feeling of exerting oneself.

This is stretched so the folds radiate from this point.

He is exerting himself so the calves are flexed.

I can't reach it!

The fingers are spread and firmly press against the wall.

The legs are not only opened laterally but also to the front and back.

This hip is pulled by the right arm.

Following the form of the wall, it raises up.

Make sure this part of the backside is visible.

! Key

When the arm and wall are perpendicular, force is most directly applied to the wall. When exerting all one's might, drawing the pose with a right angle is more effective.

I've almost got it!

The backside is drawn in more than in the above illustration and the upper body is bent to the left to its extreme.

The folds assemble at this underarm.

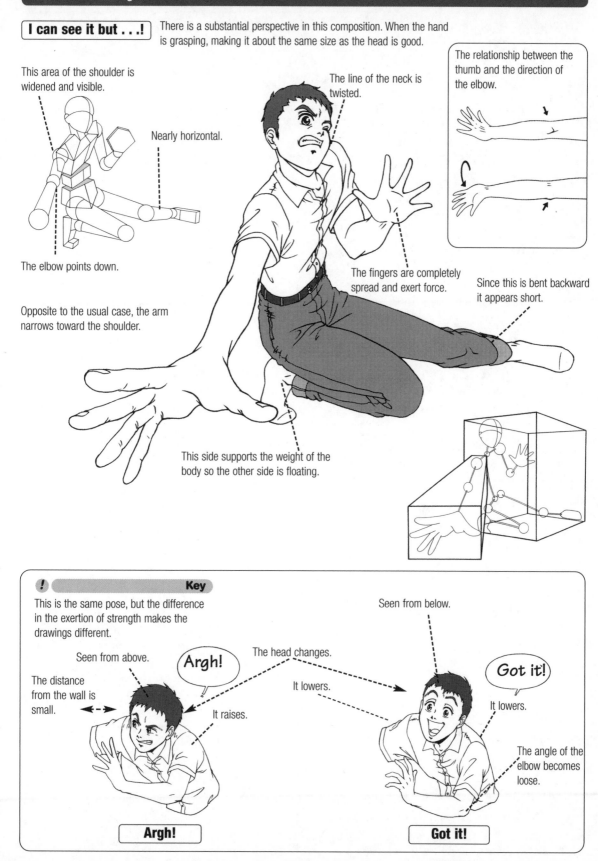

I can see it but . . .!

There is a substantial perspective in this composition. When the hand is grasping, making it about the same size as the head is good.

This area of the shoulder is widened and visible.

Nearly horizontal.

The line of the neck is twisted.

The relationship between the thumb and the direction of the elbow.

The elbow points down.

Opposite to the usual case, the arm narrows toward the shoulder.

The fingers are completely spread and exert force.

Since this is bent backward it appears short.

This side supports the weight of the body so the other side is floating.

Key

This is the same pose, but the difference in the exertion of strength makes the drawings different.

Seen from below.

Seen from above.

The head changes.

Argh!

The distance from the wall is small.

It lowers.

It raises.

Got it!

It lowers.

The angle of the elbow becomes loose.

Argh!

Got it!

Variations of Sitting

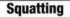 **Squatting** Draw the loose parts (sleeve and collar) and the tight parts (shoulders and sash) differently.

The neck sticks out from the upper body.

The border of the back and neck caves in slightly.

Unlike western clothing, the left side of the kimono goes over the right side.

The outline of the sash is straight. The constriction of the waist is not drawn.

To keep balance, the feet are slightly spread.

The direction of the sandal.

They are placed in the direction the feet are directed in.

The position of the shoulder on the other side. The shoulder should be on the line connecting the arms.

The block of the pelvis is not square. To express the roundedness of a woman's body, it must have a bulge.

Remember what parts of the feet are visible.

The waist is straight.

This line shows the strain on the foot's underside.

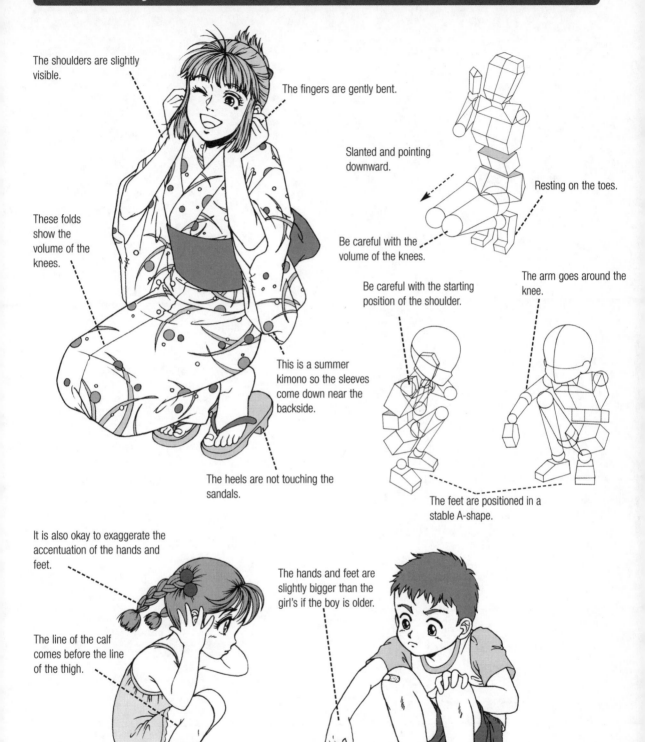

The shoulders are slightly visible.

The fingers are gently bent.

Slanted and pointing downward.

Resting on the toes.

These folds show the volume of the knees.

Be careful with the volume of the knees.

The arm goes around the knee.

Be careful with the starting position of the shoulder.

This is a summer kimono so the sleeves come down near the backside.

The heels are not touching the sandals.

The feet are positioned in a stable A-shape.

It is also okay to exaggerate the accentuation of the hands and feet.

The hands and feet are slightly bigger than the girl's if the boy is older.

The line of the calf comes before the line of the thigh.

When squatting, the heels are flat on the ground.

Variations of Sitting

Riding a Bicycle When the center of gravity is at not the center of the body, the bicycle will fall over. Depending on the design of the bicycle, the bend of the elbows and the height of the hands will change. Let's try it.

The face is raised, looking to the side as though she is wondering "What might that be?"

The shoulder is lowered on the side on which the foot touches the ground.

! Key

The nose (the center of gravity) is aligned with the foot on which the body's weight rests.

The backbone is slightly bent.

Waiting for the Light

When the bicycle stands erect, both hands are the same height from the ground.

This hip is lowered.

She is seated so this block is slightly reclined.

The weight of the body is on this foot.

She has mounted the bicycle so the knees point outward.

The skirt falls in the space between the legs.

She is seen from below so the neck is not visible.

The knee points down.

Because of the perspective, the bent leg looks shorter.

Match the perspective of the character and the bicycle.

The bicycle is in a perspective box.

The knee of the leg that rests on the grounds is also slightly bent.

The knee is almost bent directly towards the back.

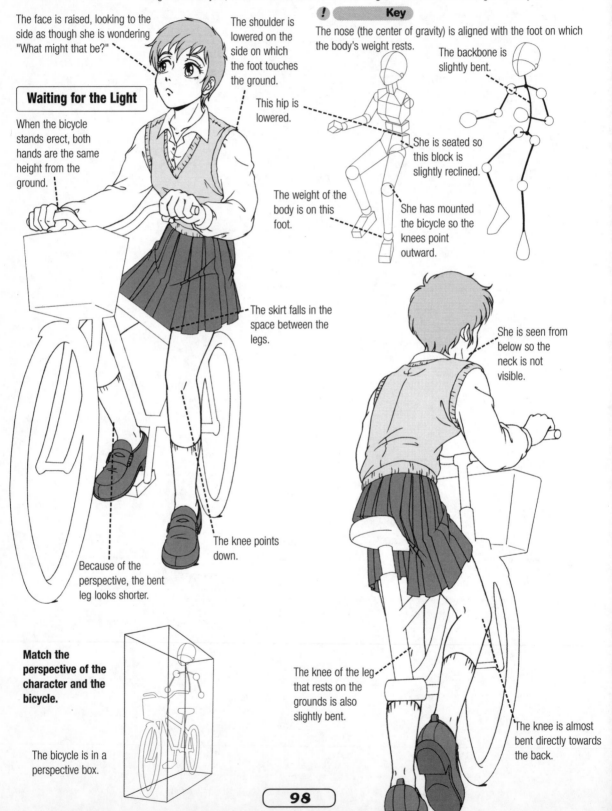

Go!

The moment of kicking off. Both elbows and the back leg exert force.

As seen from the side

The line of sight is forward.

The head is bent back.

The level of the forward tilt makes the shoulders lower and the elbows raised.

The chest is directly below the face.

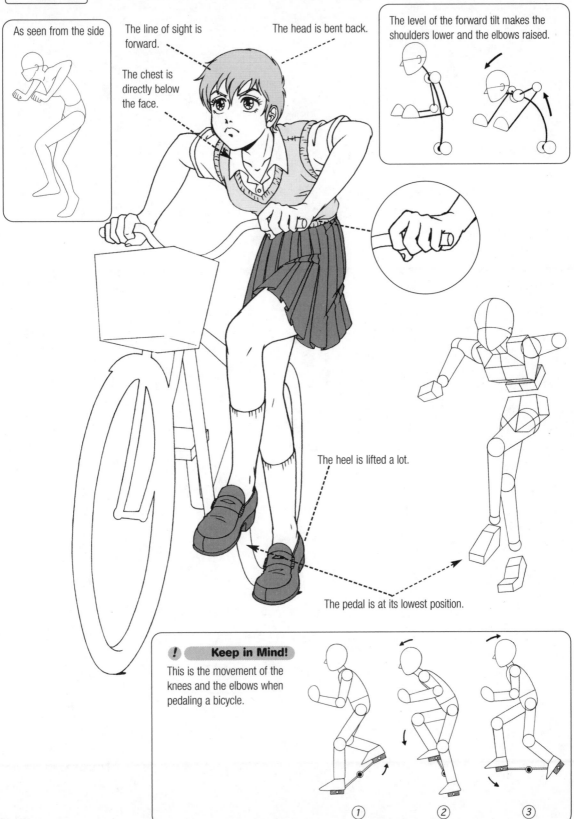

The heel is lifted a lot.

The pedal is at its lowest position.

! Keep in Mind!

This is the movement of the knees and the elbows when pedaling a bicycle.

① ② ③

Variations of Sitting

Bathtubs The pose while bathing is different for Japanese-style baths (top) and western-style baths (bottom). With either one, the body is in a relaxed pose.

Be careful with the soak lines. They should rest on the perspective lines.

The top of the head is visible.

The head rests on the shoulder, it tilts, and slants forward.

The shoulder is lowered in the direction the head tilts.

Stoop forward

The top part of the shoulder is visible.

The body is pulled in.

The elbows are slightly bent.

The knees are exposed. They should be on the same perspective line as the waterline at the chest.

This part of the shoulder along with the neck touches the wall of the bathtub.

It's good to extend the fingers, as though pressing onto the sides of the bathtub.

The body is open.

The navel is parallel to the hips and horizontal.

The legs are a good distance from the body.

The backside is fairly horizontal.

Feels Good!

A pose with complicated hands.

The elbows point out.

The knees are slightly spread.

The shoulders come forward so the back is slightly visible.

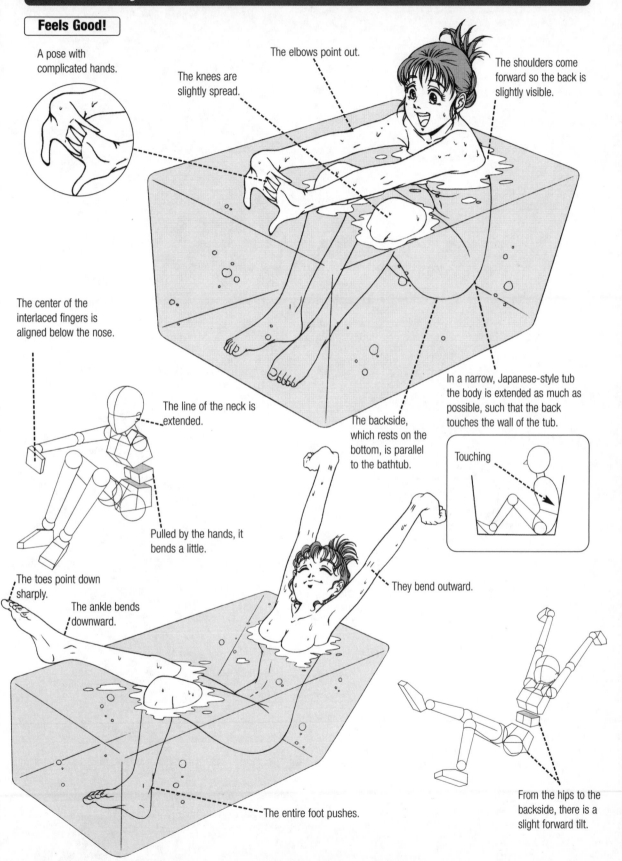

The center of the interlaced fingers is aligned below the nose.

The line of the neck is extended.

Pulled by the hands, it bends a little.

The backside, which rests on the bottom, is parallel to the bathtub.

In a narrow, Japanese-style tub the body is extended as much as possible, such that the back touches the wall of the tub.

Touching

The toes point down sharply.

The ankle bends downward.

They bend outward.

The entire foot pushes.

From the hips to the backside, there is a slight forward tilt.

Variations of Sitting.

Arrogance At a glance, he appears very relaxed. However, as he is keenly aware of being watched, he exerts strength in detailed areas of his body. Keep in mind where the distinctions should be made.

! **Key**

The face is not directed straight at the other person.

The line of sight is secured on the other person.

Though the fingers are spread apart, they are not completely limp.

The thumb is seen through the transparent glass.

Only the index finger is extended straight.

In the case of a cocktail glass

The toes are straight.

Be careful with the line of the back!

Tips
1. Strength is exerted along his fingertips, toes, and the edge of his mouth.
2. The line of sight is straight towards the other person.
3. The more he leans over, the greater the level of his arrogance.
4. He intentionally leans over in a slack manner despite wearing a tailored suit.

When seen from the front, the backbone (the centerline) is one straight line instead of a curve. With this type of detail, a concealed tension can be expressed.

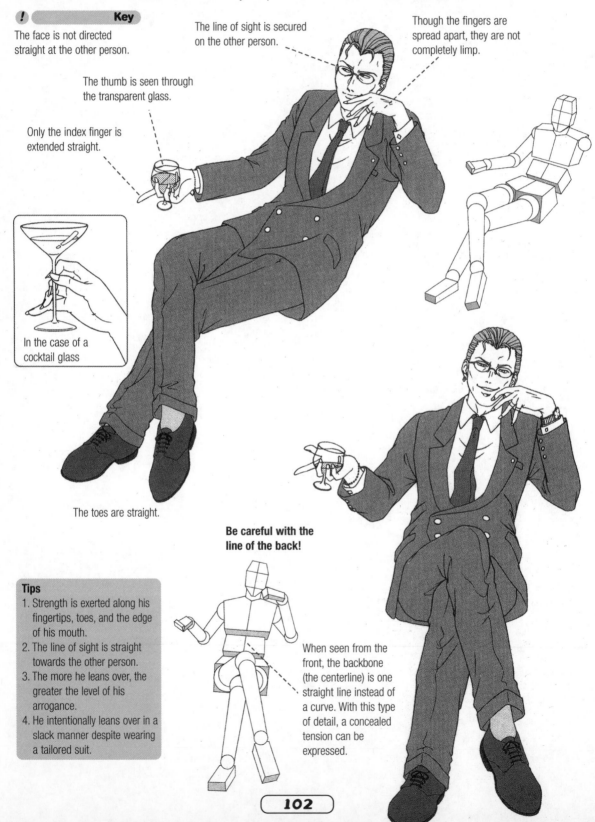

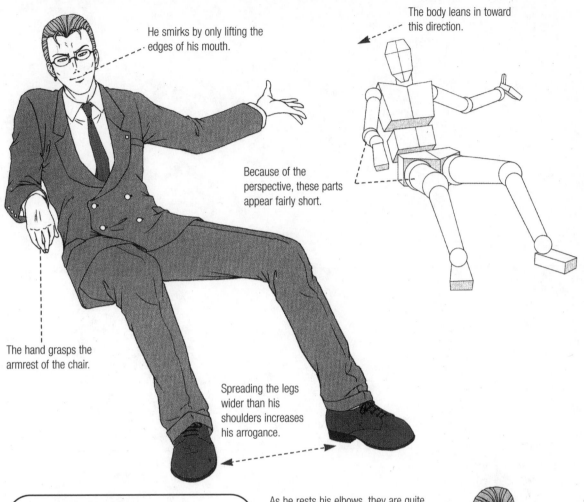

He smirks by only lifting the edges of his mouth.

The body leans in toward this direction.

Because of the perspective, these parts appear fairly short.

The hand grasps the armrest of the chair.

Spreading the legs wider than his shoulders increases his arrogance.

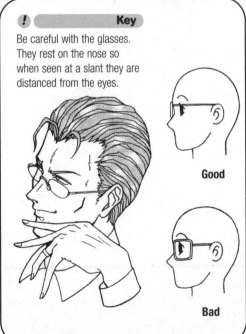

! Key

Be careful with the glasses. They rest on the nose so when seen at a slant they are distanced from the eyes.

Good

Bad

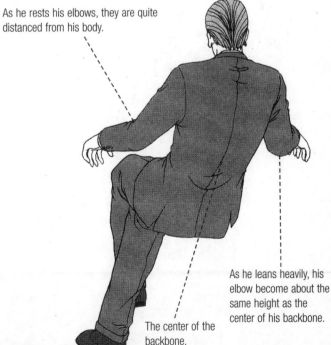

As he rests his elbows, they are quite distanced from his body.

As he leans heavily, his elbow become about the same height as the center of his backbone.

The center of the backbone.

Variations of Sitting

Bar Scene

A woman sitting alone on a barstool. In this scene, she is absorbed in thought. Within her adult demeanor, there is an element of cuteness.

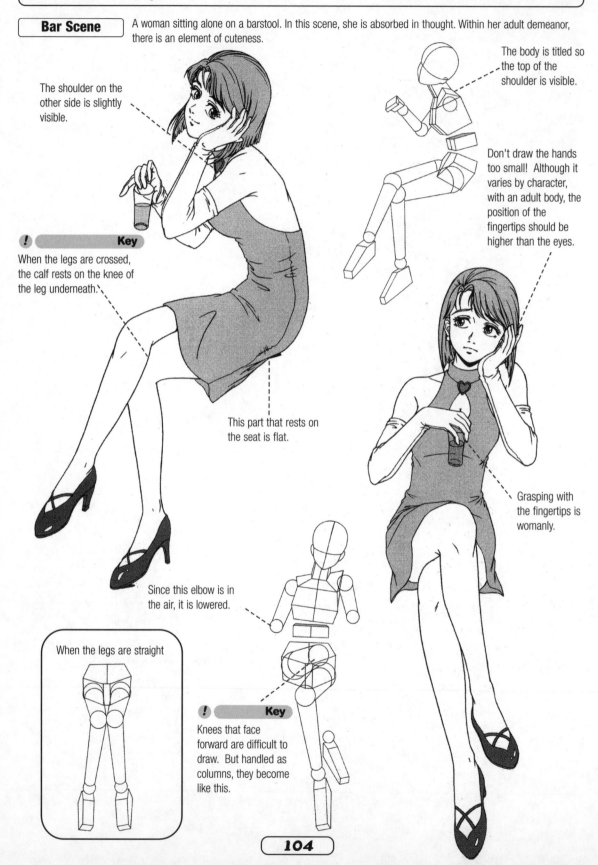

The shoulder on the other side is slightly visible.

The body is titled so the top of the shoulder is visible.

Don't draw the hands too small! Although it varies by character, with an adult body, the position of the fingertips should be higher than the eyes.

❗ Key

When the legs are crossed, the calf rests on the knee of the leg underneath.

This part that rests on the seat is flat.

Grasping with the fingertips is womanly.

Since this elbow is in the air, it is lowered.

When the legs are straight

❗ Key

Knees that face forward are difficult to draw. But handled as columns, they become like this.

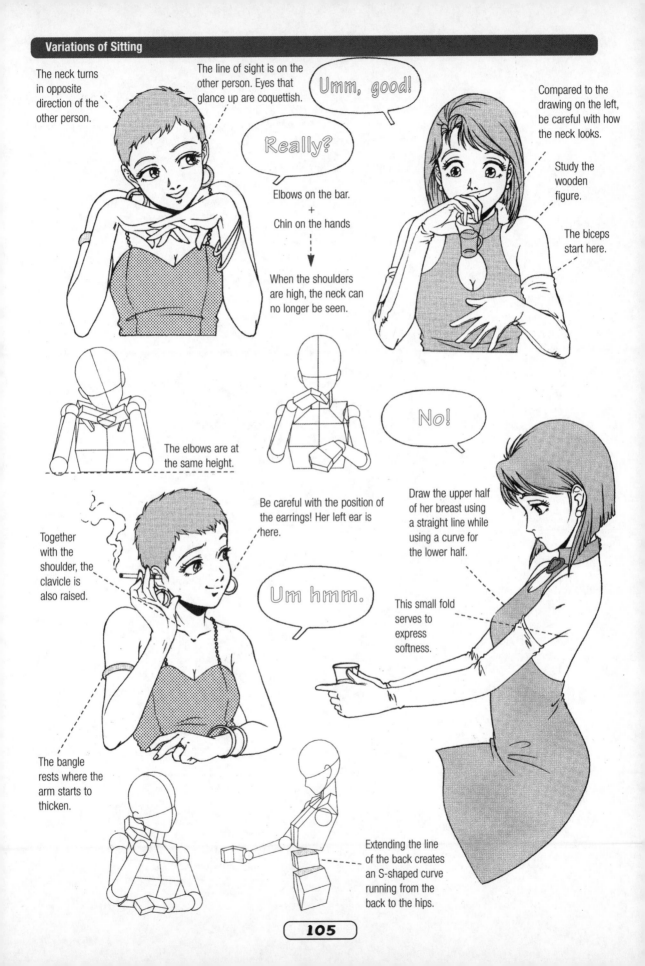

The neck turns in opposite direction of the other person.

The line of sight is on the other person. Eyes that glance up are coquettish.

Umm, good!

Really?

Compared to the drawing on the left, be careful with how the neck looks.

Study the wooden figure.

The biceps start here.

Elbows on the bar.
+
Chin on the hands
↓
When the shoulders are high, the neck can no longer be seen.

The elbows are at the same height.

No!

Be careful with the position of the earrings! Her left ear is here.

Um hmm.

Draw the upper half of her breast using a straight line while using a curve for the lower half.

Together with the shoulder, the clavicle is also raised.

This small fold serves to express softness.

The bangle rests where the arm starts to thicken.

Extending the line of the back creates an S-shaped curve running from the back to the hips.

Variations of Lying Down

Embracing This cute girl is with her boyfriend, whom she is very fond of. It is important that the boy and the girl exerts different levels of strength.

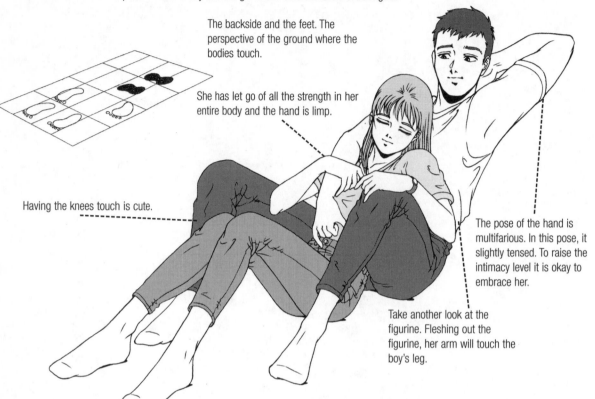

The backside and the feet. The perspective of the ground where the bodies touch.

She has let go of all the strength in her entire body and the hand is limp.

Having the knees touch is cute.

The pose of the hand is multifarious. In this pose, it slightly tensed. To raise the intimacy level it is okay to embrace her.

Take another look at the figurine. Fleshing out the figurine, her arm will touch the boy's leg.

The neck is tilted and the eyes are shut. This expresses a feeling of safety and relaxation.

Drawing each individually, let's correct the confusion of the poses with square boxes.

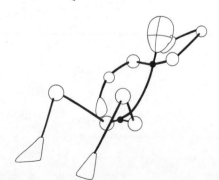

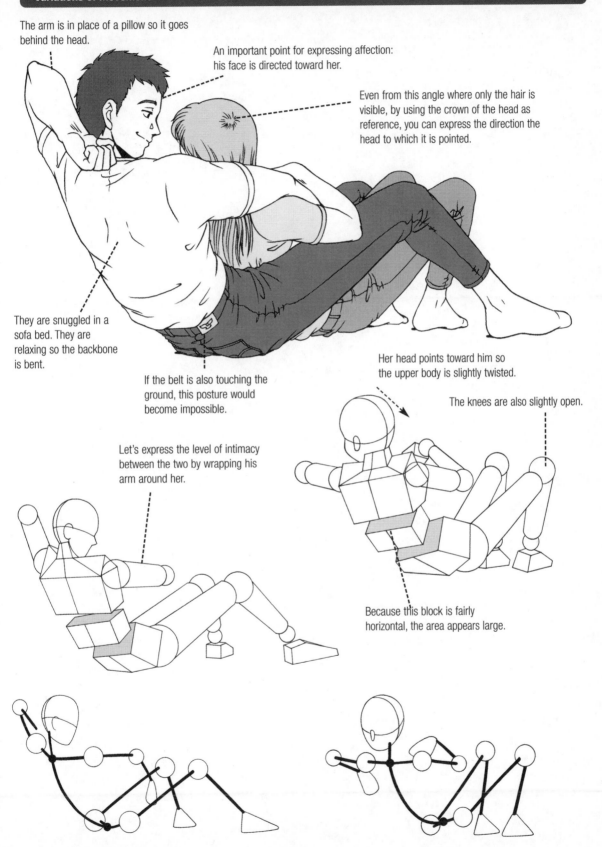

The arm is in place of a pillow so it goes behind the head.

An important point for expressing affection: his face is directed toward her.

Even from this angle where only the hair is visible, by using the crown of the head as reference, you can express the direction the head to which it is pointed.

They are snuggled in a sofa bed. They are relaxing so the backbone is bent.

If the belt is also touching the ground, this posture would become impossible.

Her head points toward him so the upper body is slightly twisted.

The knees are also slightly open.

Let's express the level of intimacy between the two by wrapping his arm around her.

Because this block is fairly horizontal, the area appears large.

Variations of Lying Down

Looking Up

What should I do? Even when she lies down to ease her mind, she still has troubled thoughts. In this pose she thinks about something over and over again.

The hand is at the forehead and she stares into space.

The head is nestled into a pillow so it is higher than the rest of the body.

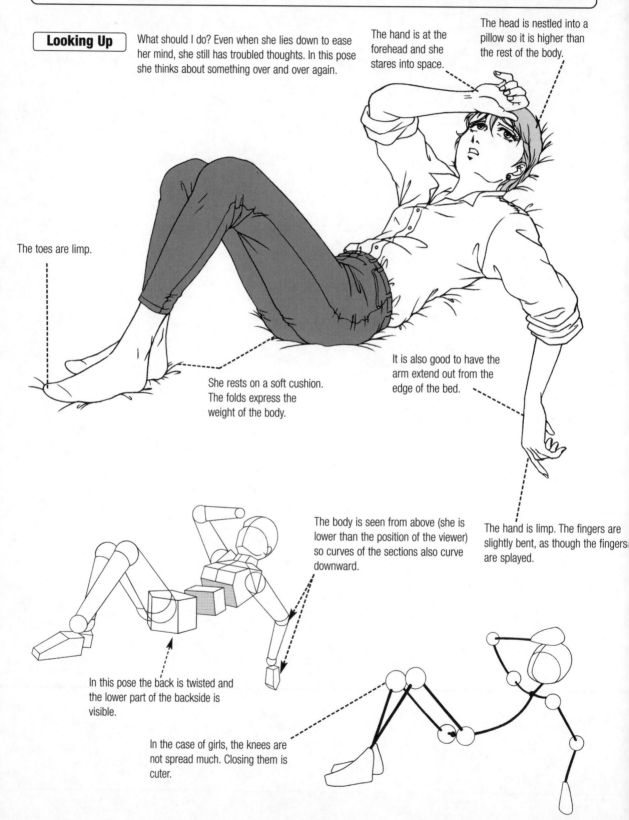

The toes are limp.

She rests on a soft cushion. The folds express the weight of the body.

It is also good to have the arm extend out from the edge of the bed.

The body is seen from above (she is lower than the position of the viewer) so curves of the sections also curve downward.

The hand is limp. The fingers are slightly bent, as though the fingers are splayed.

In this pose the back is twisted and the lower part of the backside is visible.

In the case of girls, the knees are not spread much. Closing them is cuter.

The hips are perpendicular to the surface the body is on. This angle emphasizes that this part is the most bowed.

A pose where the hands are at play.

The head and the chest point up. In this pose, the body is twisted from below the hips, where it begins to rest on its side.

The bowed hips (pelvis) and the pinched part of the hips emphasize her womanliness.

It's good not to clearly define the border between the neck and chin.

The folds of the thigh and the chest. They have the same curves as the wooden figure.

This gesture strongly emphasizes his emotion.

You can show his manliness by drawing the Adam's apple clearly.

Viewed from the Front at a Higher Angle

In contrast to the woman, the knees are spread wide open.

Strength is exerted all the way to the tip of his fingers, adding to express his misery.

The downward curved line expresses how vertical the leg is.

The knee is completely visible. With this size, you can show how the knee extends straight out.

Variations of Lying Down

Head on the Lap This pose of relaxation can be used when drawing a boyfriend or a small child resting their head on her lap.

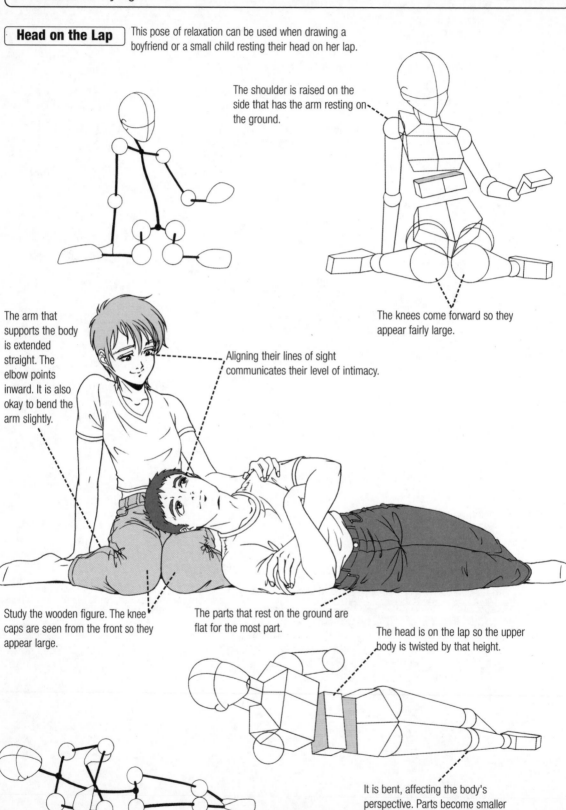

The shoulder is raised on the side that has the arm resting on the ground.

The knees come forward so they appear fairly large.

The arm that supports the body is extended straight. The elbow points inward. It is also okay to bend the arm slightly.

Aligning their lines of sight communicates their level of intimacy.

Study the wooden figure. The knee caps are seen from the front so they appear large.

The parts that rest on the ground are flat for the most part.

The head is on the lap so the upper body is twisted by that height.

It is bent, affecting the body's perspective. Parts become smaller toward the toes.

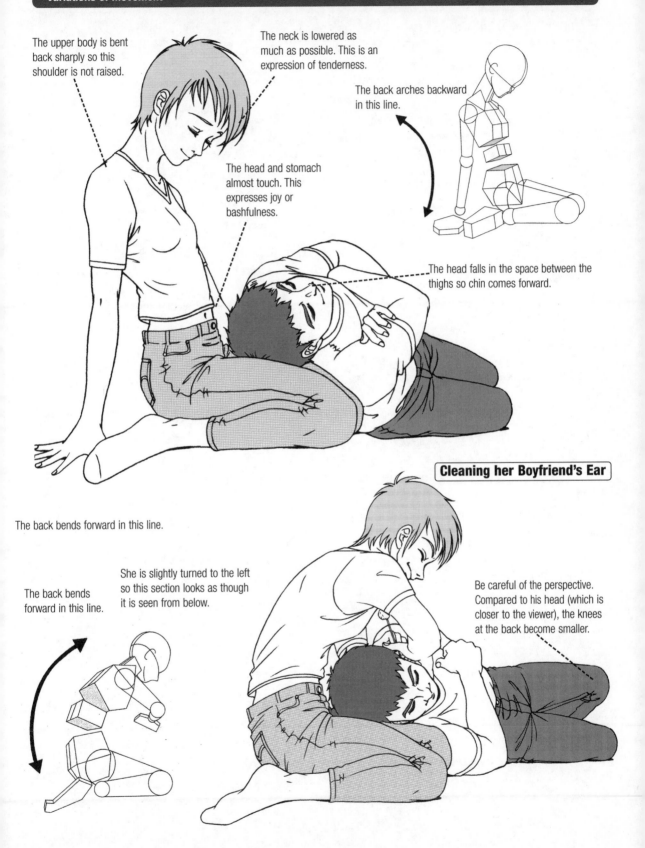

The upper body is bent back sharply so this shoulder is not raised.

The neck is lowered as much as possible. This is an expression of tenderness.

The back arches backward in this line.

The head and stomach almost touch. This expresses joy or bashfulness.

The head falls in the space between the thighs so chin comes forward.

Cleaning her Boyfriend's Ear

The back bends forward in this line.

The back bends forward in this line.

She is slightly turned to the left so this section looks as though it is seen from below.

Be careful of the perspective. Compared to his head (which is closer to the viewer), the knees at the back become smaller.

Variations of Lying Down

Happy This pose is used when someone is relaxing and enjoying himself. With a little exaggeration, his comfort can be expressed.

It's best to draw the bones and muscle of a boy rugged.

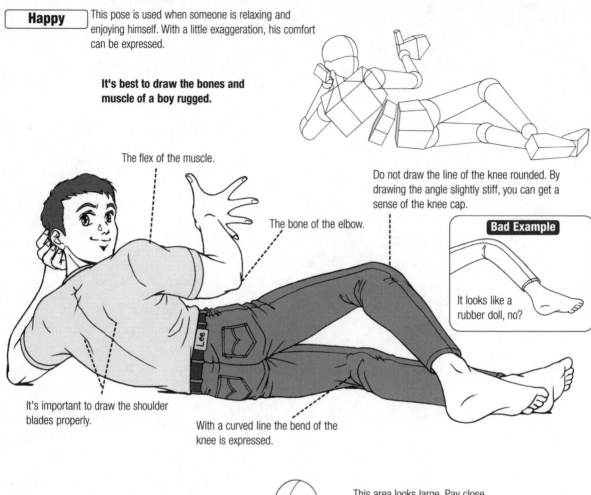

The flex of the muscle.

The bone of the elbow.

Do not draw the line of the knee rounded. By drawing the angle slightly stiff, you can get a sense of the knee cap.

Bad Example

It looks like a rubber doll, no?

It's important to draw the shoulder blades properly.

With a curved line the bend of the knee is expressed.

This area looks large. Pay close attention to the neckline of the T-shirt.

Even though this is a boy, the pinch of the waist is drawn.

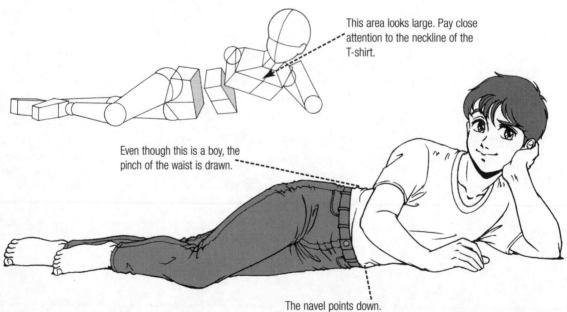

The navel points down.

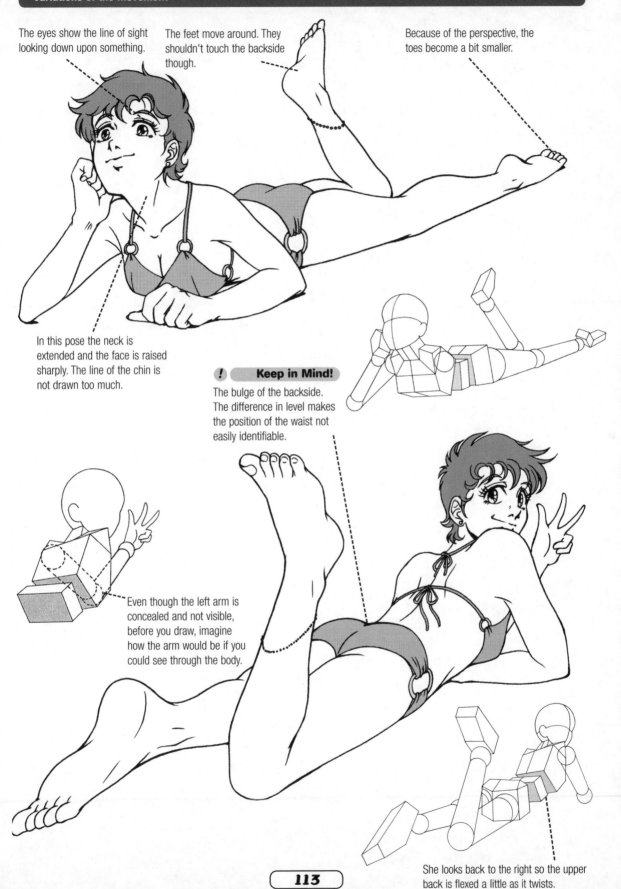

The eyes show the line of sight looking down upon something.

The feet move around. They shouldn't touch the backside though.

Because of the perspective, the toes become a bit smaller.

In this pose the neck is extended and the face is raised sharply. The line of the chin is not drawn too much.

! Keep in Mind!

The bulge of the backside. The difference in level makes the position of the waist not easily identifiable.

Even though the left arm is concealed and not visible, before you draw, imagine how the arm would be if you could see through the body.

She looks back to the right so the upper back is flexed a little as it twists.

Variations of Lying Down

Hugging Pillow For some reason the character is calm when hugging the pillow. In this pose, the body is limp.

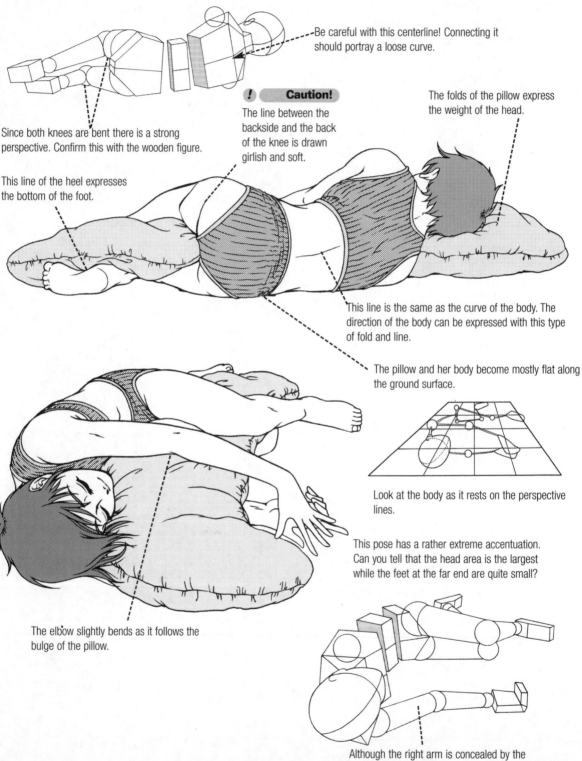

Be careful with this centerline! Connecting it should portray a loose curve.

Since both knees are bent there is a strong perspective. Confirm this with the wooden figure.

This line of the heel expresses the bottom of the foot.

! Caution!

The line between the backside and the back of the knee is drawn girlish and soft.

The folds of the pillow express the weight of the head.

This line is the same as the curve of the body. The direction of the body can be expressed with this type of fold and line.

The pillow and her body become mostly flat along the ground surface.

Look at the body as it rests on the perspective lines.

This pose has a rather extreme accentuation. Can you tell that the head area is the largest while the feet at the far end are quite small?

The elbow slightly bends as it follows the bulge of the pillow.

Although the right arm is concealed by the pillow and is not visible, during a rough sketch, make sure you draw the shoulder and elbow by imagining their position.

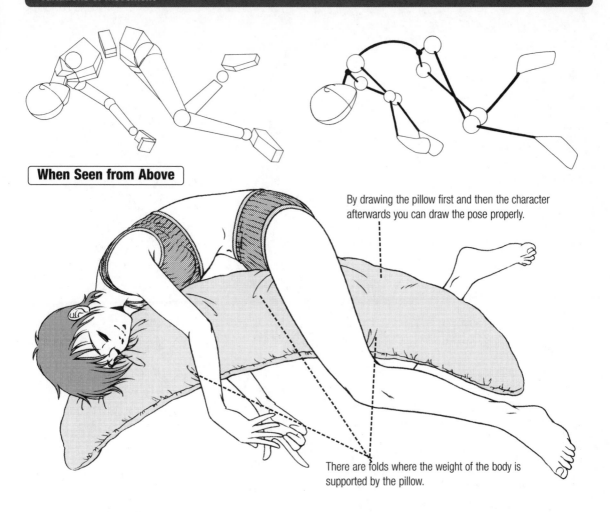

When Seen from Above

By drawing the pillow first and then the character afterwards you can draw the pose properly.

There are folds where the weight of the body is supported by the pillow.

When Seen from the Side

Since the thigh is being pushed up by the pillow, draw it on the thicker side.

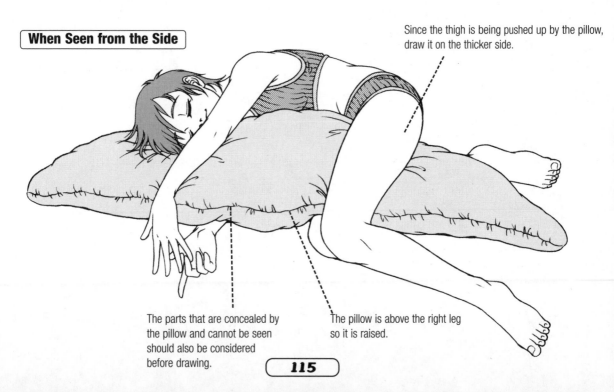

The parts that are concealed by the pillow and cannot be seen should also be considered before drawing.

The pillow is above the right leg so it is raised.

Variations of Lying Down

Waking Up

When drawing someone trying to get up, it is important to emphasize the part that exerts force.

A View from Behind the Clock

This pose is shot at a low angle which is effective for accentuating the ringing of the alarm clock.

Use the appropriate composition to show the ringing of the alarm clock.

The figure is on its stomach, at an angle, close to facing forward. The back is not visible for the most part. Over the shoulders you can see that only the hips are making motions to get up.

The part that touches the ground is mostly flat.

Oh, no!

The alarm clock is grasped firmly with both hands. It is girlish and childlike at the same time.

The eyes are fixed on something up close so the pupils draw close to each other.

Surprised, she is bent back and the hips lift slightly up.

 Key

This fold is at the joint of the leg. The curve is drawn the way the leg attaches on the wooden figure.

Be aware of the knee cap.

The upper body is lying on its stomach while the face and the body from below the hips is on its side. The pose has twists and turns but it has the suppleness of a human form and expresses presence. It is a difficult pose but challenge yourself!

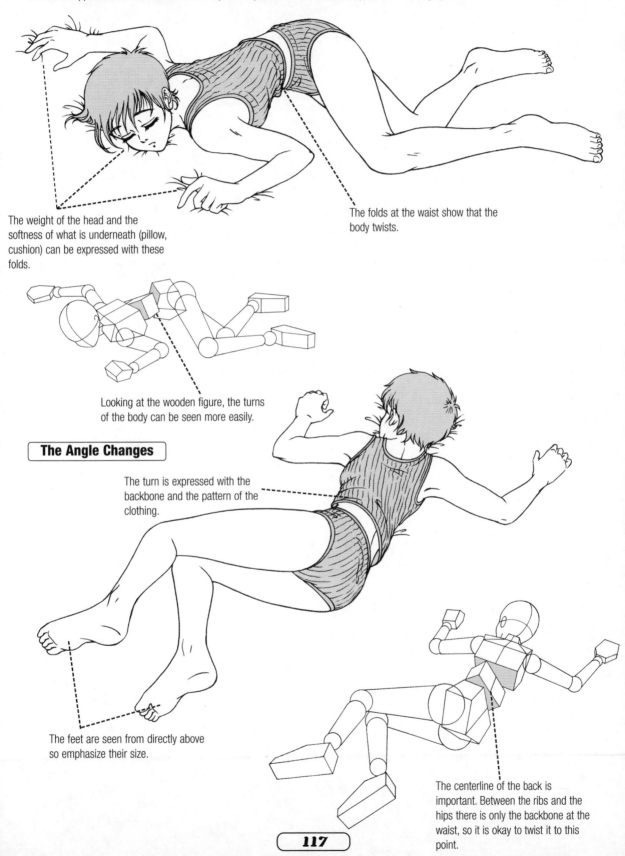

The weight of the head and the softness of what is underneath (pillow, cushion) can be expressed with these folds.

The folds at the waist show that the body twists.

Looking at the wooden figure, the turns of the body can be seen more easily.

The Angle Changes

The turn is expressed with the backbone and the pattern of the clothing.

The feet are seen from directly above so emphasize their size.

The centerline of the back is important. Between the ribs and the hips there is only the backbone at the waist, so it is okay to twist it to this point.

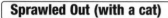

Variations of Lying Down

Sprawled Out (with a cat)

In this pose she is lying down and relaxing. You can use this pose in a scene with her lover by changing the direction of the face.

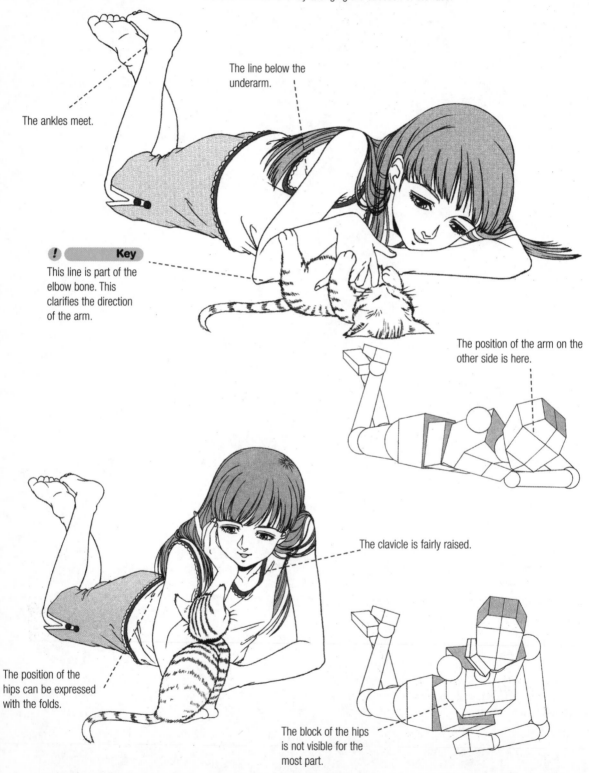

The ankles meet.

The line below the underarm.

! Key

This line is part of the elbow bone. This clarifies the direction of the arm.

The position of the arm on the other side is here.

The clavicle is fairly raised.

The position of the hips can be expressed with the folds.

The block of the hips is not visible for the most part.

Check how much of the shoulder is visible.

Following this line, folds can be drawn.

The crown of the head shows the direction of the face.

Folds made by constriction can be added here.

The folds follow the form of the thigh.

Don't forget the line beneath the underarm.

The belt is between the blocks of the hips and the stomach.

The upper body is supported by the elbows so the shoulders are raised.

It stands straight so there is no special perspective for the most part.

Following his line, folds can be made.

Drawing in the bones makes him boyish.

Variations of Walking

Yawning

The illustrations below reflect the momentary action she takes as she unexpectedly bumps into someone she knows during her relaxed, leisurely walk.

Tips
1. Keep the arms and legs pressed tightly against the body and the drawing will become still and quiet.
2. The center of gravity is straight down.
3. When the arms or feet are lifted, they are also straight.
4. Slightly accent the straight lines.

The shoulders are slightly raised deliberately.

Compare the spread of the fingers to when she is in a relaxed pose.

The neck is concealed.

The shoulders are not lowered.

Oh!

She is surprised to run into someone she knows. This is a variation of a "Tense" pose.

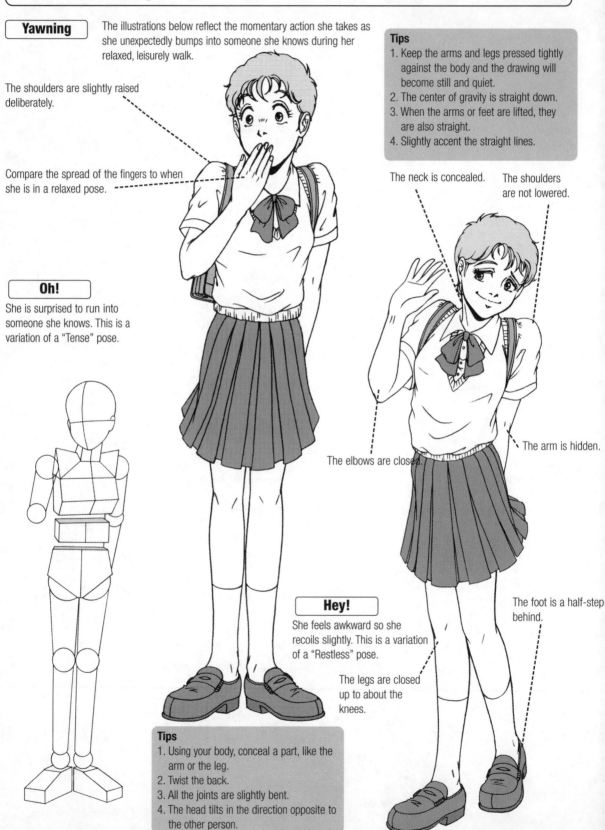

The elbows are closed.

The arm is hidden.

Hey!

She feels awkward so she recoils slightly. This is a variation of a "Restless" pose.

The legs are closed up to about the knees.

The foot is a half-step behind.

Tips
1. Using your body, conceal a part, like the arm or the leg.
2. Twist the back.
3. All the joints are slightly bent.
4. The head tilts in the direction opposite to the other person.

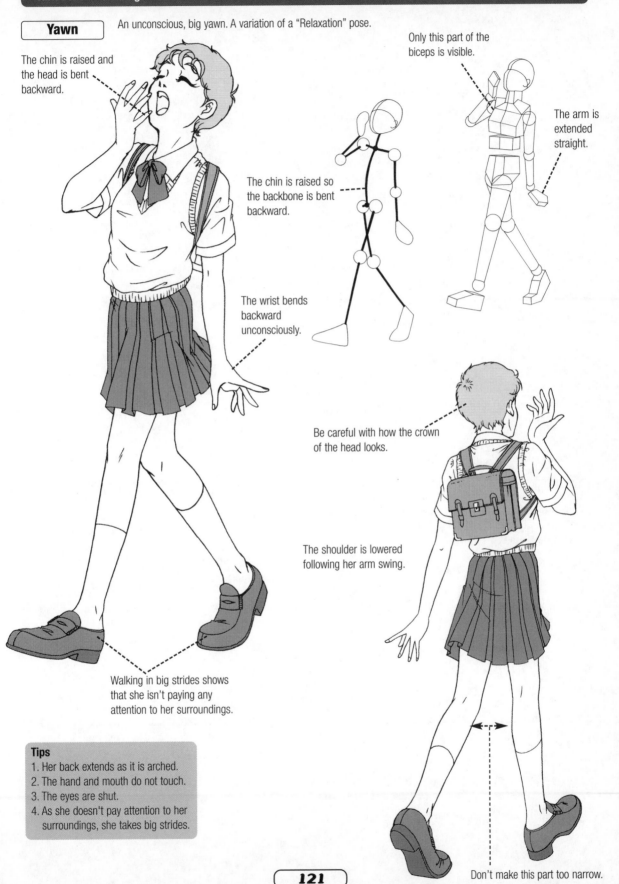

Yawn An unconscious, big yawn. A variation of a "Relaxation" pose.

The chin is raised and the head is bent backward.

Only this part of the biceps is visible.

The arm is extended straight.

The chin is raised so the backbone is bent backward.

The wrist bends backward unconsciously.

Be careful with how the crown of the head looks.

The shoulder is lowered following her arm swing.

Walking in big strides shows that she isn't paying any attention to her surroundings.

Tips
1. Her back extends as it is arched.
2. The hand and mouth do not touch.
3. The eyes are shut.
4. As she doesn't pay attention to her surroundings, she takes big strides.

Don't make this part too narrow.

Variations of Walking

Poses with a Cell Phone

Unlike with standard phones, there is usually something else being done while one uses a cell phone. Since the attention is split between the phone and whatever else is being done at the moment, be careful how you depict this.

I got cut off.

The head is tilted forward so the neck is concealed.

The dropped shoulders give a feeling of depression.

The elbow is lowered.

The arm goes limp and rests against the body.

It's not going through.

The eyes point up and look into the distance.

The head is down as though it touches the ear.

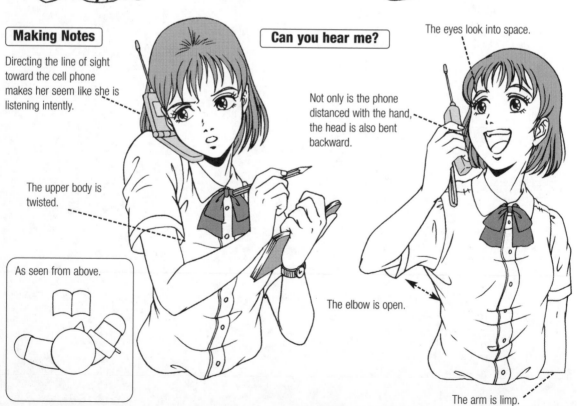

Making Notes

Directing the line of sight toward the cell phone makes her seem like she is listening intently.

The upper body is twisted.

As seen from above.

Can you hear me?

The eyes look into space.

Not only is the phone distanced with the hand, the head is also bent backward.

The elbow is open.

The arm is limp.

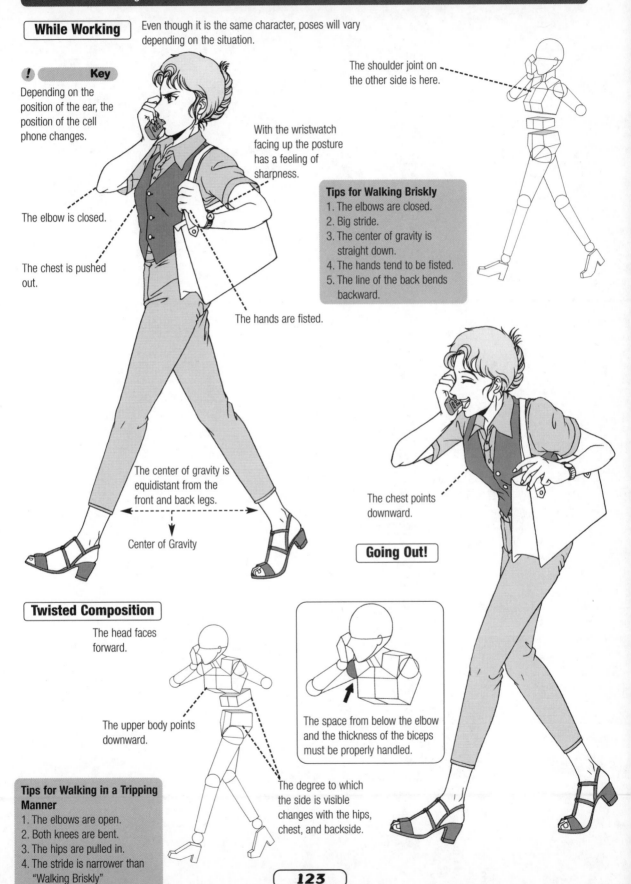

While Working

Even though it is the same character, poses will vary depending on the situation.

! Key

Depending on the position of the ear, the position of the cell phone changes.

The elbow is closed.

The chest is pushed out.

With the wristwatch facing up the posture has a feeling of sharpness.

The shoulder joint on the other side is here.

Tips for Walking Briskly
1. The elbows are closed.
2. Big stride.
3. The center of gravity is straight down.
4. The hands tend to be fisted.
5. The line of the back bends backward.

The hands are fisted.

The center of gravity is equidistant from the front and back legs.

Center of Gravity

The chest points downward.

Going Out!

Twisted Composition

The head faces forward.

The upper body points downward.

The space from below the elbow and the thickness of the biceps must be properly handled.

The degree to which the side is visible changes with the hips, chest, and backside.

Tips for Walking in a Tripping Manner
1. The elbows are open.
2. Both knees are bent.
3. The hips are pulled in.
4. The stride is narrower than "Walking Briskly"
5. The backbone is bent.

Variations of Walking

Lost

She is holding a map looking around. In her lost pose, she wonders, "Is this it?"

! Key

The directions of the hand holding the note, the body, and the face are all different.

This hand is outside the silhouette of the body.

She checks the map again as the note is brought close to the face.

Tilting forward, the head comes before the shoulders and the neck is not visible for the most part.

An important point to an upward-pointed chest: The line at the top of the chest is the thinnest within the outline.

Making the hands and feet move about with unease is also important.

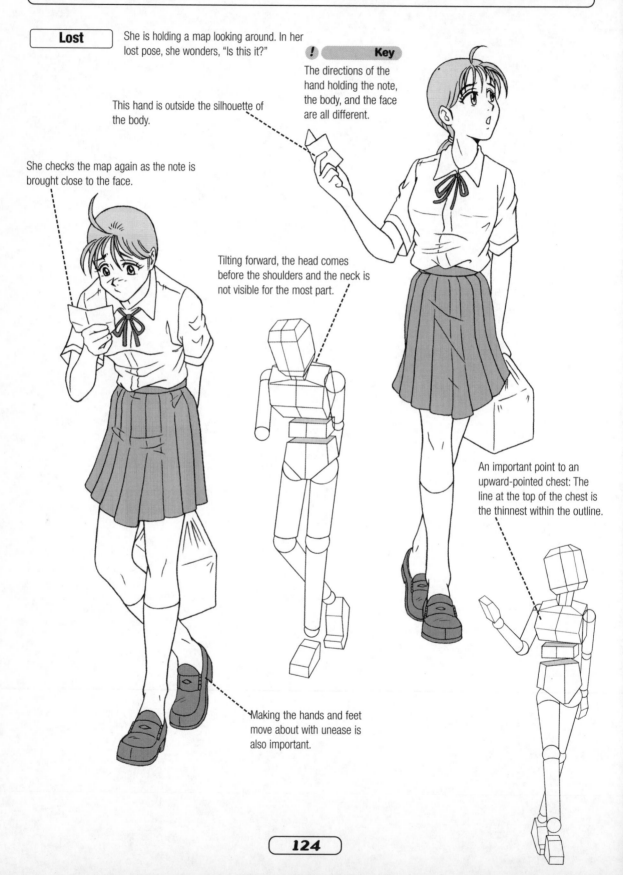

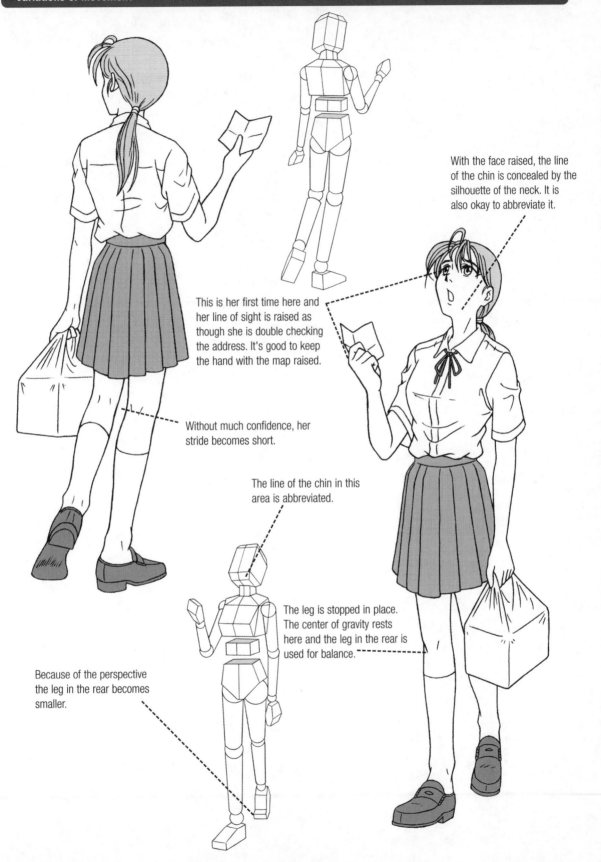

With the face raised, the line of the chin is concealed by the silhouette of the neck. It is also okay to abbreviate it.

This is her first time here and her line of sight is raised as though she is double checking the address. It's good to keep the hand with the map raised.

Without much confidence, her stride becomes short.

The line of the chin in this area is abbreviated.

The leg is stopped in place. The center of gravity rests here and the leg in the rear is used for balance.

Because of the perspective the leg in the rear becomes smaller.

Variations of Walking

Looking for Something

A person wouldn't normally be tilted forward like this. The line of sight is continually on the floor.

Small gestures such as tucking the hair back and wrapping the hand behind herself, play surprisingly important roles.

! Caution!

This act is of one looking for something that has fallen on the floor. Changing the direction of the body and the face is important. The body is bent forward, making the line of sight drop down.

This line shows the highest part of the chest. At this angle the lower part of the chest is barely visible.

To show the forward stoop there are folds. They follow the form of the stomach.

Drawing the hair between the fingers enhances the reality of her tucking her hair.

Don't forget to round this part of the backbone.

The steps are small, giving the feeling of walking slowly. Walking with the toes turned in adds a girlish quality.

Consider the position of the shoulder on the other side. Don't make a mistake with the length of the arm.

The hand that is not used wraps to the back. This girlish fidgeting is a symbol of her cuteness.

The hand pushes back the hair that slips down. This is an effective means to bring out her exertion.

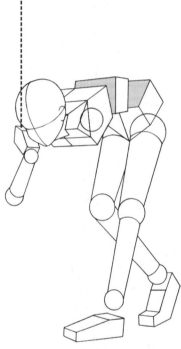

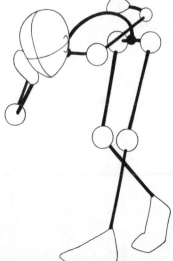

! **Key**

Tucking back the hair was introduced as a gesture of womanliness but do you follow what is happening with the hand's movement? By drawing such details properly, her womanliness can be brought about. Such poses are also effective to highlight the accessories worn by the character.

Variations of Walking

Heavy Bags He bought too much. The bags are heavy and have to be held with both hands. What's most important here is the correctly depicting the shifted center of gravity.

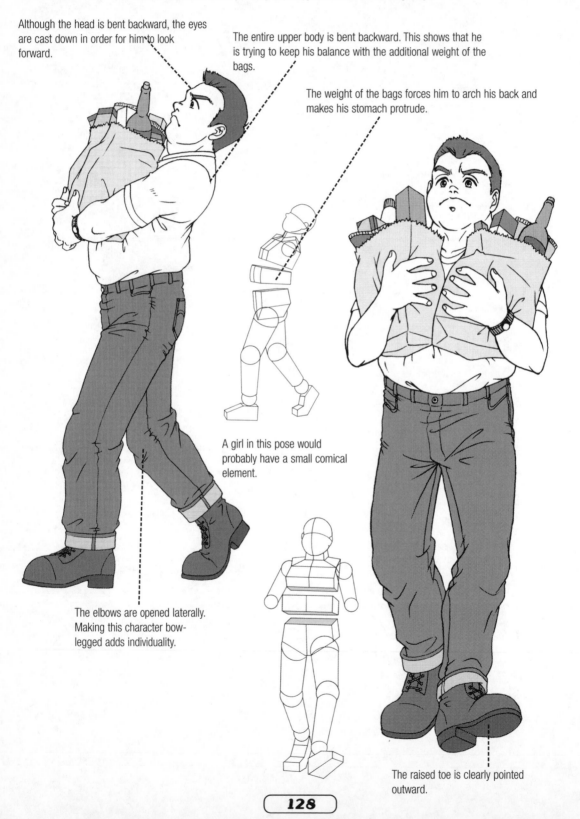

Although the head is bent backward, the eyes are cast down in order for him to look forward.

The entire upper body is bent backward. This shows that he is trying to keep his balance with the additional weight of the bags.

The weight of the bags forces him to arch his back and makes his stomach protrude.

A girl in this pose would probably have a small comical element.

The elbows are opened laterally. Making this character bow-legged adds individuality.

The raised toe is clearly pointed outward.

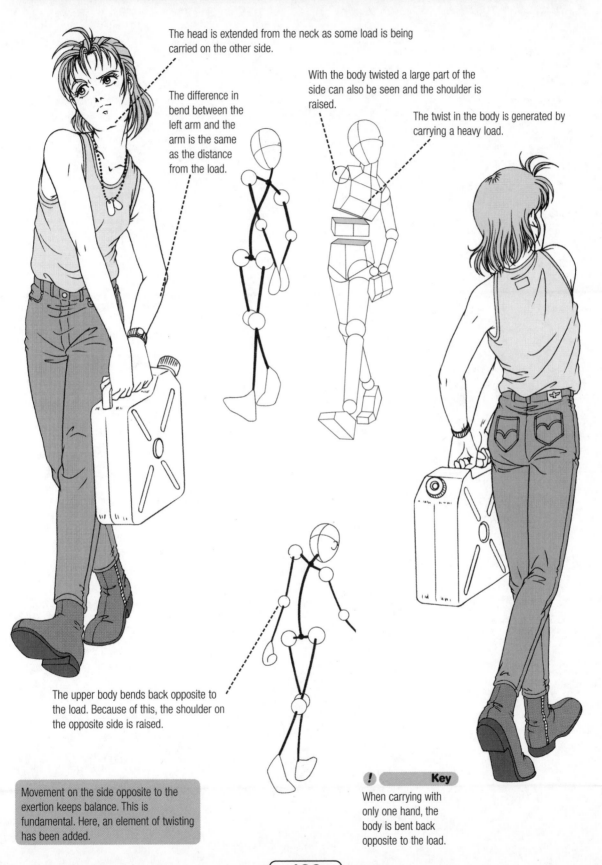

The head is extended from the neck as some load is being carried on the other side.

The difference in bend between the left arm and the arm is the same as the distance from the load.

With the body twisted a large part of the side can also be seen and the shoulder is raised.

The twist in the body is generated by carrying a heavy load.

The upper body bends back opposite to the load. Because of this, the shoulder on the opposite side is raised.

Movement on the side opposite to the exertion keeps balance. This is fundamental. Here, an element of twisting has been added.

! **Key**

When carrying with only one hand, the body is bent back opposite to the load.

Variations of Walking

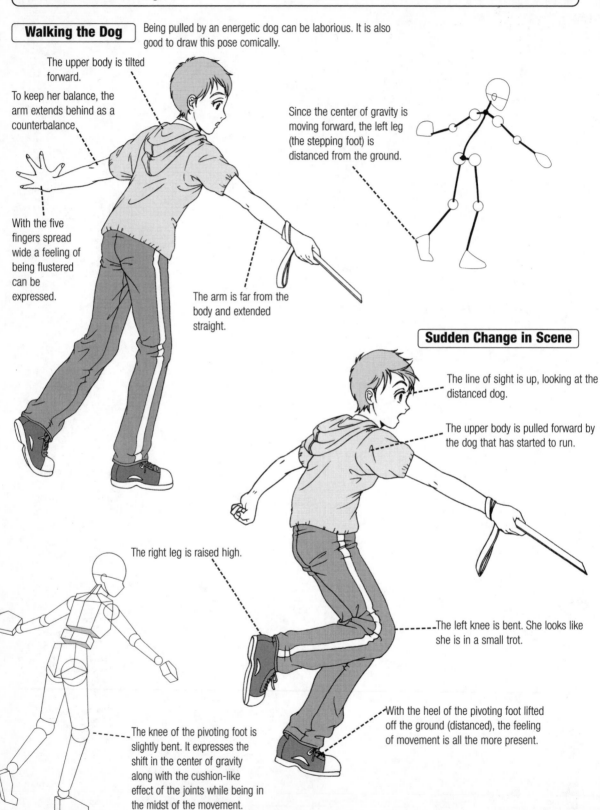

Walking the Dog

Being pulled by an energetic dog can be laborious. It is also good to draw this pose comically.

The upper body is tilted forward.

To keep her balance, the arm extends behind as a counterbalance.

Since the center of gravity is moving forward, the left leg (the stepping foot) is distanced from the ground.

With the five fingers spread wide a feeling of being flustered can be expressed.

The arm is far from the body and extended straight.

Sudden Change in Scene

The line of sight is up, looking at the distanced dog.

The upper body is pulled forward by the dog that has started to run.

The right leg is raised high.

The left knee is bent. She looks like she is in a small trot.

With the heel of the pivoting foot lifted off the ground (distanced), the feeling of movement is all the more present.

The knee of the pivoting foot is slightly bent. It expresses the shift in the center of gravity along with the cushion-like effect of the joints while being in the midst of the movement.

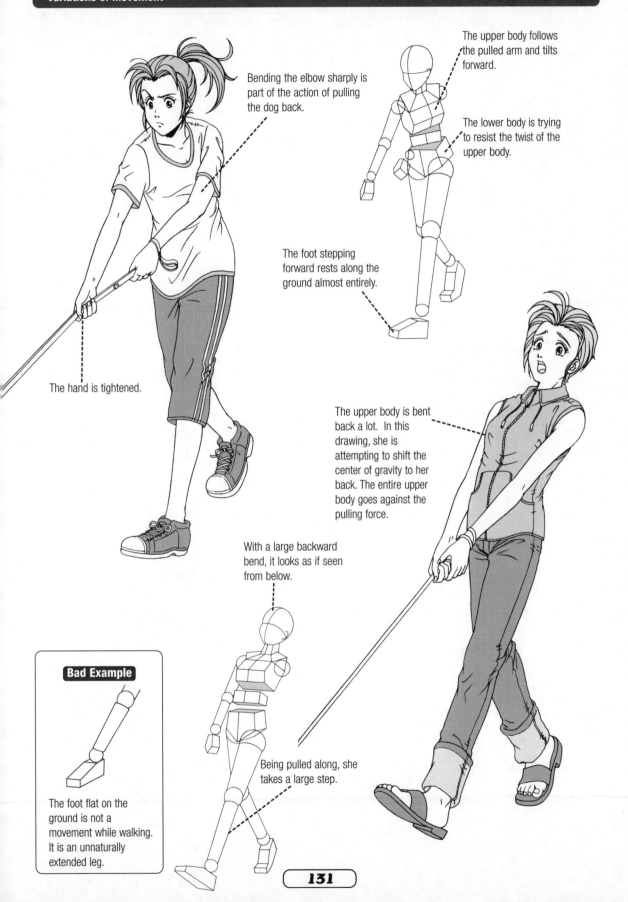

The upper body follows the pulled arm and tilts forward.

Bending the elbow sharply is part of the action of pulling the dog back.

The lower body is trying to resist the twist of the upper body.

The foot stepping forward rests along the ground almost entirely.

The hand is tightened.

The upper body is bent back a lot. In this drawing, she is attempting to shift the center of gravity to her back. The entire upper body goes against the pulling force.

With a large backward bend, it looks as if seen from below.

Bad Example

Being pulled along, she takes a large step.

The foot flat on the ground is not a movement while walking. It is an unnaturally extended leg.

Variations of Walking

Rainy Day　Sudden rain. Having fun in the rain during a typhoon. Use items like an umbrella to maximum effect.

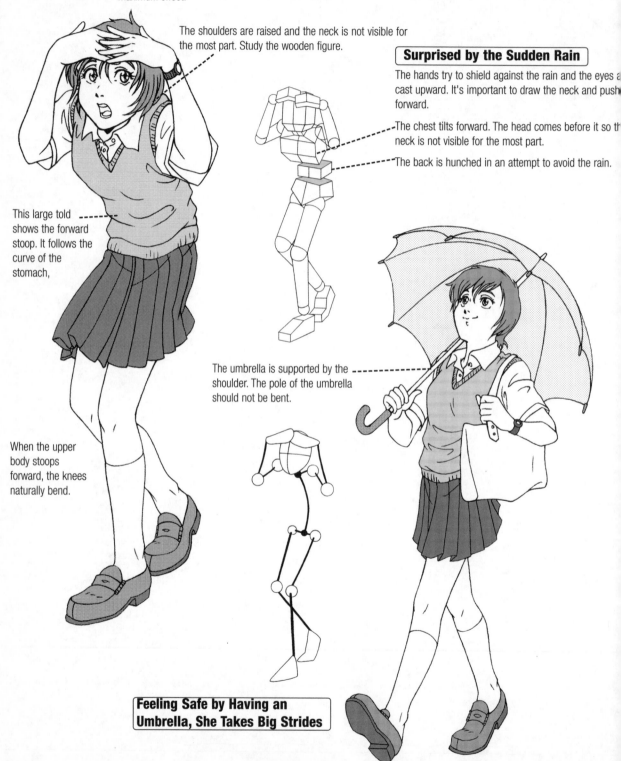

The shoulders are raised and the neck is not visible for the most part. Study the wooden figure.

Surprised by the Sudden Rain

The hands try to shield against the rain and the eyes a cast upward. It's important to draw the neck and push forward.

The chest tilts forward. The head comes before it so th neck is not visible for the most part.

The back is hunched in an attempt to avoid the rain.

This large told shows the forward stoop. It follows the curve of the stomach,

When the upper body stoops forward, the knees naturally bend.

The umbrella is supported by the shoulder. The pole of the umbrella should not be bent.

Feeling Safe by Having an Umbrella, She Takes Big Strides

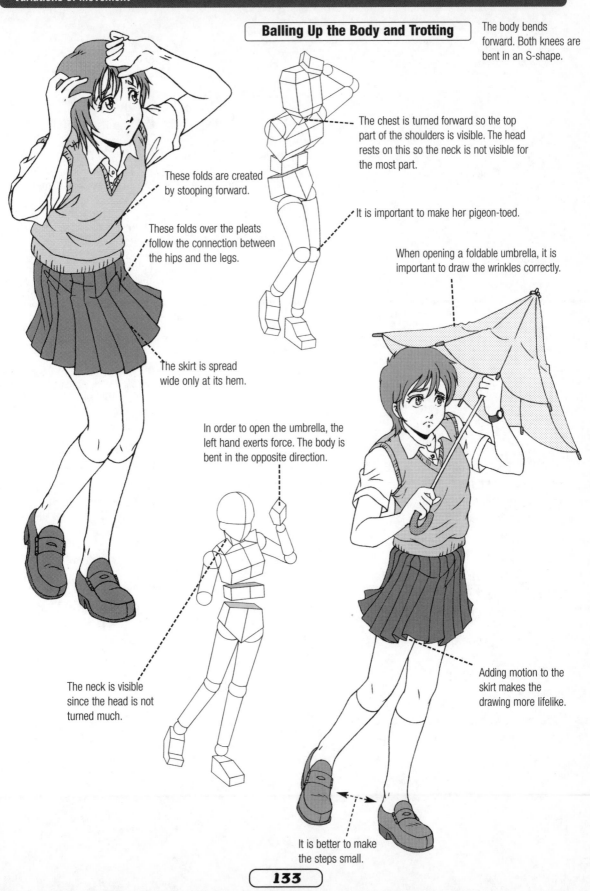

Balling Up the Body and Trotting

The body bends forward. Both knees are bent in an S-shape.

The chest is turned forward so the top part of the shoulders is visible. The head rests on this so the neck is not visible for the most part.

These folds are created by stooping forward.

It is important to make her pigeon-toed.

These folds over the pleats follow the connection between the hips and the legs.

When opening a foldable umbrella, it is important to draw the wrinkles correctly.

The skirt is spread wide only at its hem.

In order to open the umbrella, the left hand exerts force. The body is bent in the opposite direction.

The neck is visible since the head is not turned much.

Adding motion to the skirt makes the drawing more lifelike.

It is better to make the steps small.

Variations of Walking

Taking It Easy (Eating ice cream) Doing something while walking is effective not only for communicating the situation of the character but also for expressing the character's individuality.

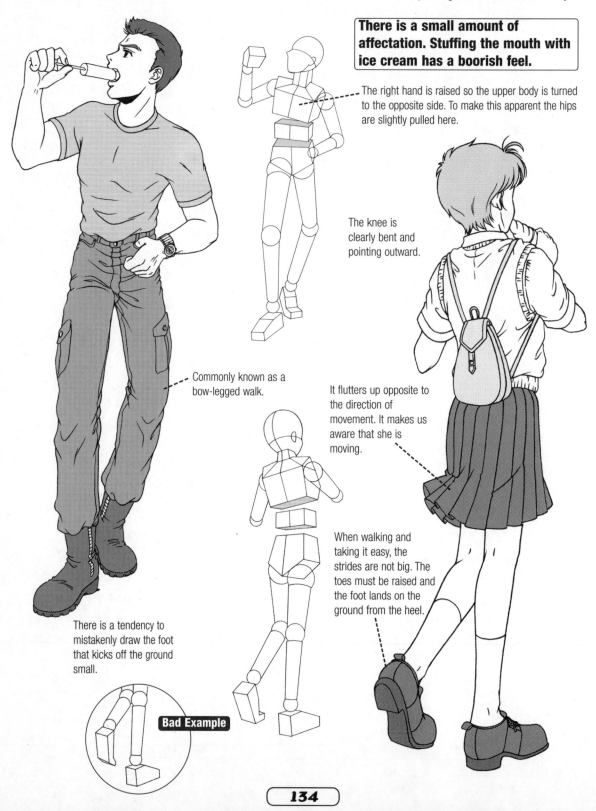

There is a small amount of affectation. Stuffing the mouth with ice cream has a boorish feel.

The right hand is raised so the upper body is turned to the opposite side. To make this apparent the hips are slightly pulled here.

The knee is clearly bent and pointing outward.

Commonly known as a bow-legged walk.

It flutters up opposite to the direction of movement. It makes us aware that she is moving.

When walking and taking it easy, the strides are not big. The toes must be raised and the foot lands on the ground from the heel.

There is a tendency to mistakenly draw the foot that kicks off the ground small.

Bad Example

The tongue sticks out to lick. Her girlishness is expressed at the same time as her childishness.

The line of sight indicates that she is thinking about something else rather than what she is eating.

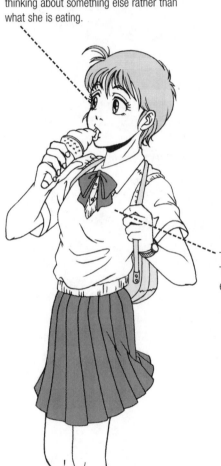

Overall, the body is turned to the left.

The way he eats ice cream is different from the girl as it is not made childish.

Except for the slight pose in this walk, the walk can be used for a wide range of different walks.

The upper body is slightly bent back. This emphasizes that the mind is elsewhere.

The upper body is slightly bent back.

This character has a cool atmosphere so don't make him bow-legged.

He is slightly posed as the right hand gestures.

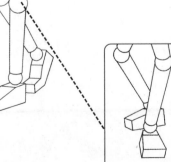

Bad Example

Be careful not to make a girl bow-legged.

135

Variations of Walking

Taking Care of a Girlfriend | He has no choice but to carry his passed out girlfriend on his back.

 Caution!

This is an embracing pose. He is carrying her on his back and the contact of the two bodies results in parts that cannot be seen. Using the wooden figure as reference, draw the parts that cannot been seen. This is the first step in improving your drawing.

The folds of the chest and the curve of the belt are the same as on the wooden figure.

The line of sight is toward her. It expresses his tenderness.

The forward tilt increases in proportion with the weight on the back.

First draw the two separately and confirm the position of the shoulder on this side.

Carrying just one high-heeled shoe has the sense of a story.

The joint of the thigh is like this.

In order to walk quietly and slowly, his stride is small.

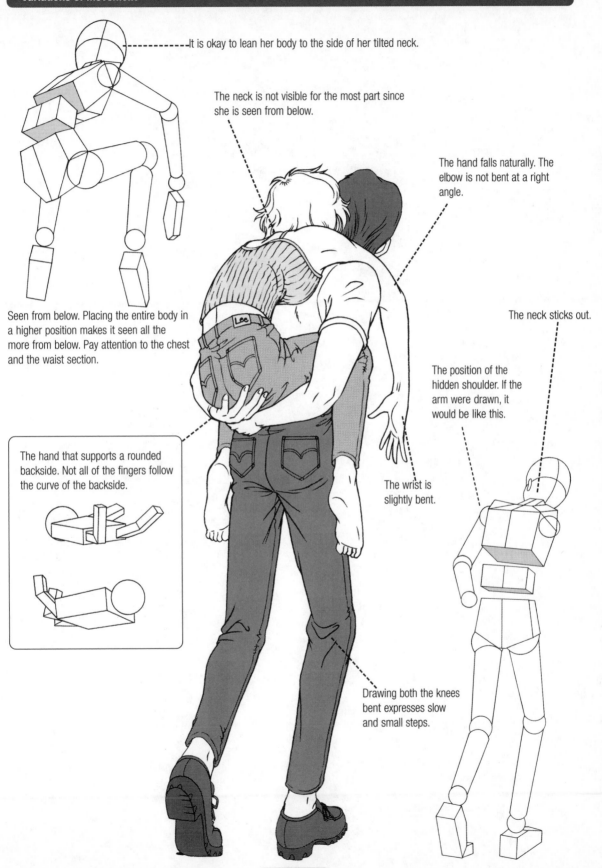

It is okay to lean her body to the side of her tilted neck.

The neck is not visible for the most part since she is seen from below.

The hand falls naturally. The elbow is not bent at a right angle.

The neck sticks out.

Seen from below. Placing the entire body in a higher position makes it seen all the more from below. Pay attention to the chest and the waist section.

The position of the hidden shoulder. If the arm were drawn, it would be like this.

The hand that supports a rounded backside. Not all of the fingers follow the curve of the backside.

The wrist is slightly bent.

Drawing both the knees bent expresses slow and small steps.

137

Variations of Running

Bye! He says "See ya!" while running. He is waving to his friend behind him.

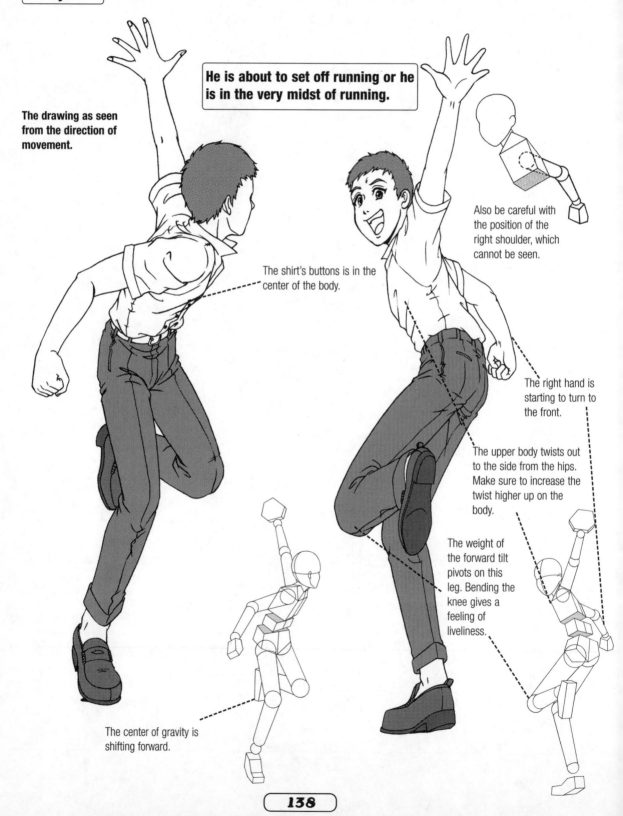

He is about to set off running or he is in the very midst of running.

The drawing as seen from the direction of movement.

Also be careful with the position of the right shoulder, which cannot be seen.

The shirt's buttons is in the center of the body.

The right hand is starting to turn to the front.

The upper body twists out to the side from the hips. Make sure to increase the twist higher up on the body.

The weight of the forward tilt pivots on this leg. Bending the knee gives a feeling of liveliness.

The center of gravity is shifting forward.

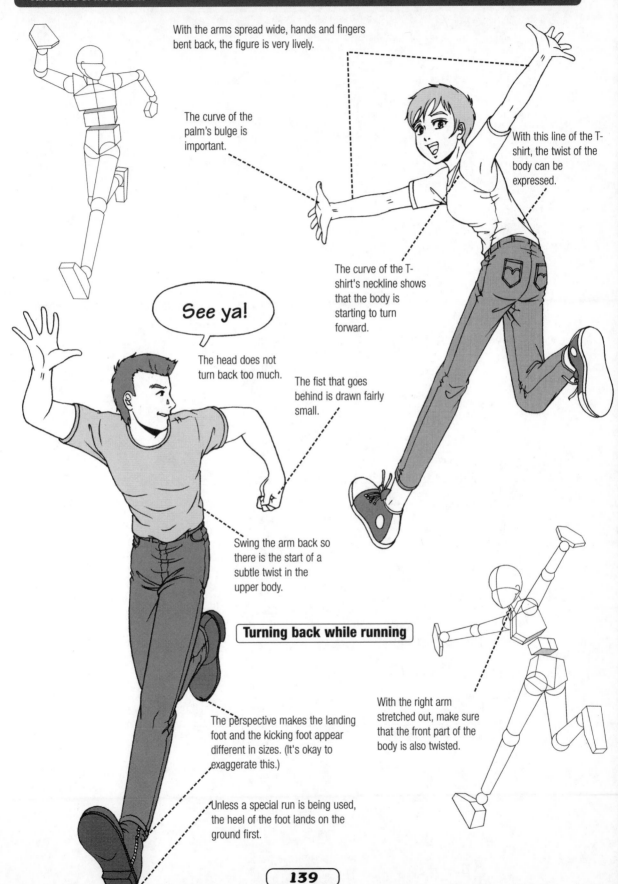

With the arms spread wide, hands and fingers bent back, the figure is very lively.

The curve of the palm's bulge is important.

With this line of the T-shirt, the twist of the body can be expressed.

The curve of the T-shirt's neckline shows that the body is starting to turn forward.

See ya!

The head does not turn back too much.

The fist that goes behind is drawn fairly small.

Swing the arm back so there is the start of a subtle twist in the upper body.

Turning back while running

The perspective makes the landing foot and the kicking foot appear different in sizes. (It's okay to exaggerate this.)

Unless a special run is being used, the heel of the foot lands on the ground first.

With the right arm stretched out, make sure that the front part of the body is also twisted.

Variations of Running.

Forgotten Item | The act of rushing with irritation mixed in. The waitress is searching for the owner of the folder she has in her hands. Her confusion is expressed through her entire body.

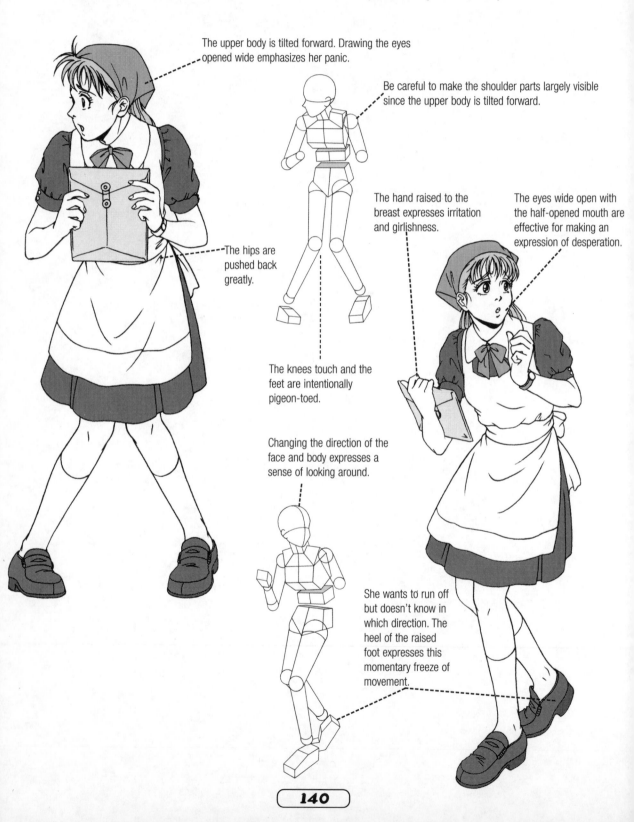

The upper body is tilted forward. Drawing the eyes opened wide emphasizes her panic.

Be careful to make the shoulder parts largely visible since the upper body is tilted forward.

The hand raised to the breast expresses irritation and girlishness.

The eyes wide open with the half-opened mouth are effective for making an expression of desperation.

The hips are pushed back greatly.

The knees touch and the feet are intentionally pigeon-toed.

Changing the direction of the face and body expresses a sense of looking around.

She wants to run off but doesn't know in which direction. The heel of the raised foot expresses this momentary freeze of movement.

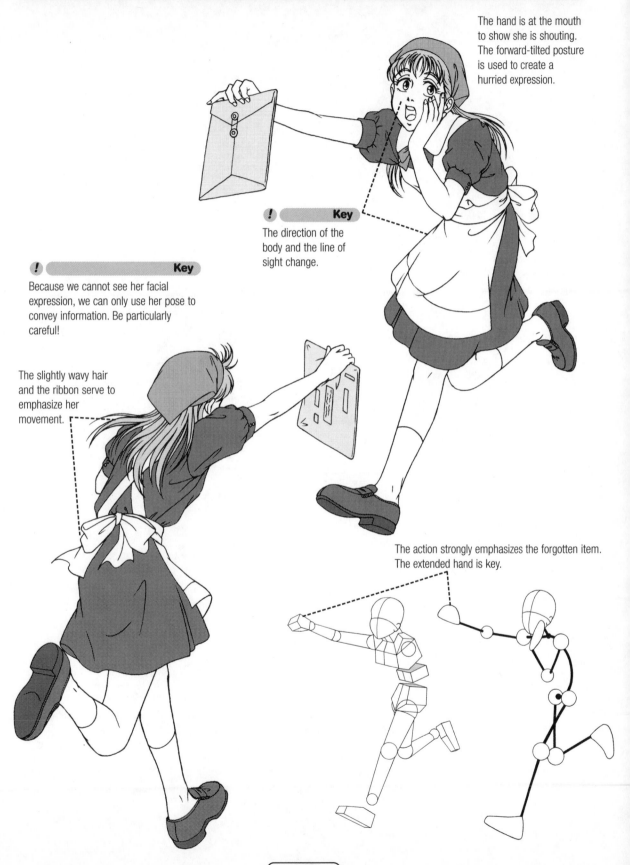

The hand is at the mouth to show she is shouting. The forward-tilted posture is used to create a hurried expression.

! **Key**

The direction of the body and the line of sight change.

! **Key**

Because we cannot see her facial expression, we can only use her pose to convey information. Be particularly careful!

The slightly wavy hair and the ribbon serve to emphasize her movement.

The action strongly emphasizes the forgotten item. The extended hand is key.

Variations of Running

Throwing on a Jacket

An action while doing something else. This pose will be fairly difficult if you have not already mastered drawing "Walking."

In this stance the wrists are bent up and both elbows are raised. He throws on his jacket in a flurry.

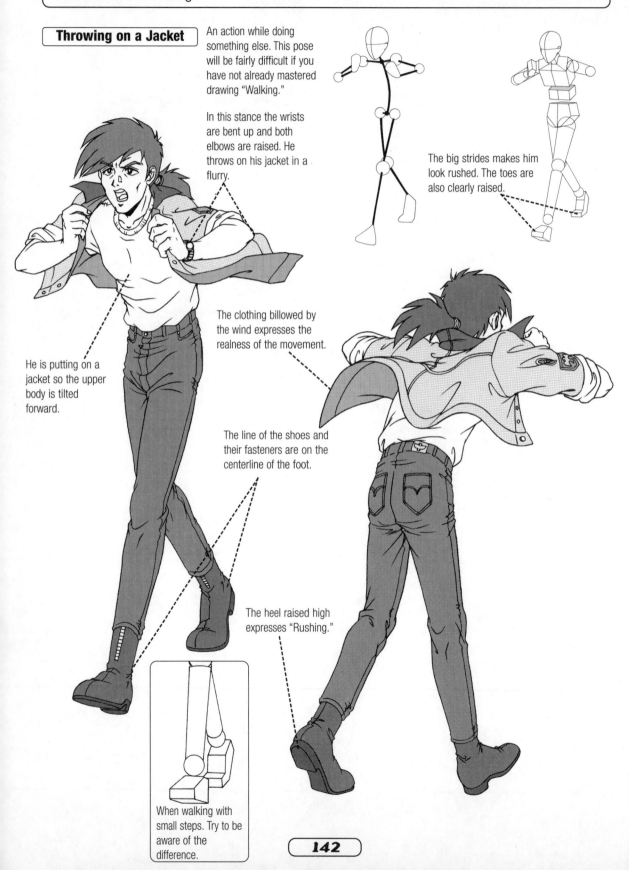

The big strides makes him look rushed. The toes are also clearly raised.

The clothing billowed by the wind expresses the realness of the movement.

He is putting on a jacket so the upper body is tilted forward.

The line of the shoes and their fasteners are on the centerline of the foot.

The heel raised high expresses "Rushing."

When walking with small steps. Try to be aware of the difference.

Take another look at the wooden figure and wire frame figure.

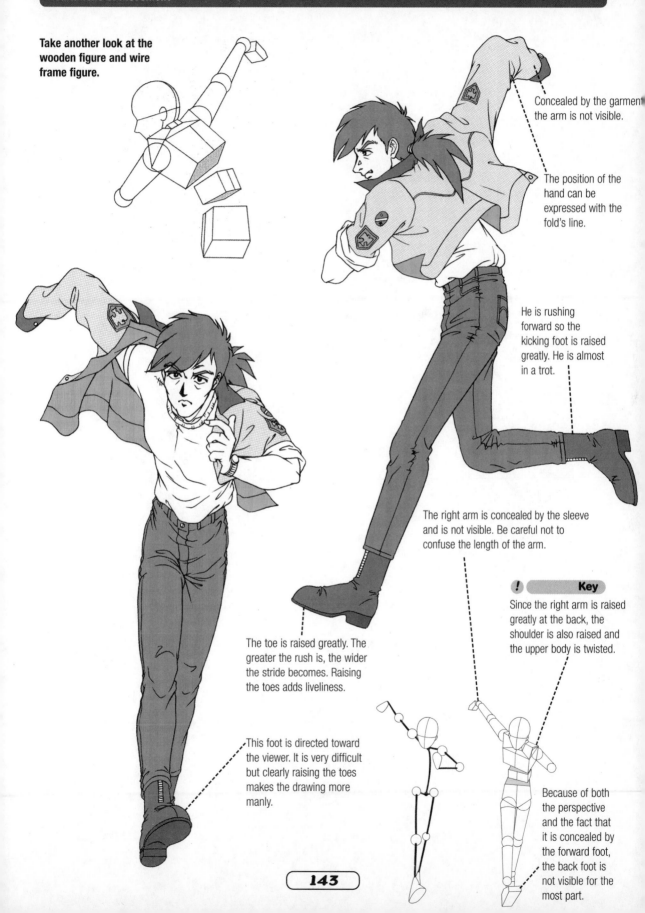

Concealed by the garment the arm is not visible.

The position of the hand can be expressed with the fold's line.

He is rushing forward so the kicking foot is raised greatly. He is almost in a trot.

The right arm is concealed by the sleeve and is not visible. Be careful not to confuse the length of the arm.

! **Key**

Since the right arm is raised greatly at the back, the shoulder is also raised and the upper body is twisted.

The toe is raised greatly. The greater the rush is, the wider the stride becomes. Raising the toes adds liveliness.

This foot is directed toward the viewer. It is very difficult but clearly raising the toes makes the drawing more manly.

Because of both the perspective and the fact that it is concealed by the forward foot, the back foot is not visible for the most part.

Variations of Running

I'm late! Here, attention is focused on one point as she runs. This is subtly different from the usual Rushing."

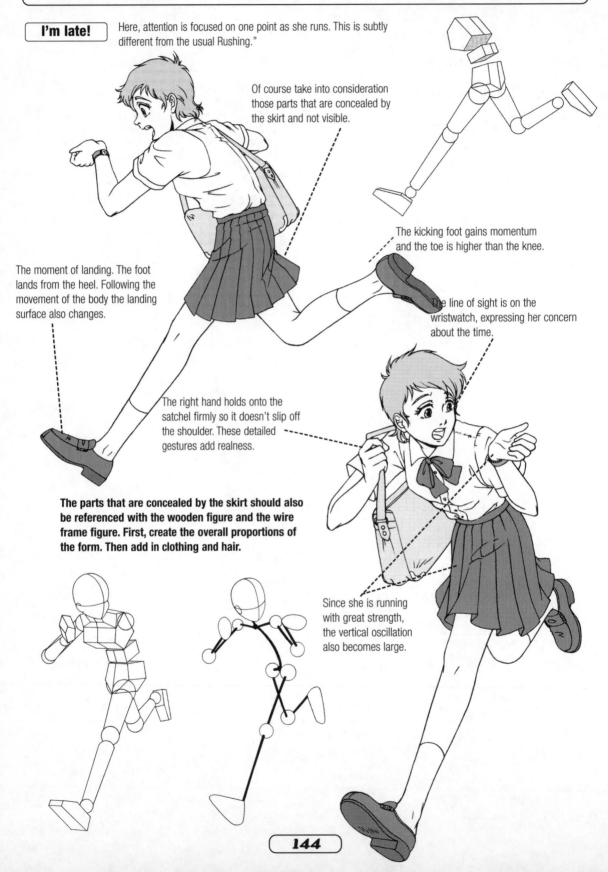

Of course take into consideration those parts that are concealed by the skirt and not visible.

The kicking foot gains momentum and the toe is higher than the knee.

The moment of landing. The foot lands from the heel. Following the movement of the body the landing surface also changes.

The line of sight is on the wristwatch, expressing her concern about the time.

The right hand holds onto the satchel firmly so it doesn't slip off the shoulder. These detailed gestures add realness.

The parts that are concealed by the skirt should also be referenced with the wooden figure and the wire frame figure. First, create the overall proportions of the form. Then add in clothing and hair.

Since she is running with great strength, the vertical oscillation also becomes large.

Running Afar

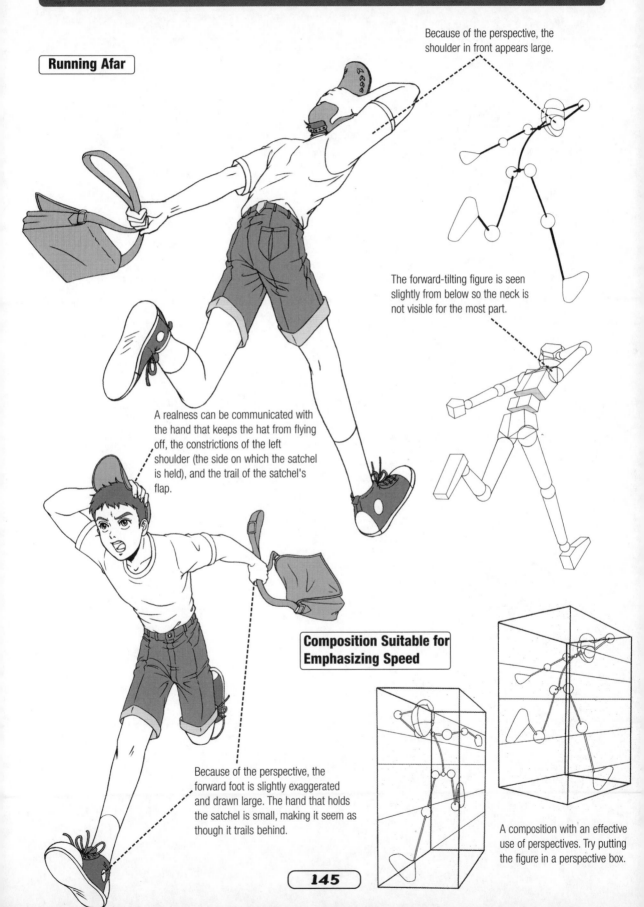

Because of the perspective, the shoulder in front appears large.

The forward-tilting figure is seen slightly from below so the neck is not visible for the most part.

A realness can be communicated with the hand that keeps the hat from flying off, the constrictions of the left shoulder (the side on which the satchel is held), and the trail of the satchel's flap.

Composition Suitable for Emphasizing Speed

Because of the perspective, the forward foot is slightly exaggerated and drawn large. The hand that holds the satchel is small, making it seem as though it trails behind.

A composition with an effective use of perspectives. Try putting the figure in a perspective box.

Variations of Running

Escaping Together

They are wrapped up in some bad event. "Let's get out of here quick!" The tense hands and feet are key.

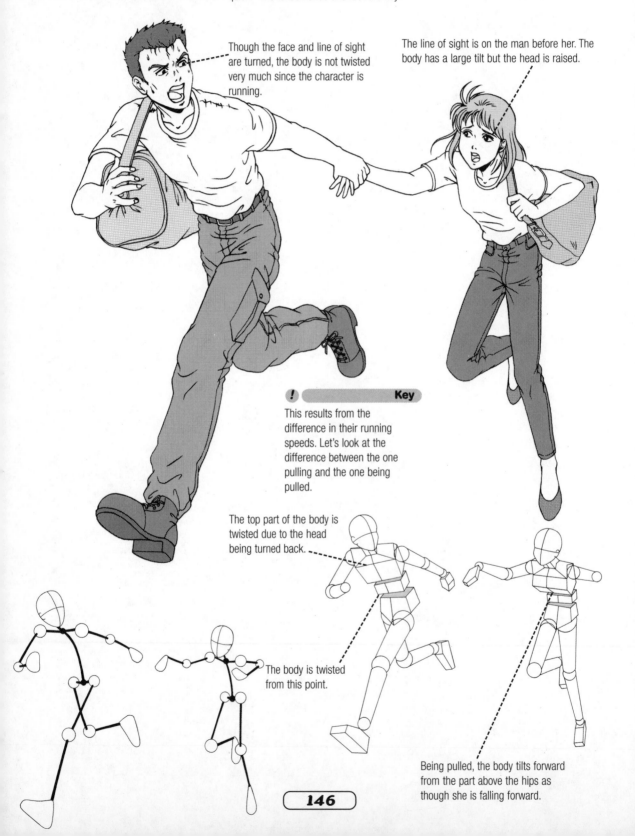

Though the face and line of sight are turned, the body is not twisted very much since the character is running.

The line of sight is on the man before her. The body has a large tilt but the head is raised.

! Key

This results from the difference in their running speeds. Let's look at the difference between the one pulling and the one being pulled.

The top part of the body is twisted due to the head being turned back.

The body is twisted from this point.

Being pulled, the body tilts forward from the part above the hips as though she is falling forward.

Though this is the same "Running" action, the key here is the use of a completely different timing. Here, drawing the girl who is being pulled with an unstable timing heightens the realness of the scene.

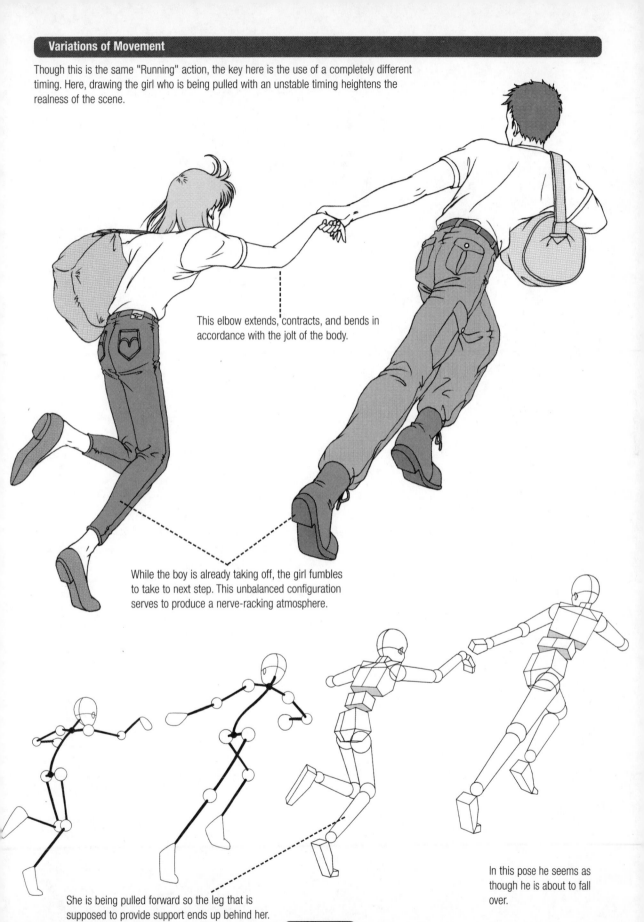

This elbow extends, contracts, and bends in accordance with the jolt of the body.

While the boy is already taking off, the girl fumbles to take to next step. This unbalanced configuration serves to produce a nerve-racking atmosphere.

She is being pulled forward so the leg that is supposed to provide support ends up behind her.

In this pose he seems as though he is about to fall over.

Variations of Running

Carrying a Weapon | A trained professional. Be very careful as this pose is meant to convey a quick action.

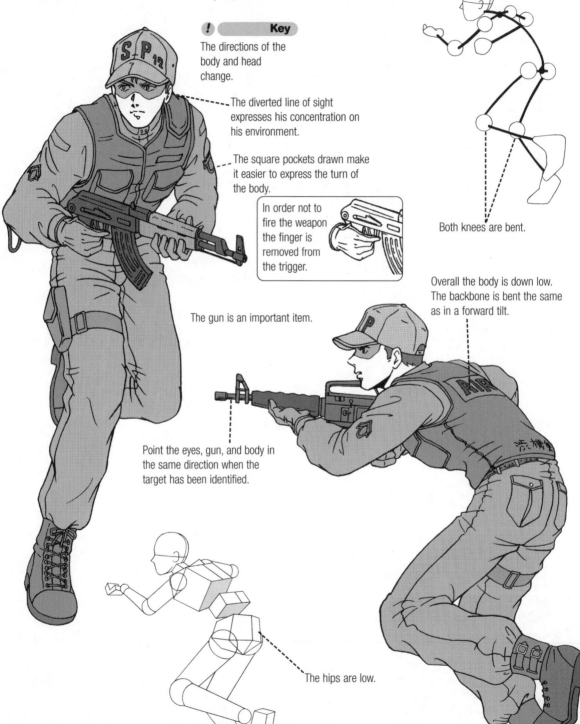

! **Key**

The directions of the body and head change.

The diverted line of sight expresses his concentration on his environment.

The square pockets drawn make it easier to express the turn of the body.

In order not to fire the weapon the finger is removed from the trigger.

The gun is an important item.

Both knees are bent.

Overall the body is down low. The backbone is bent the same as in a forward tilt.

Point the eyes, gun, and body in the same direction when the target has been identified.

The hips are low.

The line of sight and the gun point in the same direction. This is important to show that his attention is focused on the target.

Ready to fire, the finger is on the trigger.

The character is seen from below so the neck is not visible.

The border between the belt and the jacket is an upward curve. It clarifies the angle of the body.

One leg is off the ground and held in the air. This gives a greater sense of tension and speed than the spread-leg running pose.

The outfit is drawn with the same level of detail as the gun, particularly the shoelaces. When drawn properly, they seem real.

Composition used in the Charge Scene of a Battle

The character runs on his toes. Placing the entire underside of the foot on the ground reduces the feeling of speed.

Advice from Young Illustrators

Taisuke Honma

D.O.B. March 4th, 1979
Tokyo

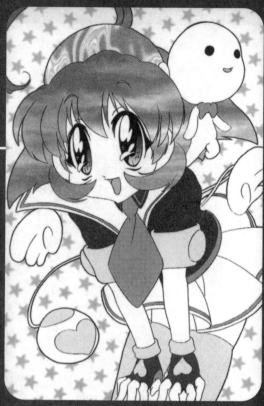

Why do you want to draw?
It's fun for me.
Drawing is fun, isn't it?
What do you think it means to have fun?
I think it is nourishment for a truly human existence.
A truly human existence is difficult and so it's fun.

Don't you think poetry is fun?
Poetry and drawing have the same aroma.
An image, cuisine, a stroll,
Video game, dance. Fun, don't you think?
Everyone has the same aroma but
Having fun is difficult, no?
Once you find one thing that is fun, finding something else that is fun becomes difficult.
That is the difficulty of getting nutrition for a truly human existence.
Living by getting a lot of good nutrition polishes your personality and makes it beautiful.

Today my nutrition is drawing.
I control how much delicious nutrition I get.
The drawing I did today was delicious.
Drawing characters is delicious.
Sweet like a cake, tart like a lemon and, sharp like wasabi.
I can freely add seasoning.

The flavor today was like this:
First was the look . . .
Well, . . . then I wanted to tack on a mouse.
Mouse, then computer, then cyber-like.
Freedom is great . . . let's add wings to her.
On the inside . . . to fly from here
I am here to study . . . I'm a student
Friends are essential . . . perhaps?
. . . and, afterwards salt and pepper. Just a little.
HOW TO DRAW ANIME & GAME CHARACTERS, my private mascot character,
Kyaradeza-ko is complete.
Thanks for the meal.
What shall I eat tomorrow?

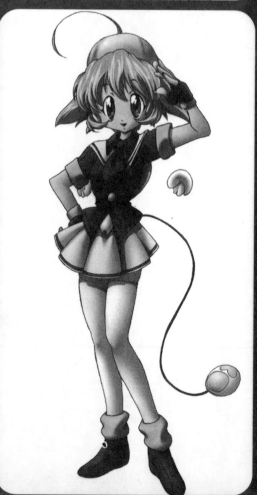

Chapter 4
Experience on Paper!

In this corner, we invited the readers to submit their works. The author selected and corrected the works, which then got reproduced here. The suggested corrections and the corrected example are also reproduced. Truly, the figures below the illustrations are the most important key. Making a mistake with the direction of the body and how the joints bend, the character won't look good no matter how much care is put into the character's costume.

Chapter 4

Touch Up Example 1

At first sight, the character seems to be standing straight but the center of gravity is off. This is the reason why it looks unstable! The feel of the scene and the items are drawn well.

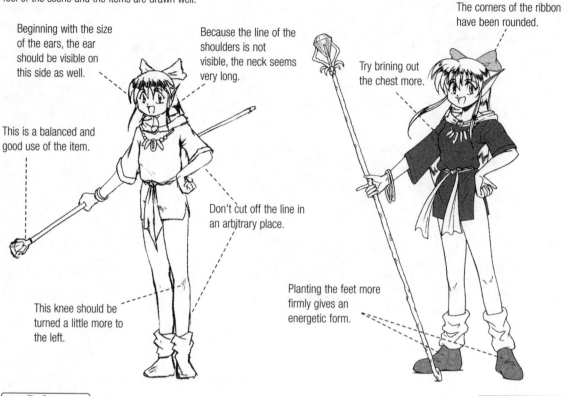

The corners of the ribbon have been rounded.

Beginning with the size of the ears, the ear should be visible on this side as well.

Because the line of the shoulders is not visible, the neck seems very long.

Try brining out the chest more.

This is a balanced and good use of the item.

Don't cut off the line in an arbitrary place.

This knee should be turned a little more to the left.

Planting the feet more firmly gives an energetic form.

Before

After

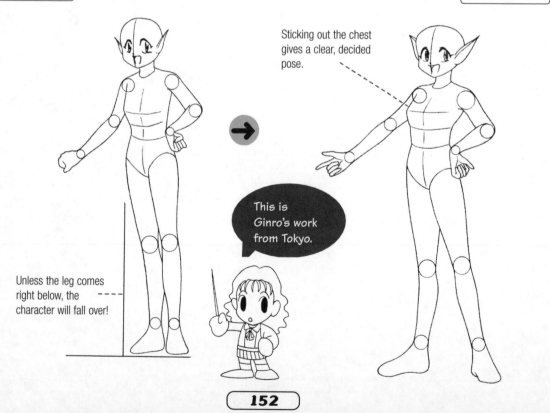

Sticking out the chest gives a clear, decided pose.

Unless the leg comes right below, the character will fall over!

This is Ginro's work from Tokyo.

Touch Up Example 2

The costume is very good! And the use of items gives the impression of having studied the items well. Unfortunately, the pose's angle does not bring out the charm of the costume completely. It would have been better to have the back directed a little more to the viewer, right?

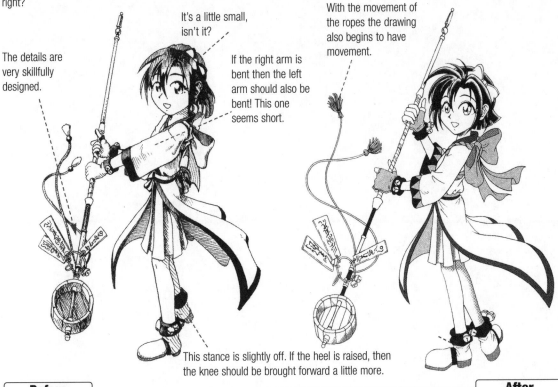

The details are very skillfully designed.

It's a little small, isn't it?

If the right arm is bent then the left arm should also be bent! This one seems short.

With the movement of the ropes the drawing also begins to have movement.

This stance is slightly off. If the heel is raised, then the knee should be brought forward a little more.

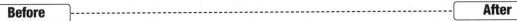

Before — **After**

The position of the nose (the center of gravity) is off center.

It is a pity that the back is not visible at all.

The lengths of the arms appear to be different.

This is Imano's work from Akita Prefecture.

Be careful with the spread of the toes.

Center of Gravity

Supporting Leg

Touch Up Example 3

This character is drawn with a realistic face so the 1-to-5 proportion of head to body is a waste! First, set the proportion ratio between the face and body and then draw.

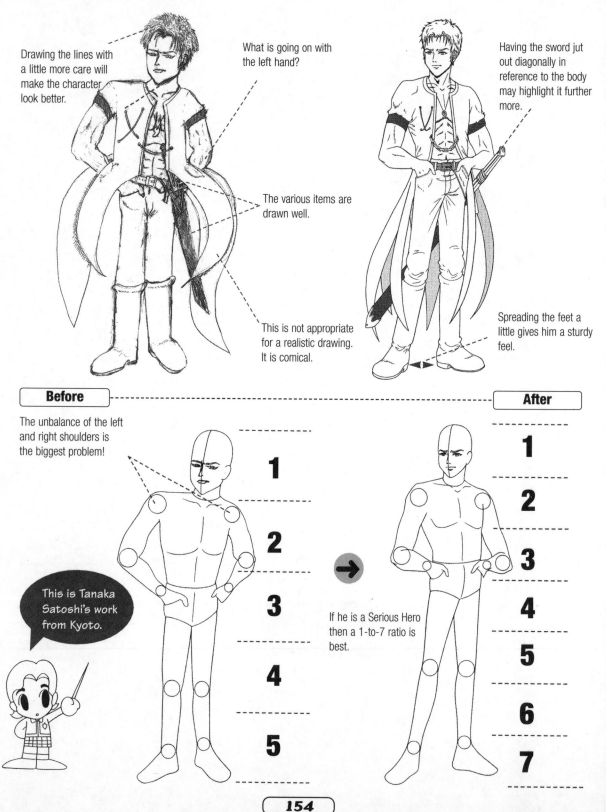

Drawing the lines with a little more care will make the character look better.

What is going on with the left hand?

Having the sword jut out diagonally in reference to the body may highlight it further more.

The various items are drawn well.

This is not appropriate for a realistic drawing. It is comical.

Spreading the feet a little gives him a sturdy feel.

Before

The unbalance of the left and right shoulders is the biggest problem!

This is Tanaka Satoshi's work from Kyoto.

After

If he is a Serious Hero then a 1-to-7 ratio is best.

Touch Up Example 4

The skill level of this illustrator is high. The details and the composition as a whole give the sense that this illustrator has practiced and is proficient. When the body is in a pose, try to be more particular with the direction of each part.

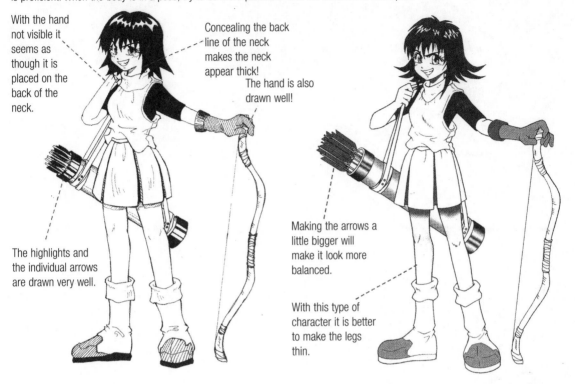

With the hand not visible it seems as though it is placed on the back of the neck.

Concealing the back line of the neck makes the neck appear thick!

The hand is also drawn well!

The highlights and the individual arrows are drawn very well.

Making the arrows a little bigger will make it look more balanced.

With this type of character it is better to make the legs thin.

Before

After

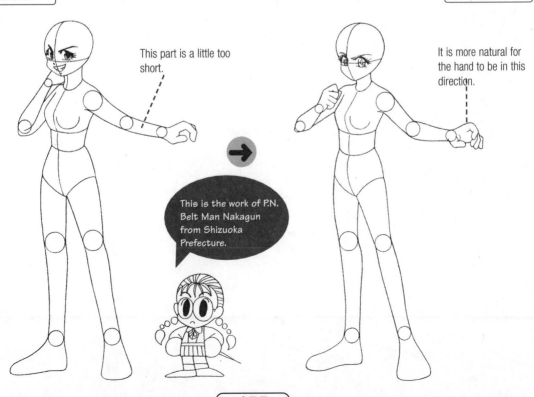

This part is a little too short.

It is more natural for the hand to be in this direction.

This is the work of P.N. Belt Man Nakagun from Shizuoka Prefecture.

Tadashi Ozawa:

A freelance animator, Ozawa has done contact work for such companies as Studio GHIBLI and Mad House. He took part in several hit works-The Art of NAUSICCA, LAPUTA, AKIRA, LODOSS WARS and YAWARA! An animation director at Studio GHIBLI, he worked as a producer at Mad House and was in charge of training new animators.